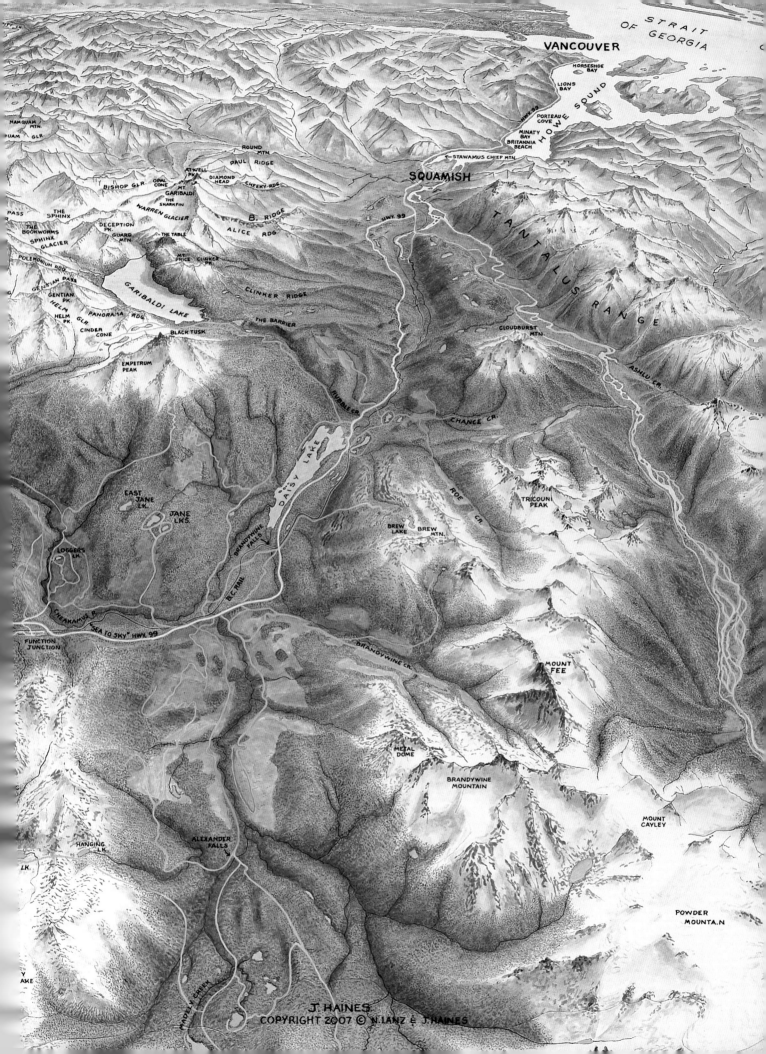

STRAIT OF GEORGIA

VANCOUVER

HORSESHOE BAY

LIONS BAY

HOWE SOUND

HWY. 99

PORTEAU COVE

MINATY BAY
BRITANNIA BEACH

MAMQUAM MTN.

QUAM GLR.

ROUND MTN.

PAUL RIDGE

ATWELL PK.

BISHOP GLR.

OPAL CONE

MT. GARIBALDI

THE SHARKFIN

DIAMOND HEAD

CHEEKY RDG.

STAWAMUS CHIEF MTN.

SQUAMISH

PASS

THE SPHINX

THE BOOKWORMS

SPHINX GLACIER

DECEPTION PK.

WARREN GLACIER

GUARD MTN.

THE TABLE

B. RIDGE

ALICE RDG.

HWY. 99

TANTALUS RANGE

POLEMONIUM RDG.

MT. PRICE

CLINKER PK.

GENTIAN PASS

GARIBALDI LAKE

CLINKER RIDGE

GENTIAN PK.

HELM PK.

HELM GLR.

PANORAMA RDG.

THE BARRIER

CLOUDBURST MTN.

CINDER CONE

BLACK TUSK

ASHLU CR.

EMPETRUM PEAK

RUBBLE CR.

CHANCE CR.

DAISY LAKE

EAST JANE LK.

JANE LKS.

ROE CR.

TRICOUNI PEAK

BREW LAKE

BREW MTN.

LOGGERS LK.

BRANDYWINE FALLS

B.C. RAIL

CHEAKAMUS R.

SEA TO SKY HWY. 99

FUNCTION JUNCTION

BRANDYWINE CR.

MOUNT FEE

METAL DOME

BRANDYWINE MOUNTAIN

HANGING LK.

ALEXANDER FALLS

MOUNT CAYLEY

LK.

Y AKE

POWDER MOUNTA.N

MADELY CREEK

J. HAINES
COPYRIGHT 2007 © N. LANZ & J. HAINES

Top of the Pass

Whistler and the Sea-to-Sky Country

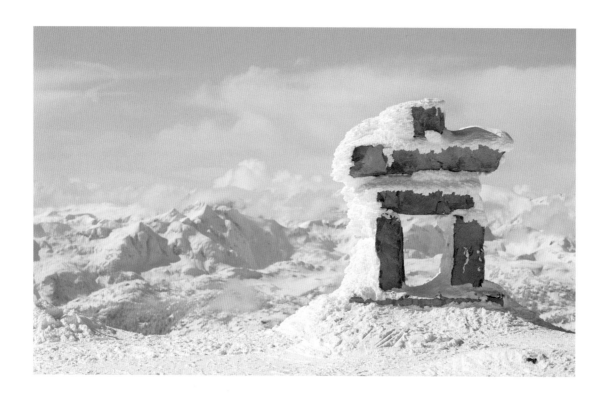

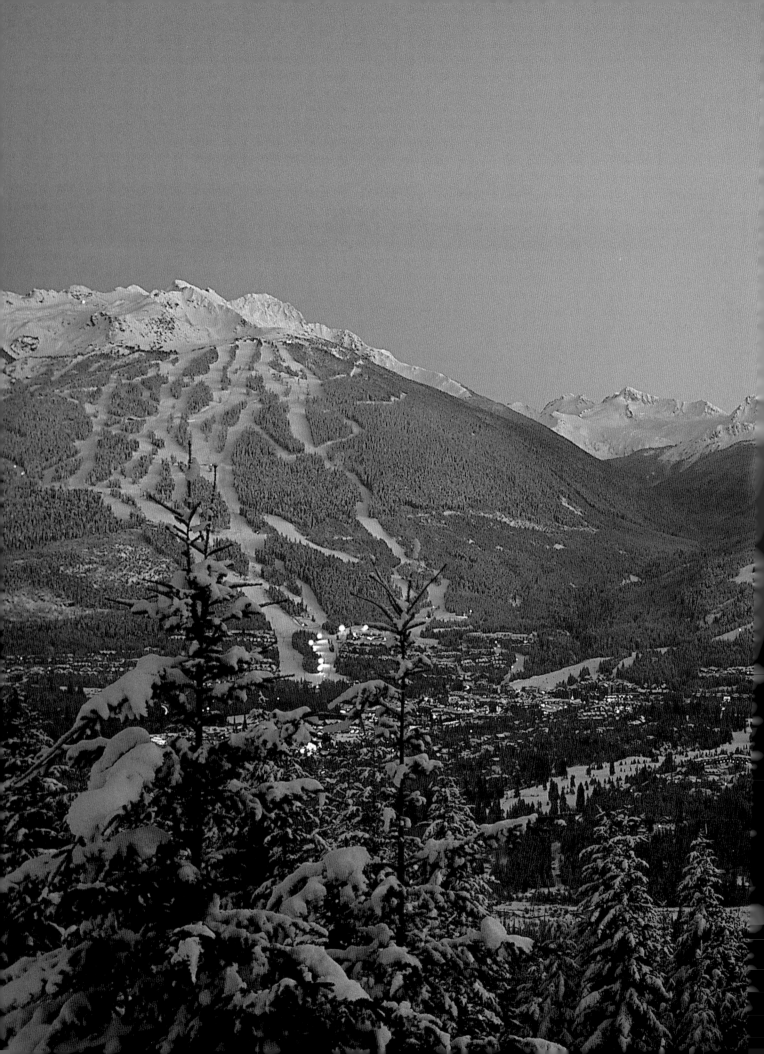

Top of the Pass

Whistler and the Sea-to-Sky Country

STEPHEN VOGLER

photography by TOSHI KAWANO
& BONNY MAKAREWICZ

HARBOUR PUBLISHING

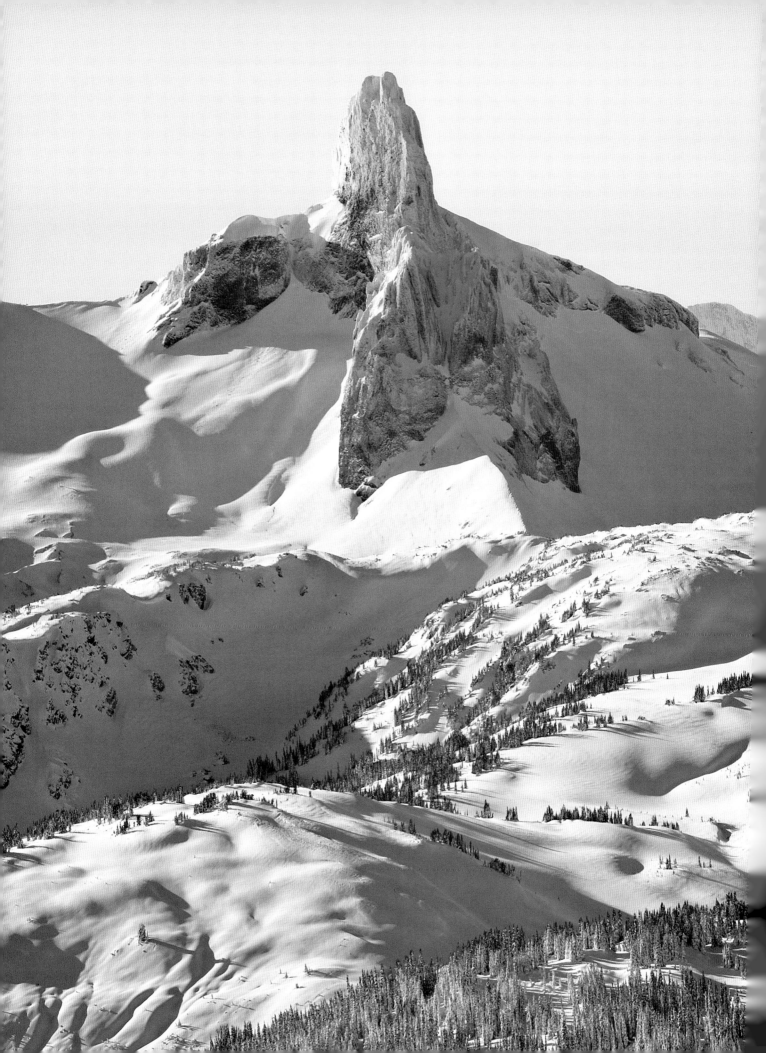

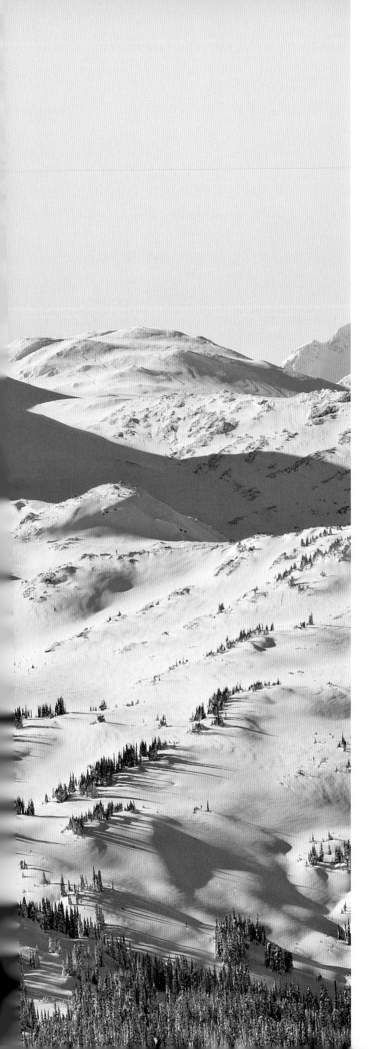

CONTENTS

Page 1: **The Inunnguaq at the top of Whistler Peak looks out over the snow-clad Coast Mountains.** TK

Previous pages: **Blackcomb and Whistler Mountain aglow in the twilight above Whistler Village and Alta Lake.** BM

The volcanic spire of Black Tusk is one of the most recognizable and photographed features in Garibaldi Park. BM

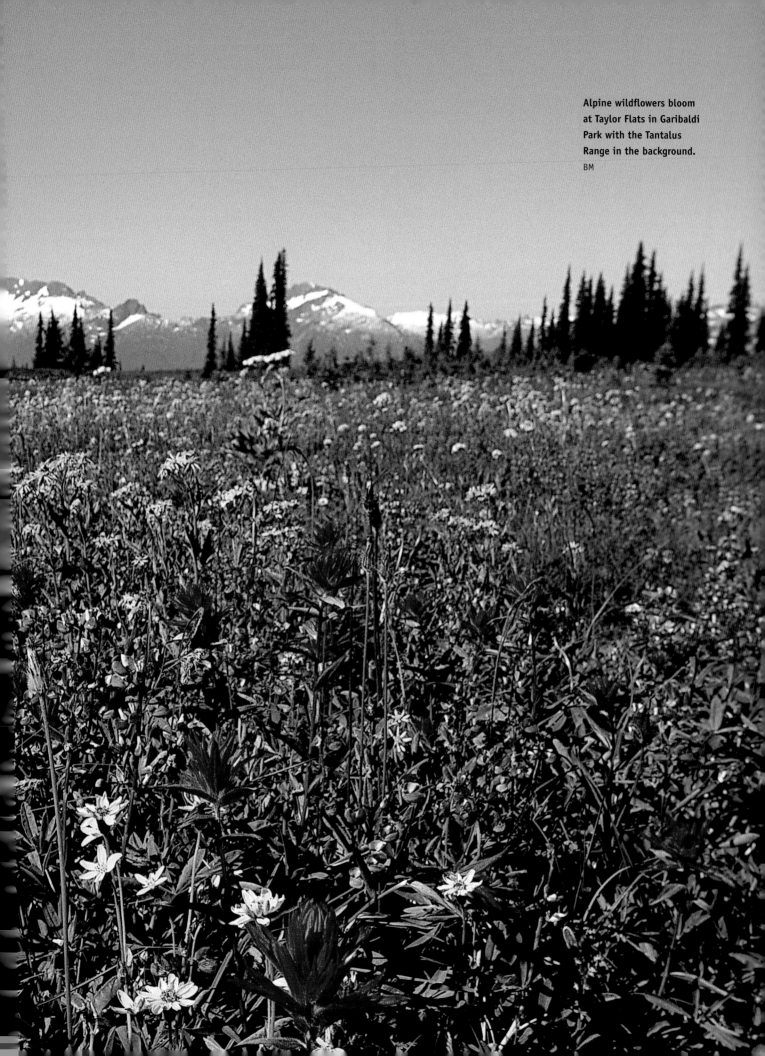

Alpine wildflowers bloom
at Taylor Flats in Garibaldi
Park with the Tantalus
Range in the background.
BM

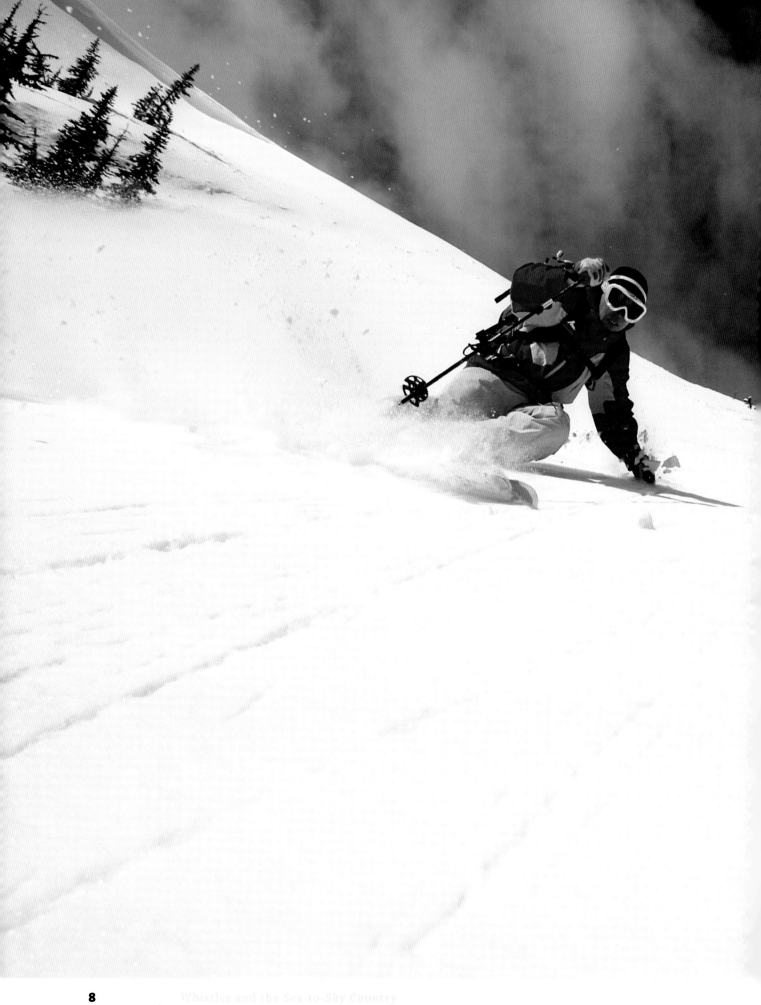

W HISTLER IS A PLACE TO MOVE THROUGH —IT ALWAYS HAS BEEN. *SITUATED AT THE TOP OF A NARROW PASS IN THE* COAST MOUNTAINS, *ITS WATERS FLOW OUT FROM EITHER END OF THE VALLEY.* ALTA LAKE, *ONCE THE NAME OF THE TOWN, MARKS NOT ONLY THE CENTRE OF THE PASS, BUT THE DIVIDE BETWEEN TWO WATERSHEDS; THE CRACK THAT FORMS IN THE ICE AT ITS MID-POINT EACH SPRING ATTESTS TO ITS UNIQUE GEOGRAPHIC POSITION.* IN A VALLEY CHARACTERIZED BY SUCH TRICKS OF GRAVITY, IT'S NOT SURPRISING THAT THE POPULATION, WHETHER PERMANENT, SEMI-PERMANENT OR VISITING, IS ALSO ENAMOURED WITH MOTION. IN WHISTLER, GRAVITY IS REVERED LIKE A DEITY.

Top of the Pass

Previous pages: **Toshiya Sato finds untracked April powder on Tiger's Terrace, Whistler Mountain.** TK

It's not only with skis, boards or mountain bikes beneath their feet that people in this valley celebrate motion. There is the constant movement and turnover of population: the seasonal worker who does a stint as a liftee or waiter before returning to school or travelling elsewhere; the avid Vancouver skiers who have driven to their Whistler cabins every weekend for the past twenty-five years; the residents of neighbouring Pemberton and Squamish who arrive to work or play and leave again at the end of their shift; or the second-home owner from New York or Tokyo who spends a week here every year.

Whistler is one of the few small towns that, on any given day, might have people from Japan, Italy, Mexico and Australia milling about its village. Conversely, many long-time Whistlerites also have a penchant for travelling. And even when they move away, temporarily or permanently, they often maintain a thread of connection to the valley—alumni members of a Whistler community that is in constant flux.

But to the newly arrived visitor sitting on a patio in Whistler Village, the very word *community* is often greeted with skepticism. "Do people actually live here?" is a commonly asked question. As one wanders for the first time through the twists and turns of the pedestrian streets, past shops, cafés and restaurants, with the Coast Mountains jutting like a faux backdrop from each view corridor, it's easy to believe that this is Whistler in its entirety: an instant village devoid of history.

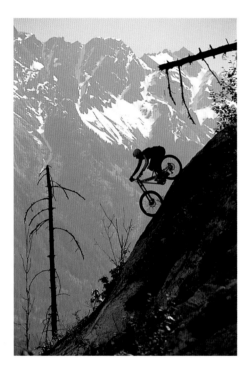

Steep descents are part of a good day's work for professional mountain biker Claire Buchar. BM

Yet the history is there, thin at times though it is, and meandering like the waterways that lead out of the valley. Whistler is a place that remakes itself on a regular basis. Its older selves disappear from easy view; they sink into the layers of valley sediment and require some archaeological digging to unearth. But in the sifting process it may still be possible to discover some kind of connective thread that runs through all of the valley's incarnations; something that connects the ancient Lil'wat trail with the Sea-to-Sky Highway; the log fishing lodges on Alta Lake with the volleyball and boom-box beach scene at Rainbow Park; the trapper's cabin with the hippy ski-bum squatter with the hipster snowboarder artist.

Those who make Whistler their long-term home are willing to put up with the oddities and challenges of the place in order to wake up to that rarefied mountain air, to sneak a walk or bike ride up a forested trail named Whip-Me-Snip-Me or Mel's Dilemma before work, or perhaps during or after. Many Whistlerites have given up a more normal, mainstream existence elsewhere—one where the goal posts of the *real world* were much more clearly defined. If there's any one thing that unites the community, lends it its spirit, it is people's shared passion for the valley itself, and for playing in the Coast Mountains. Overall there's a tenacity of spirit and a hardiness of soul among Whistler's population. It is formed by people who are willing to create their reality in a place that seems to offer no concrete ground to stand on—a place in constant motion.

Since the first phase of the village opened in 1980, and even in the years leading up to that date, Whistler has been in the throes of a boomtown existence. It's easy to forget completely about those sleepy decades before the town was incorporated in 1975 as BC's first resort municipality: the post-logging years when most of the good timber was cut and the camps moved on to more remote areas of the province; the post-fishing-lodge days when the romance of a train ride to Alta Lake was usurped by the new freedom and greater range of the automobile. When one is floating along on a booming economy, the present quickly becomes the norm and all else seems a remote and unlikely possibility. But if one were to sit on that village patio again, and happened to have

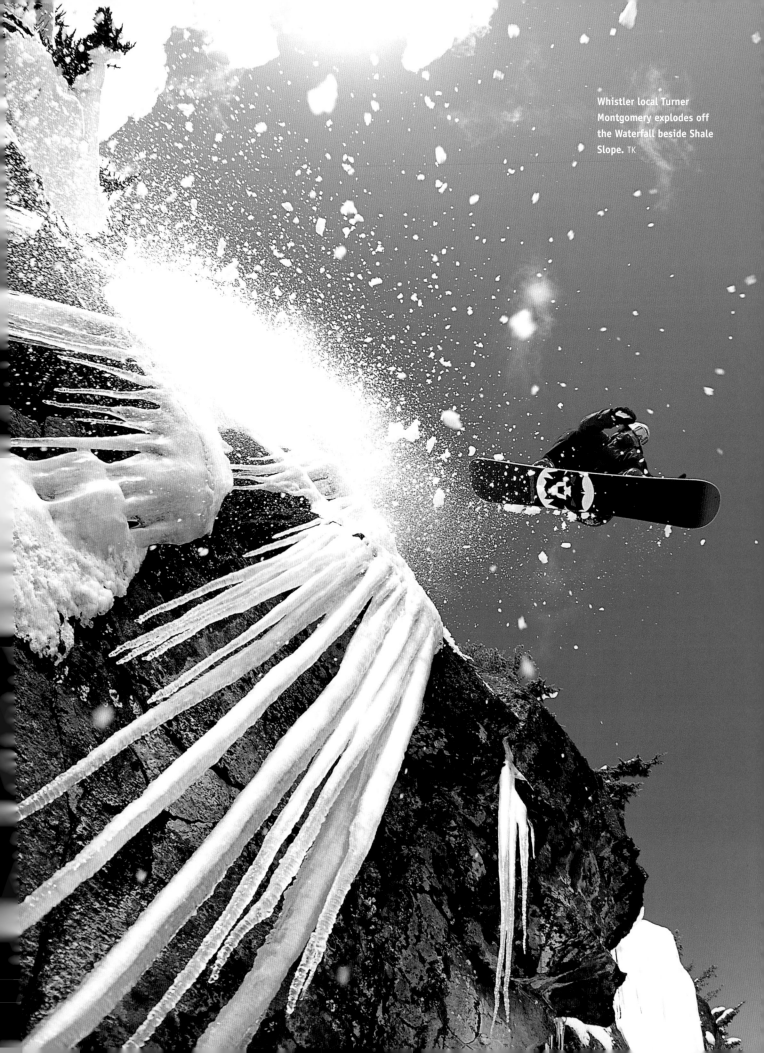

Whistler local Turner
Montgomery explodes off
the Waterfall beside Shale
Slope. TK

Above: **Riding high in the Adventure Zone at the base of Blackcomb.** BM

Below: **A bike race streaks through the heart of Whistler Village.** BM

a shovel handy, one might be able to dig back into an earlier era and unearth one of Whistler's most treasured scraps of lore: that beneath this immaculate village sits the remnants of the town's old garbage dump.

What does this little irony at the heart of Whistler's village mean in terms of today's successful four-season resort with its high-speed lifts and four-star hotels? It's a fun question to ponder. With the knowledge of the village's past life, one can't help but look around at today's splendour and wonder about its permanence. In a province rich with boom-and-bust cycles, perhaps each new incarnation of a town grows from the detritus of the last, like a young western forest growing from the rotting humus of its fallen giants.

The 2010 Winter Olympics offers its own version of a completed cycle in Whistler's history. Construction of the Athletes' Village, the largest development Whistler had seen since construction of the first village, began in 2006 in the Cheakamus Valley at the south end of town. The site, one might not be surprised to learn, was Whistler's second garbage dump. This time, pipes were laid into the ground to make use of all that lingering methane gas as a heating source.

In a community that observes sports as a form of religion, hosting the Olympic Games is the Holy Grail. Whether one views the Games as the height of purity in sports, or as a commercial mega-project with expensive TV rights, once they're coming to town there's plenty of work to be done. In the years leading up to the Olympics, Whistler has had the feel of a household preparing to throw a dinner party for its most influential friends. All other matters of significance are pushed aside, stuffed away in old sock drawers until the big hoorah is over.

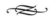

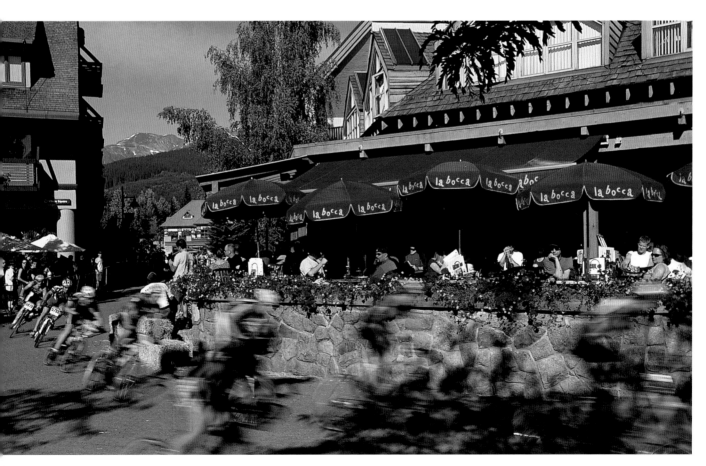

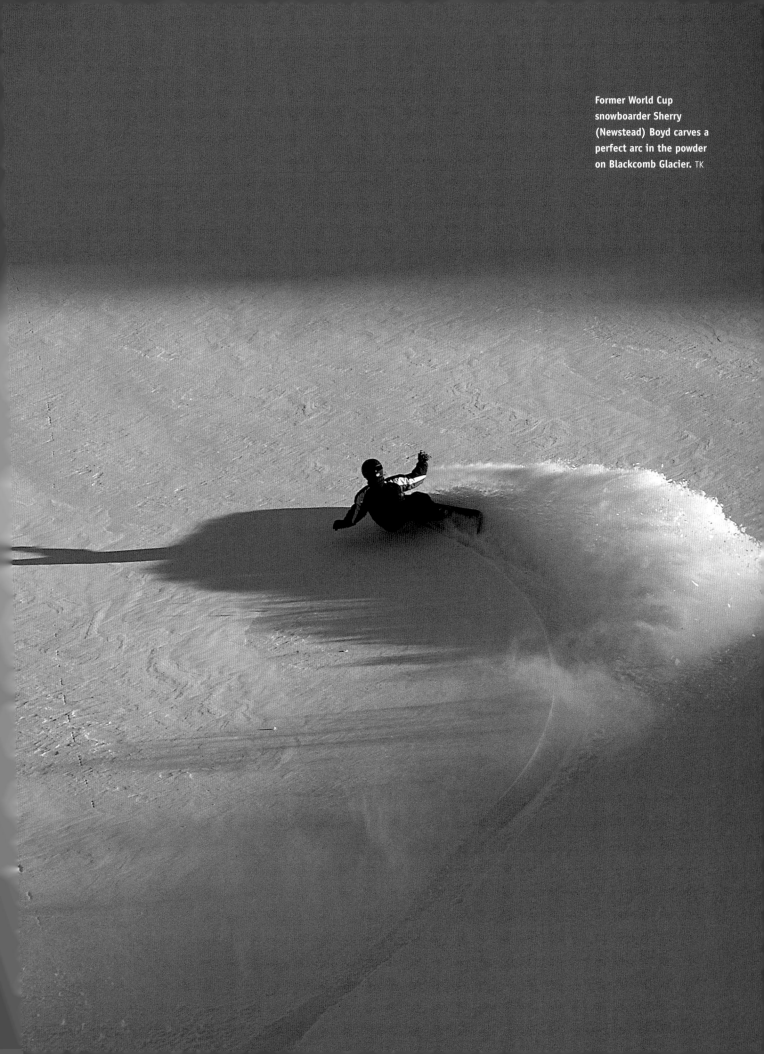

Former World Cup snowboarder Sherry (Newstead) Boyd carves a perfect arc in the powder on Blackcomb Glacier. TK

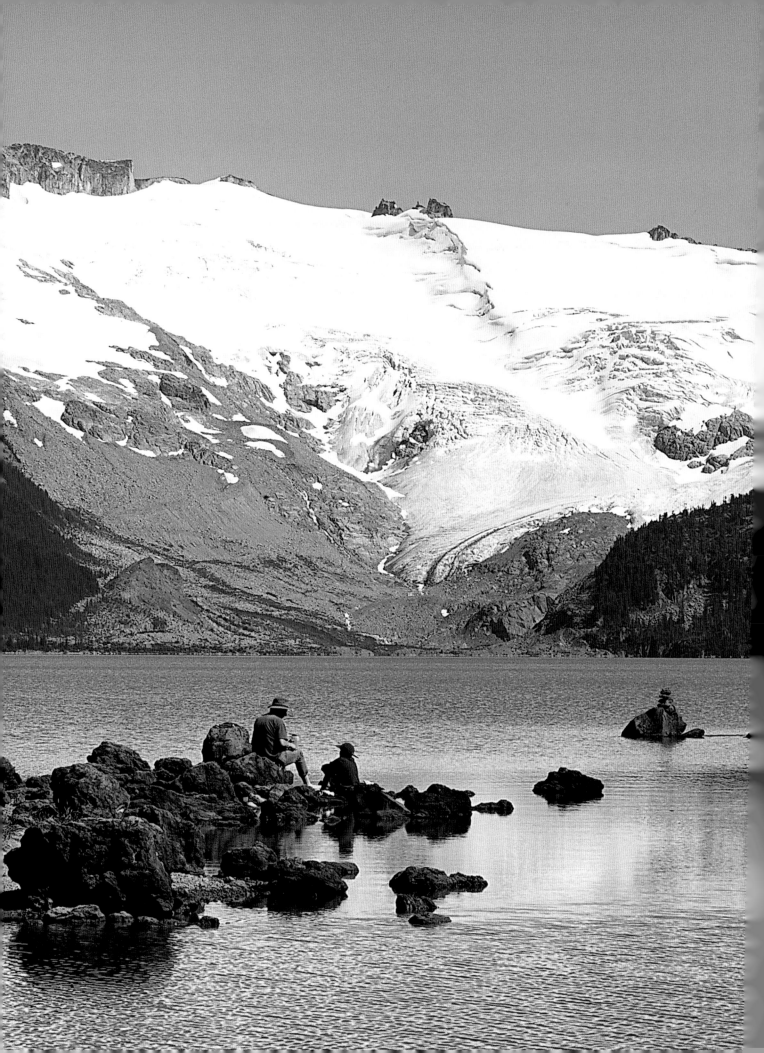

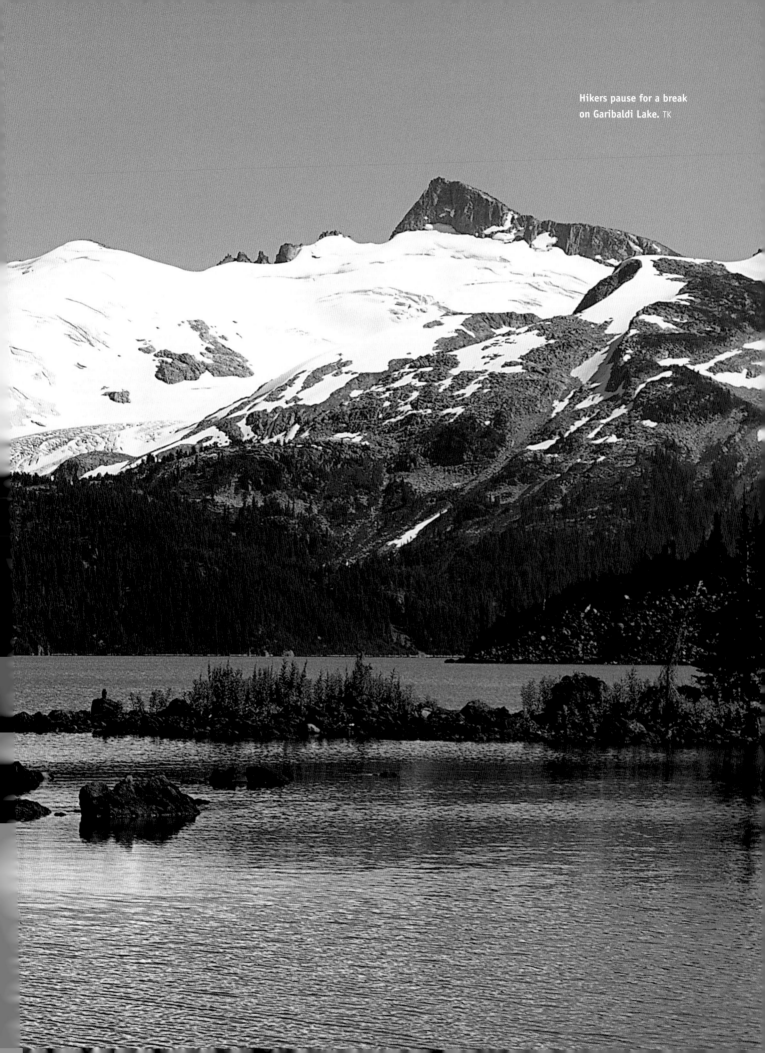

Hikers pause for a break on Garibaldi Lake. TK

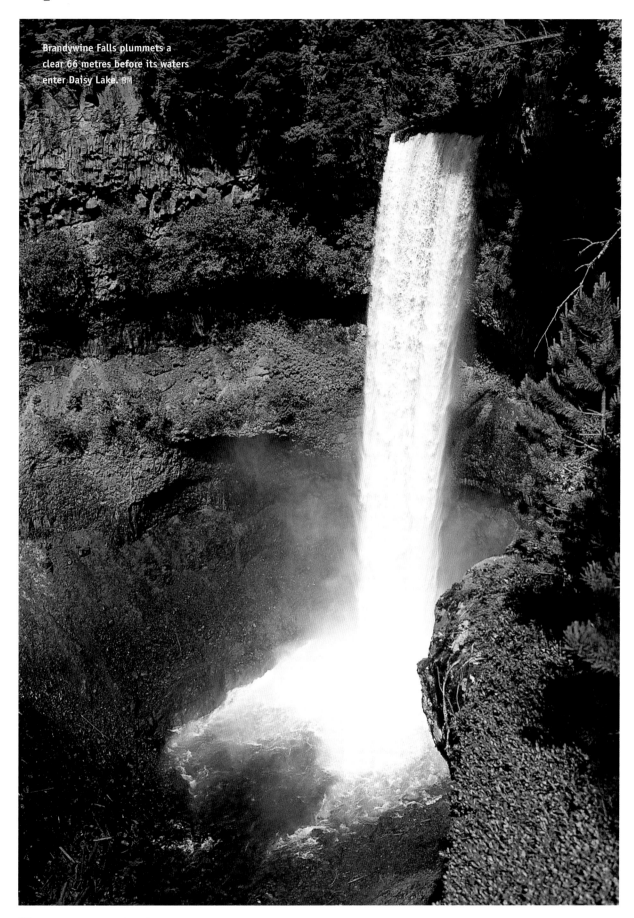

Brandywine Falls plummets a clear 66 metres before its waters enter Daisy Lake. BM

Sitting at the top of the pass, it's easy to forget about the rest of the world. But Whistler exists in the context of its neighbouring communities in the Sea-to-Sky corridor: Squamish to the south and Pemberton and Mount Currie to the north, along with a host of smaller places such as Lions Bay, Britannia Beach, Furry Creek, Birken, D'Arcy and Anderson Lake. Many former Whistler residents have moved to these neighbouring communities, some still working at the resort, others weaning themselves from its economic pull. A sense of shared destiny has increased in the region over the years as the resource-based economies have slowly turned toward tourism. The Olympics, by sheer dint of its mega-project status, has also created a shared consciousness throughout the corridor. If nothing else, the communities from Lions Bay to Mount Currie will have to pull together to weather the Olympic storm sweeping up the corridor.

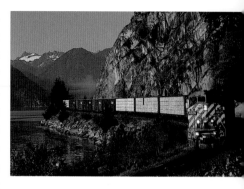

A freight train hugs the steep cliffs along Howe Sound. BM

Squamish and Pemberton, situated at sea level and 700 feet respectively, are very different places from Whistler at the 2,200-foot pass between them. The Coast Mountains jut impressively from their low, expansive valley bottoms and the fertile soil and slightly longer summers allow for the growing of food. These are places to hunker down, to raise families, and to enjoy many of the same recreational pursuits that Whistler has to offer. In many ways, Whistler's neighbouring communities are in a better position to weather the peaks and valleys of the region's tourist economy. Tourism spills over into Pemberton and Squamish, but it's not their entire existence.

Whatever changes come to Whistler, there will be just as many elements that remain the same: the pristine air you feel when you arrive in the valley, the chain of mountains carved into the skyline; the string of lakes emptying glacier water from each end of the valley; and perhaps most of all, that feeling that change itself is always on the horizon. The many colourful characters who have settled into the layers of Whistler life don't rely on a booming economy to keep them here. They know that what goes up must come down, and they've accordingly become artists in the field of gravity. They also know that in this part of the world, it's not uncommon for the next phase of growth to spring directly from the refuse of the last.

A BC Ferry plies the calm waters of Howe Sound with Anvil Island in the background. TK

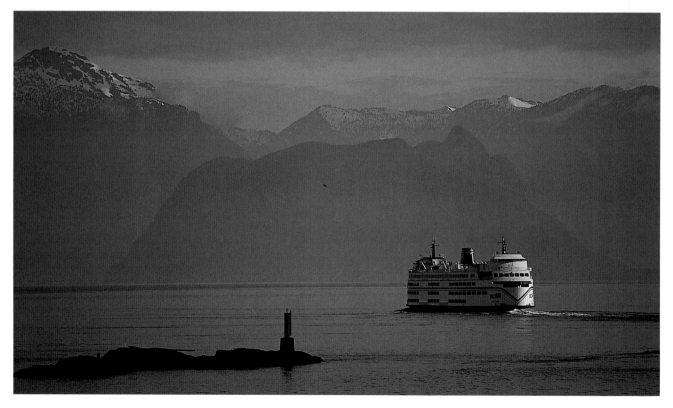

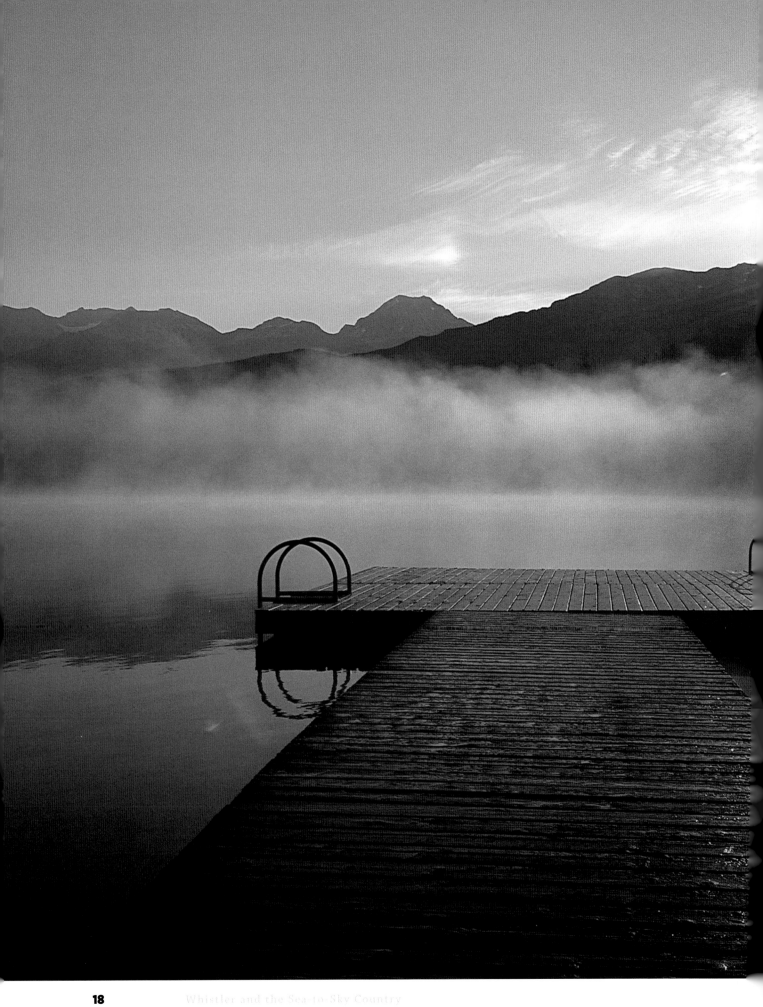

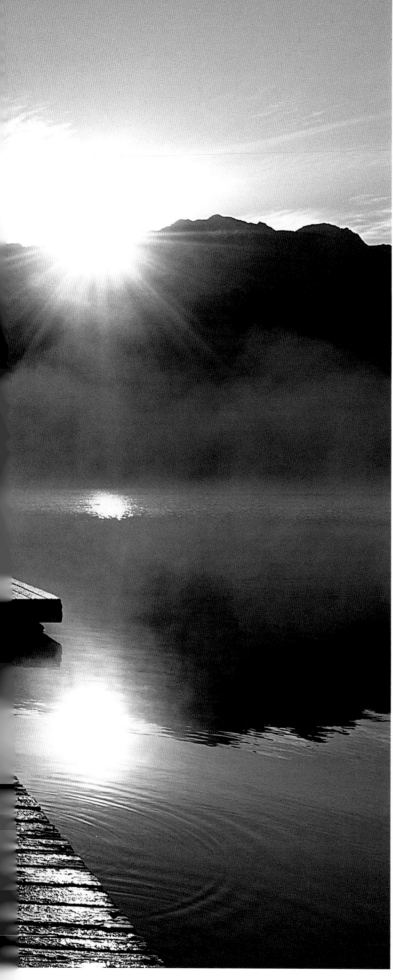

Alta Lake

BLUEBERRY HILL STANDS BETWEEN WHISTLER VILLAGE AND ALTA LAKE LIKE A PARTITION DIVIDING TWO ERAS OF THE TOWN. THE VILLAGE MAY HAVE THE DANCE CLUBS, BANK MACHINES AND GONDOLAS, BUT ALTA LAKE, AS THE DIVIDE BETWEEN TWO WATERSHEDS AND THE VERY CENTRE OF THE VALLEY, IS STILL THE HEARTBEAT OF THE COMMUNITY.

The story goes that at the height of its own boomtown days in the 1930s, Rainbow Lodge on Alta Lake was the most popular resort west of Jasper. Another story, told at the Horseshoe Grill in Vancouver in 1911, led to the building of Rainbow Lodge by legendary pioneers Myrtle and Alex Philip. John Millar was the raconteur of that tale and Alex Philip provided the keen ears and the dreaming mind. Millar was the first of a long line of eccentrics to set up camp in the Whistler Valley. A cattle wrangler and cook from Texas with bandy legs, a black Stetson and two notches in his gun, he built a cabin

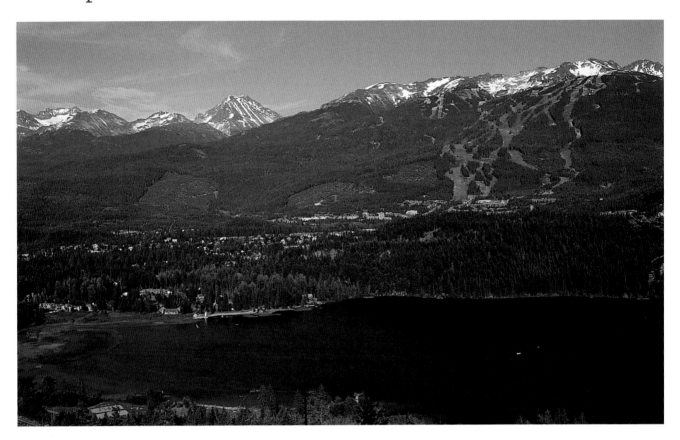

Top: **The northern end of Alta Lake with Blackcomb, Wedge and Armchair Mountain in the background.** BM

Above: **The guest cabins at Rainbow Lodge bore the weight of many good snow years.** Photo courtesy J'Anne Greenwood

Previous pages: **A pristine late-summer morning on the dock at Rainbow Park** BM

near Function Junction in the early 1900s. Millar ran a trapline up the Cheakamus Valley to Singing Pass, and cooked home-grown vegetables and coon or muskrat stew for the odd prospector who came up the Pemberton Trail: fifty cents a bed, fifty cents a meal. John spun a few of his tales about the rugged Alta Lake wilderness to Alex (including, I like to think, the one about the dead wolverine in John's Trapper Nelson backpack that proved to be only frozen and chewed its way through the canvas to bite him in the ass), and soon the Philips were making the three-day journey to Alta Lake on horseback and foot.

So begins the predominant history of settlement at Alta Lake. But there is another partition separating eras in this valley; a partition that is as much a matter of culture as it is of history. The Lil'wat people have lived in the area of Alta Lake and Green Lake for thousands of years. They too have stories of this place, though those stories are not always easy to find and are sometimes kept close to the people who know them. In their own St'at'imcets language, the flat land near Alta Lake is called Skitsiklhtin, and the marmots Whistler Mountain is named for are known as *cwítma*. The mythical transformers, who brought order to the Lil'wat territory, passed through this valley on their return to the coast.

One look at the character of the surrounding mountains, from Armchair and Wedge to Mount Currie and the thunderbolt of Black Tusk, and even the most rational of scientists might begin to believe that the gods and transformers have roamed this land. The Lil'wat have hunted, fished, picked berries, trapped animals, sung songs and told their stories in this valley since what their elders call the beginning of time. But smallpox brought in during the Cariboo Gold Rush reduced Lil'wat numbers by 80 to 90 percent. The reserve scheme implemented by Governor James Douglas then placed the remaining population on a reservation at Mount Currie northwest of Whistler.

Along with the tales spun by John Millar to the Philips was the simple mention of a cedar

canoe tucked in the woods along the shore of Alta Lake. That abandoned canoe speaks volumes about the immense changes that had swept through the Lil'wat culture leading up to the time of the Philips' arrival. The pristine lake that Myrtle and Alex paddled out onto on their first visit was not part of an uncharted wilderness, but rather a land echoing with the recent struggles and losses of a thriving Interior Salish culture.

If you paddle out onto Alta Lake today, you'll see much of Whistler's history laid out on the shore. Early ski cabins sit tucked in the trees next to the latest in megalithic superhomes. Some of the oldest summer cabins still stand at the south end of the lake. Their sloped roofs, mosquito-netted porches and rickety docks speak of the days when ten minutes of fishing netted a good dinner, and social visits around town were made by boat.

Now if you let your canoe drift at the centre of the lake (providing an afternoon southerly doesn't blow you down to the River of Golden Dreams), the panoramic view will have changed surprisingly little since the heyday of the fishing lodges. The forested slope of Blueberry Hill still runs uninterrupted to the shore, hiding the village's hotels and condos like a secret it is unwilling to divulge. From here, cradled at the centre of this Coast Mountain pass, the eastern horizon is carved by a chain of peaks and bowls from Whistler Mountain in the south to Mount Currie in the north, while the western sky is dominated by the rounder formations of Sproatt and Rainbow Mountain. With much of the shore still flanked by either forest or park, and the old cabins standing undaunted next to the new mansions, Alta Lake serves as a kind of time machine for the valley.

Beginning in 1914, the thriving summer tourist season brought throngs of fly fishers, outdoor enthusiasts, honeymooners and general vacationers to Rainbow aboard the old Pacific Great Eastern (PGE) steam train. Despite the rugged setting, Rainbow offered a kind of cosmopolitan wilderness experience. Myrtle Philip, and later, chef Lam Shu, turned out gourmet meals from the

Above: **A few old summer cabins still dot the shore along Alta Lake.** BM

Below: **A traditional Lil'wat dugout canoe built by Marvin Wells.** Photo Johnny Jones

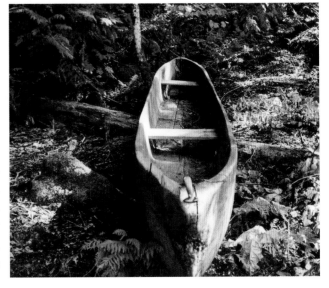

Top of the Pass

Alta Lake pioneer Bill Bailiff admires his catch after climbing out of an old Lil'wat canoe.
Photo courtesy J'Anne Greenwood

kitchen (breakfasts included pancakes with strawberries and cream from the Barnfield dairy at the north end of the lake); the bar was always well stocked—a harbinger of the future Whistler village; a lawn tennis court was built beside the lodge; and Alex was known to gondolier honeymooners down the meandering "River of Golden Dreams and Memories" (named by Alex himself) in his *Alta Clipper*, spinning romantic tales as he paddled through the lush wetland.

The success of Rainbow led to the building of other lodges around the lake: Harrop's at Cypress Point with its boat-access tea room, Hillcrest on the southeast shore surrounded by tiny log cabins, and the Alta Lake Hotel at Alta Lake Station, which eventually grew into the townsite with a school and community hall. Alfred Barnfield and his son Fred delivered milk from the dairy by canoe around the lake. Their morning journey also carried news from one lodge to the next, as a sense of community began to develop at Alta Lake.

While owning a summer cabin was one level of commitment to the place, it took a hardy and adventurous soul to live full time at Alta Lake. Myrtle Philip, a prime example, had worked with her father, Sewell Tapley, and her brothers building the Rainbow Lodge while Alex still cooked at the Horseshoe Grill in Vancouver to earn money for materials. The Tapleys hand-logged the trees for the lodge, peeled them and dragged them into place with Old Bob, their workhorse. Myrtle cooked meals for the train crews coming up the newly constructed rail line. She was known not

Canoeing up the River of Golden Dreams; the view has changed little since the early 20th century. BM

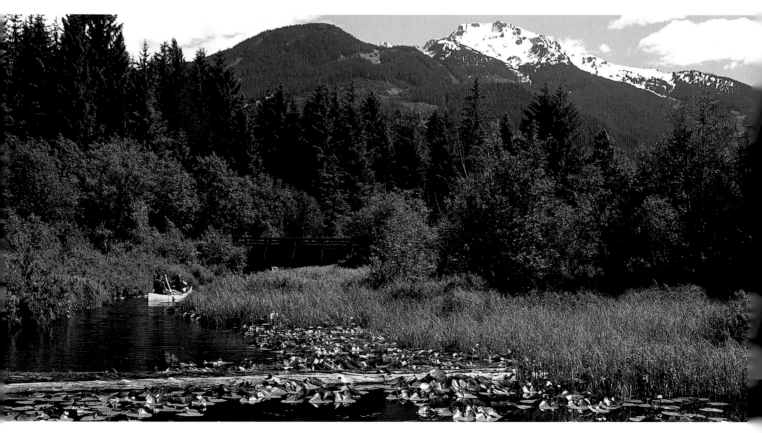

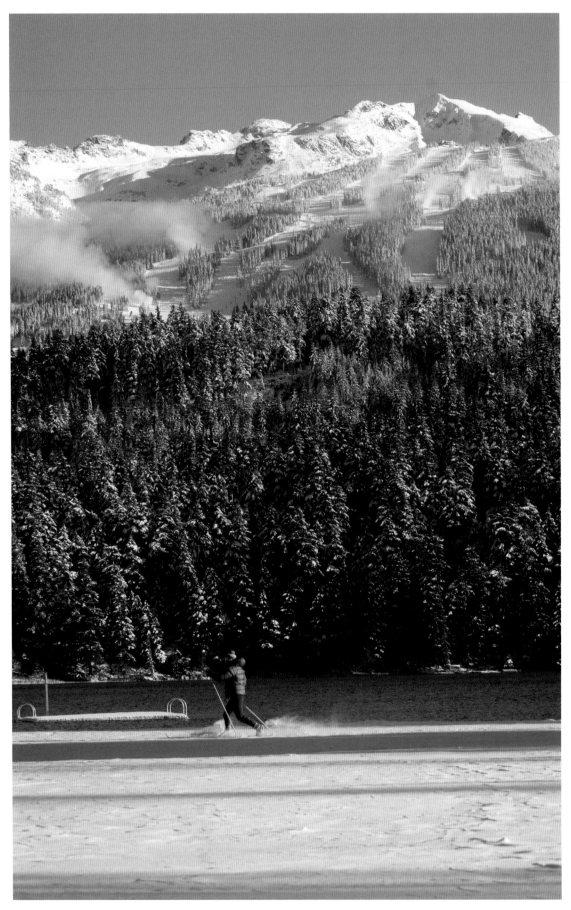

A cross-country
skier glides along
the shore of Alta
Lake at Rainbow
Park. BM

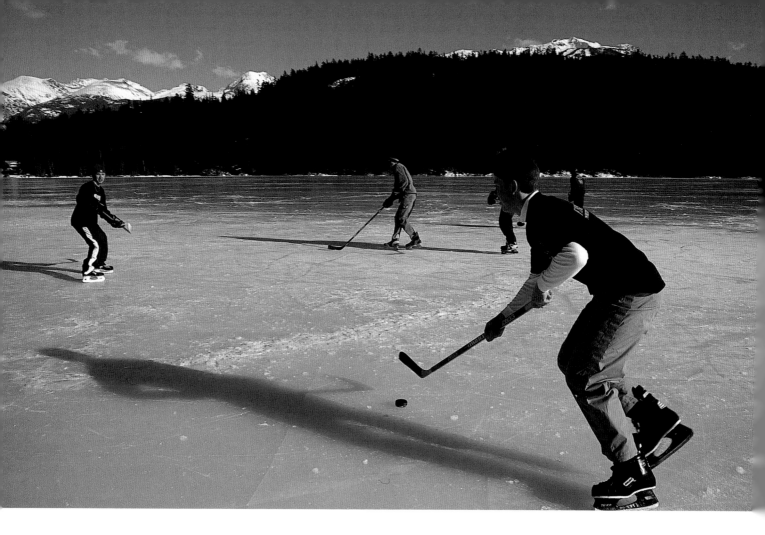

In a land of heavy Coast Mountain snowfalls, a game of hockey on Alta Lake is a rare treat. BM

only as an excellent cook, but as one of the best fishers in the district, as well as a skilled horse woman, offering mountain trail rides to the lodge guests. Her brother Phil Tapley took over the farm and dairy from the Barnfields, and he and his wife Dorothy lived a pioneer existence there with wood heat and no running water until 1971. Tapley's Farm is now home to Easy Street, a neighbourhood where many young Whistler families have raised their children over the last quarter of a century.

Florence and Andy Petersen

Florence and Andy Petersen are one of the few couples who have been prominent members of both the old Alta Lake community and the new Whistlerized version. In their seventies now, they're still spry and active and recall stories from the valley with youthful enthusiasm.

"Still my favourite," Andy says in a slight Danish accent from his living room overlooking the lake, "is when Dick [Fairhurst] and I put in the new water system in Scotia Creek. We'd never worked with dynamite before and we nearly blasted the whole valley."

"There was just this side of the lake then," Florence says of the old Alta Lake community. "Just this and Hillcrest Lodge on the other side. Everyone helped each other out. People went to Dick Fairhurst at Cypress Lodge if they needed something.

"Myrtle Philip and Dick Fairhurst saw the sweeping changes that skiing was bringing," Florence recalls. "They said to me, 'People aren't even going to know we lived here.' I told them, 'When I retire I'll gather stories and photos and prove you all lived here.'" Thus began Whistler's Museum and Archives Society. The museum was set up in the back corner of the first library in the basement of the municipal hall with shelving and cases built by Andy. Myrtle Philip had donated many items and saw the first display in 1986 before she passed away.

Florence and Andy Petersen in their home overlooking Alta Lake. TK

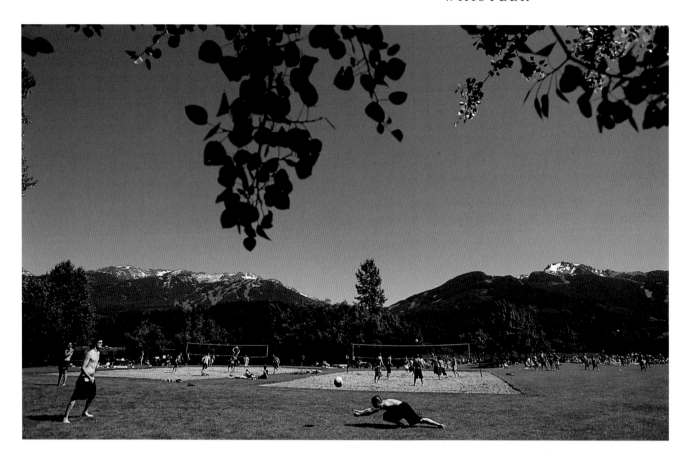

A classic story of giving up the workaday world in order to settle at Alta Lake comes from Bill Bailiff, an early trapper and prospector in the valley. Originally from Cumberland, England, Bill came to western Canada to nurse his broken heart after his fiancée died of pneumonia. While working on the blasting crew clearing the path for the PGE rail line in 1913, he got into an argument with his foreman. Unable to convince the other man of the dangers of an overhanging rock, Bill picked up his bag and walked up the unfinished line as far as Alta Lake. He built a cabin at Scotia Creek on the west side of the lake and lived out his days trapping, prospecting, raising chickens and writing poetry and articles about the area.

Harry Horstman also lived near Scotia Creek when he wasn't digging for copper, silver and gold directly above on Sproatt Mountain. A rugged prospector from Kansas, Harry wheeled his belongings in a homemade wheelbarrow up the narrow trail to the 5,300-foot level. Remnants of his cabin and hand-dug tunnels are still in evidence today. In the summers Harry grew vegetables and raised chickens to supply the local lodges. He was known in the community for his wild stories that kept listeners spellbound for hours.

Along with summer vacationers, the rail line also brought logging to Alta Lake. Some of the first timber harvesting was done by pole cutters, falling the straightest trees and dragging them by horse to the tracks. There was also a constant market for rail ties, and the PGE railway set up the first sawmill at the southwest end of the lake, where it milled ties and bridge timbers. Logging was not only intimately connected to the rail line, but also to the string of lakes from Alpha and Nita to Alta, Green and Lost Lake just above the current village. It brought a new source of income to the Alta Lake community and drew many new residents to the area.

Jaswan Singh, a retired Indian Army officer, operated one of the first small lumber mills just north of Alta Lake at 21 Mile Creek. In 1936 he sold it to Alf and Bessie Gebhart who renamed it the Rainbow Lumber Company and eventually moved it to the southwest shore of Alta Lake.

Volleyball players at Rainbow Park enjoy the same spectacular setting discovered by Myrtle and Alex Philip nearly a century earlier. BM

Top of the Pass

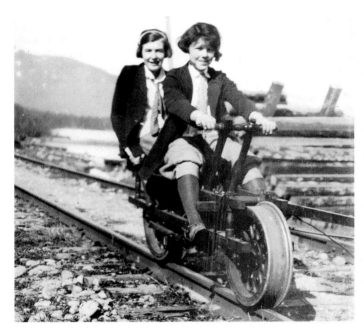

Top: **Sala Ferguson (left) and friend on a PGE speeder in 1928. Before the road came, all transport was by rail.**

Above: **Sala Ferguson (left) and friends on the boards, c.1934. Her family has had a place at Alta Lake for five generations.**

Photos courtesy J'Anne Greenwood

A couple of old trucks and other remnants of the mill can still be discovered on the small peninsula of land at the end of the lake next to the Alta Lake Station arts building.

As hand- and horse-logging was replaced by steam donkeys and eventually chainsaws and trucks, the cut blocks became larger and larger. Once the valley was stripped of most of its good timber, the loggers carried on to more remote parts of the province. The new roads that took them to the interior and the north also served to slow business to the valley's fishing lodges, as British Columbians began to explore the province on four wheels. The Alta Lake community had weathered its second boom, lost some of its swelling population, and retained a few who stayed for a love of the valley rather than its merchantable resources.

In 1943, Alta Lake resident Dick Fairhurst bought the house and cabins above Harrop's Tea Room. By the mid-1950s, he and his new wife Kelly also purchased the lower Harrop's property, rechristened it Cypress Point, and built the Cypress Lodge with four cabins. Cypress is the only lodge still standing on the shore of Alta Lake today and is the current site of the Whistler Hostel. The lodge became the centre of much socializing at Alta Lake, hosting New Year's parties, fish fries, and other social occasions as well as being the place in the community where everyone felt welcome to drop by. Brief articles in Alta Lake's *Community Sunset Weekly* tell of some of the festivities during this era and give a feel for the tenor of the community. The issue following the Fall Fish Fry and Dance read:

After the kids were in bed things became rather hazy but I do remember that Fran brought a can of Beans for mixer. Bunty slapped somebody's face. Fred went to sleep on four chairs, and we all ran out of mixer. Everyone agreed that a better time cannot be remembered.

Skiing and other sliding sports were also catching on with residents and visitors alike. Dick Fairhurst built the valley's first rope tow under the power lines on the hill above Cypress Point. The 450-foot cable was powered by an old Ford V-8 engine and could pull three skiers at a time to the top of the slope. In 1960, the *Alta Lake Echo* reported on the new popularity of skiing:

Skis, Toboggans, Ice Skates a Must: *Winter sports at Alta Lake have mushroomed into a major baggage problem for the P.G.E. and all of us concerned with local transportation of same. No one is complaining though, I suppose because it all seems to be so much fun. Like when Ronny Newton sprained his ankle and like when Mu Burge ruined the Toboggan run by gouging a rut with her face. Both are recovering slowly. The old Alta Lake sport of drinking seems to be dying out or perhaps the extra energy put forth on these other activities is dulling the normal drinking effects, in any event no New Year's casualties were noted.*

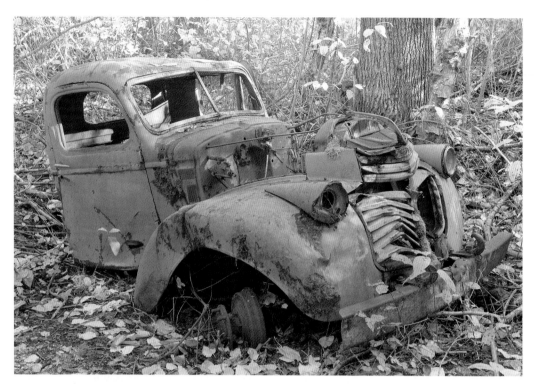

Left: **An old truck slowly returns to the earth at the site of the Alta Lake Lumber Company, south end of Alta Lake.** BM

Below: **Glowing light on Flute Mountain in Garibaldi Park. The backcountry has attracted ski tourers for nearly a century.** BM

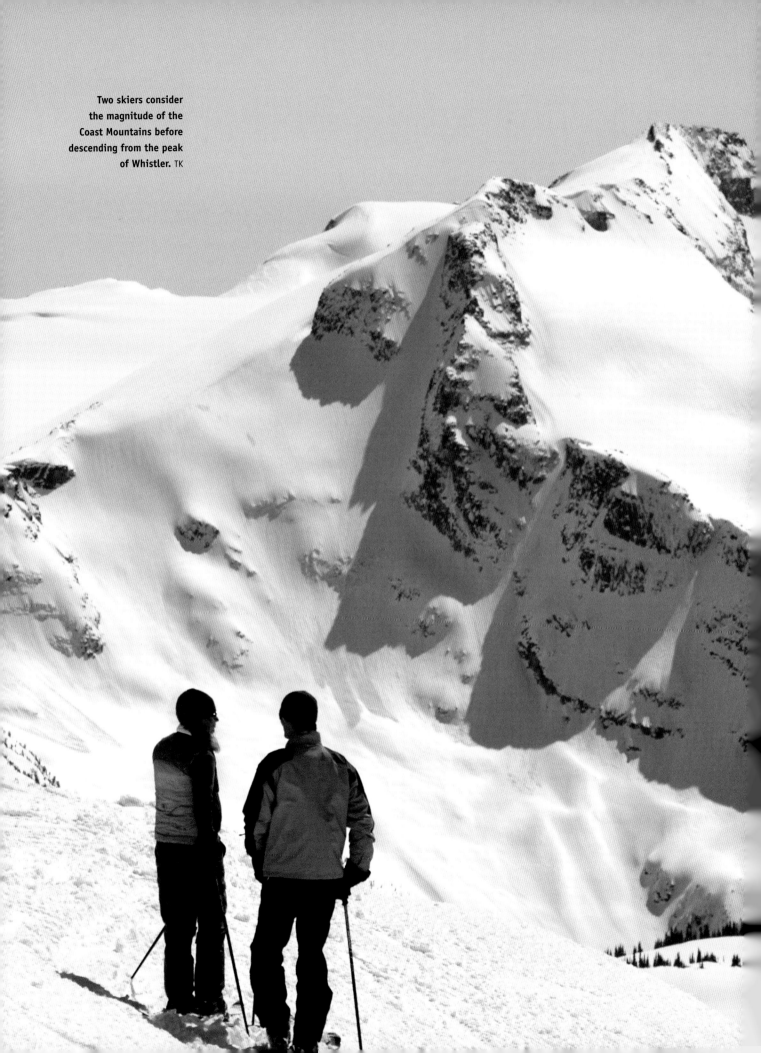

Two skiers consider the magnitude of the Coast Mountains before descending from the peak of Whistler. TK

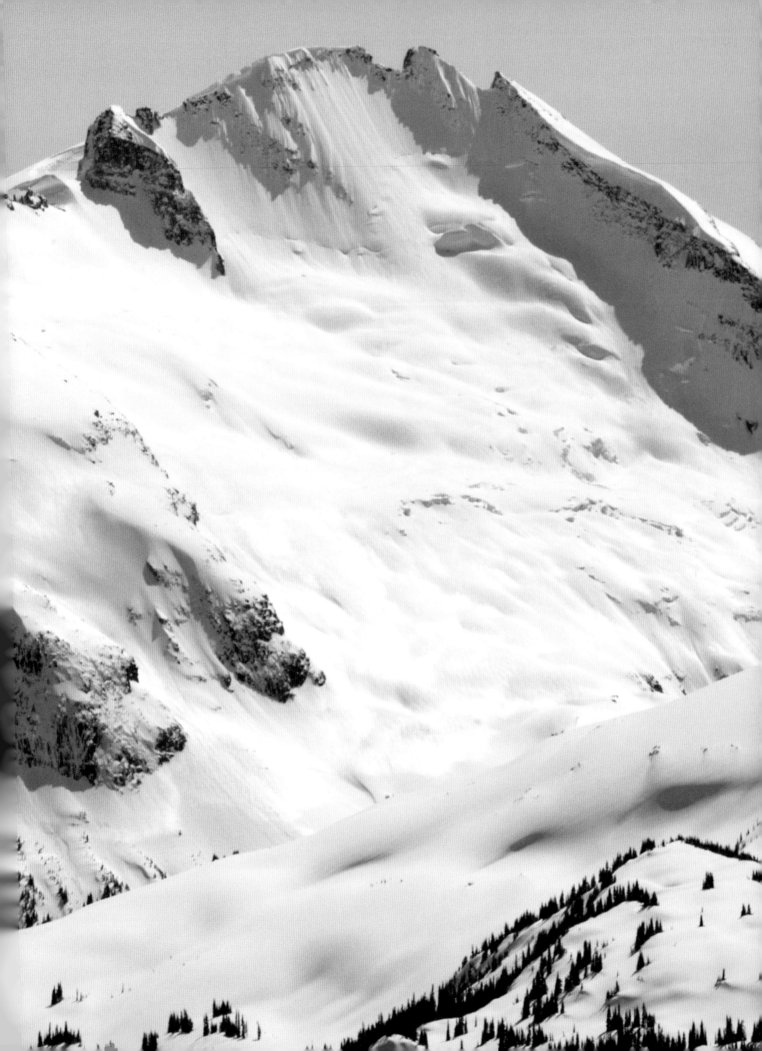

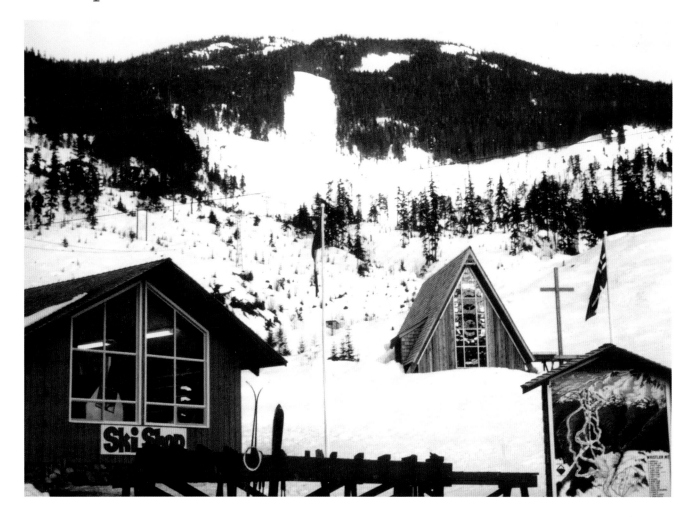

In the early years, Whistler was based at Creekside where the modest cluster of buildings included the Skiers' Chapel, Canada's first ecumenical church.
Photo courtesy Colin Pitt-Taylor

London Mountain was re-named in honour of the hoary marmot, known locally as a "whistler." BM

Whistler (London) Mountain

The beginning of skiing in the valley, and the birth of the town itself, is often attributed to the early visionaries who developed Whistler Mountain. Their story began at the 1960 Squaw Valley Olympics when Dave Mathews of Vancouver met Canadian International Olympic Committee member Sidney Dawes from Montreal. Excited by the prospect of bringing the Winter Olympics to British Columbia, the two attracted other Vancouver ski enthusiasts and businessmen to form the Garibaldi Olympic Development Association (GODA). Soon Dawes, Mathews and Okanagan Helicopters owner Glen McPherson were flying into the Garibaldi Park area looking for a suitable mountain for ski-area development. Diamond Head had a lodge used by hikers and mountaineers, but it didn't offer what the trio was looking for. They continued north to London Mountain (now Whistler) and after looking down at its high alpine bowls, sprawling forested shoulders and undulating lower slopes, Dawes reportedly pronounced, "This is the one."

GODA initially planned to develop the south flank of Whistler toward Cheakamus Lake, but Norwegian-born Vancouverite Franz Wilhelmsen was convinced the north and western slopes had more to offer. Wilhelmsen had met his wife Annette, of the Seagram distilling family, while stationed in Toronto with the Norwegian Royal Air Force during the war. Now a young businessman in Vancouver, he hung out with a group of jet-setting friends including Charles "Chunky" Woodward, Peter Bentley, Jack Shakespeare and Eric Beardmore.

All members of GODA, these men had vacationed at European ski resorts with quaint mountain villages, lengthy runs connecting one valley to the next, and vast alpine bowls with myriad pitches and exposures. It was this, rather than the typical up-and-down yo-yo skiing of early North American resorts, for which they saw the potential in London Mountain.

With Olympic bid plans underway, Wilhelmsen began exploring the mountain with his friend Stefan Ples who had moved to the valley in 1959 to start the Tyrol Ski Club. (The Tyrol Lodge still offers affordable accommodation on the west side of Nita Lake.) What the others had seen by air, Franz and Stefan got to know by foot and ski. Early in the morning they'd climb from the valley on logging roads, then ascend through the forest until they emerged above the treeline. Wilhelmsen's favourite climbing route was along the creek on the west side of the mountain next to the ski run that now bears his name.

With his unbounded enthusiasm for the mountain, Wilhelmsen took the lead with his Vancouver ski companions in forming Garibaldi Lifts, Ltd. Mathews, McPherson and others from GODA were on the original board of directors, with Wilhelmsen as president. Recognizing that none of them were ski-area experts, the directors hired Austrian ski-area consultant Willy Schaeffler, a Fédération Internationale de Ski race delegate and designer of the ski runs for the Squaw Valley Olympics. Schaeffler began exploring the mountain with Wilhelmsen and Ples, and by 1962 he released his favourable report:

> *All my findings in the Whistler Mountain area in regard to a summer and winter recreation area are very encouraging; the high Alpine character of the above timberline terrain—the unparalleled magnificent view—the unlimited skiing potential above and below timberline for recreational purposes as well as for international competition requirements—the accessibility to a city of half a million by railroad, future highway and aircraft—the growth of skiing in general for the individual as well as the family. It is everything the beginner, intermediate, advanced and expert skier could look for. At the same time, all the requirements for international Alpine skiing competition are guaranteed in the most challenging terrain offered on this mountain.*

Along with the suitable terrain, they found an abundance of snow. The Coast Mountains of BC offer the first wall of resistance to incoming Pacific storms, which drop huge amounts of precipitation. Whistler receives an annual average snowfall of ten metres—more than ski areas in the Colorado Rockies and the European Alps. While the northwesterlies bring the best powder dumps, the more common southwesterlies bring snow that isn't always light (and can easily turn to rain in the valley), but is certainly plentiful. Global warming wasn't likely on the minds of Schaeffler or Wilhelmsen in the early 1960s, but in more recent years lift expansion has focussed on the high alpine to keep skiers above rising freezing levels.

Founders Stefan Ples and Franz Wilhelmsen smile upon their creation atop Whistler Mountain. Photo courtesy Colin Pitt-Taylor

Willy Schaeffler's report legitimized the dreams of the Vancouver skiers and helped to get the development ball rolling. One of the first hurdles was getting provincial government approval to build a ski mountain on Crown land. With mining claims owned by Noranda Mines and New Jersey Zinc on the north (Whistler Village) side of the mountain, Garibaldi Lifts were forced to build their lifts on the western slopes, resulting in the original Creekside base. While the skiing was more challenging to the valley on this side of the mountain, the location allowed them to reach the six-thousand-foot level with two rather than three lifts, and it also opened up two of the finest runs in the resort: Franz's Run and the Gondola Run (later renamed the Dave Murray Downhill), respected by racers as one of the most challenging World Cup downhill courses in existence.

While GODA's Whistler bid as the Canadian nomination for the 1968 Olympics lost to Banff due to an obvious lack of regional infrastructure, the findings for a top-notch ski area at London

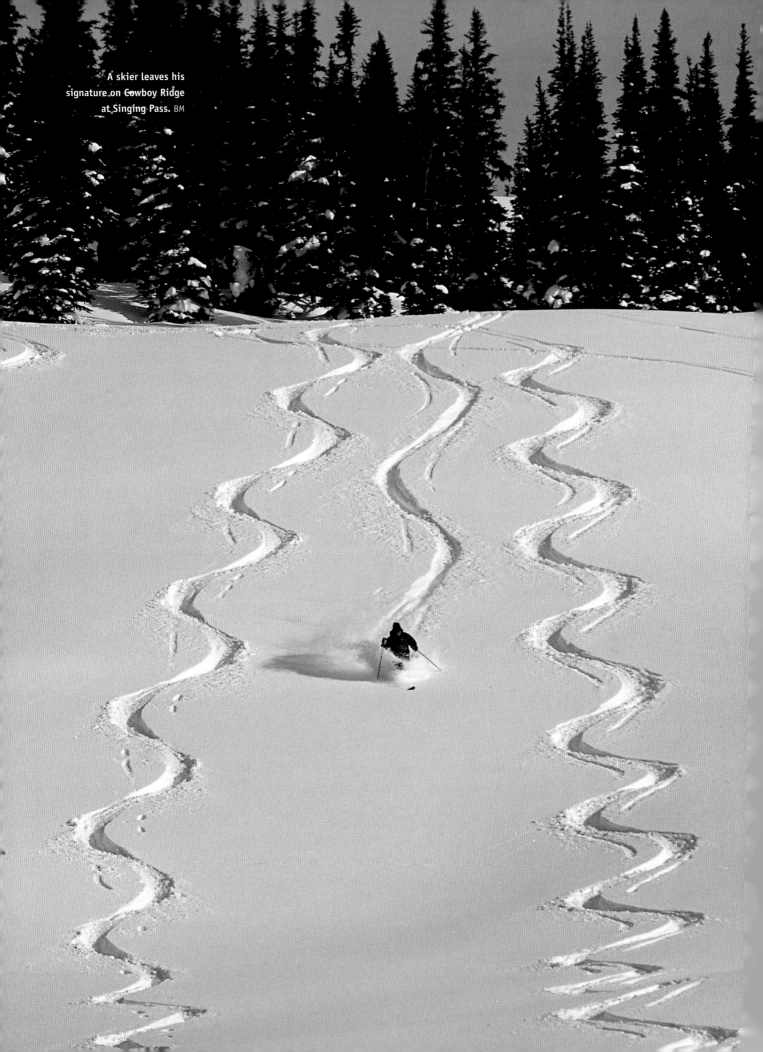

A skier leaves his signature on Cowboy Ridge at Singing Pass. BM

Mountain were so promising that plans to develop the mountain went ahead. On the business end, $500 shares were sold in Garibaldi Lifts to raise $800,000 in building capital. The majority went to interested Vancouver skiers and investors who could then purchase a half-price season's pass for five years. In the fall of 1965, the remaining 560 units were bought by Power Corporation, a Montreal investor with an interest in Vancouver's Grouse Mountain.

Highways Minister Phil Gaglardi was successfully lobbied by Garibaldi developers and Pemberton residents to push a passable road through from Squamish in 1962. (The Garibaldi directors later presented the minister with a single black metal ski, promising its mate when the highway was blacktopped; they received their pavement, and Gaglardi his second ski, in 1966.) Water lines were dug into the ground, and BC Hydro built the Rainbow Substation in 1964 to draw power from the already existing transmission lines. Pioneer Alex Philip was given the honour of throwing the switch to power the lifts and light up the valley for the first time.

The bid for the 1972 Olympics was again lost to Banff, which lost to Sapporo, Japan. While the Olympic torch wouldn't make its way to Whistler for over forty years, the dream set in motion by the original GODA members was well underway. On New Year's Day 1966, Garibaldi Lifts hosted members of the Alta Lake community to a free ride up the newly installed gondola and Red Chair, followed by a banquet at the Hillcrest Lodge at Alta Lake. The mountain opened to the public on February 15, offering an incredible 4,280 vertical feet of skiing, the most available in North America at the time.

Maureen Rickli looks toward the Green Chair from the original Roundhouse in the 1970s. Eugene Rickli

The Whistler Express Gondola carries riders from Whistler Village to the Roundhouse Lodge. BM

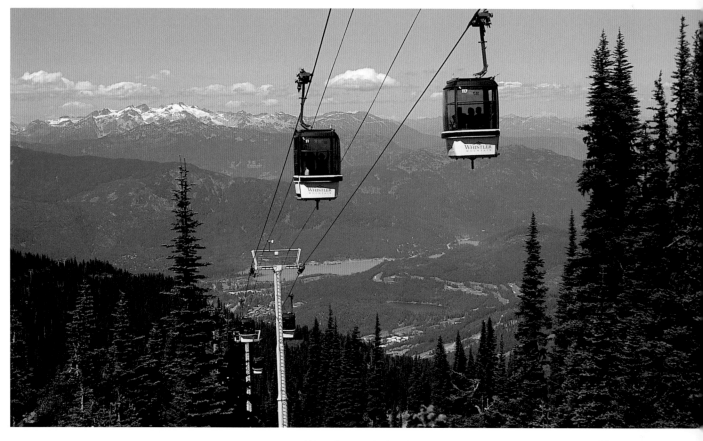

Top of the Pass

Above: **A snowed-in communications tower at the top of Whistler's Peak Chair.** BM

Below: **The Harmony Chair on Whistler offers stunning views in every direction.** TK

Garibaldi's Whistler Mountain was designed to offer skiers what Vancouver's North Shore Mountains couldn't: short lift lines, cabins with heat and running water, and vast expanses of great skiing. It delivered on all counts. Seppo Makkinen, with his small crew of Finnish loggers, hiked up every day from the base to cut the ski runs. Glen McPherson's Okanagan Helicopters poured the concrete for the lift placements (a first for a North American ski resort), and construction also commenced on a base lodge, gondola barn, mid-station building, and alpine-warming and ski-patrol hut. In the valley, the thirty-eight adjoining cabins of Whistler Alpine Villa in the Creekside were sold in a joint-ownership venture that predated condominium-style ownership. All thirty-eight of the units were bought by eager Vancouver skiers, many of them investors in Garibaldi Lifts and supporters of GODA.

The large scope of the mountain that had impressed Ples, Wilhelmsen and Schaeffler was matched from the beginning in the scale of development of lifts and runs. A four-passenger gondola took skiers to mid-station, where the double Red Chair rose to an elevation of six thousand feet. From there the vertical drop and variety of terrain was enormous for the standards of the day. One of two T-bars was built at the base to allow for ski races during inclement weather. The second took skiers above the top of the Red Chair into the high alpine where they could access such runs as Harmony Bowl, T-Bar Bowl, Headwall and Shale Slope.

Below the alpine area, Whistler's runs meander and play with the undulating terrain as though the surveyors and loggers were given free reign to enjoy their descent to the valley. In most cases, the multitude of pitches, knolls and rolling turns are testimony to the very geology of the mountain. Whistler consists of a variety of marine sedimentary and volcanic rock, formed some 60 million years ago out in the Pacific Ocean, then slammed through plate tectonics against Black-

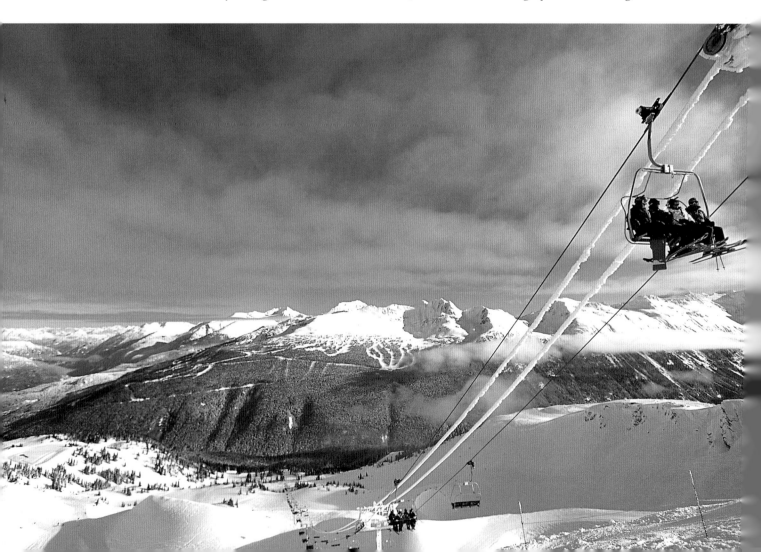

comb's 150-million-year-old granitic formation. Whistler's multitude of rock types resulted in an array of glacier-carved ridges, bowls and cirques.

While most of the runs were carefully considered prior to marking, chance played a role in the creation of others. A crew member by the name of Jimmy was sent down one foggy day to mark out Franz's Trail. He veered too far to the right and created instead the steep and challenging dog leg of Jimmy's Joker. Chunky's Choice, on whose mogul-covered pitches I spent much of my youth, was named for Chunky Woodward's favourite descent into Harmony Bowl. Extreme fire hazard in the summer of 1965 led to the naming of the easygoing Pony Trail. During installation of the alpine T-bar, there was a ban on the use of motorized machinery in the tinder-dry forest. Unable to use trucks or helicopters, the lift company hired a group of Lil'wat from Mount Currie to bring in supplies by packhorse. The most direct route they could cut for their horses became the beginner "Pony Trail" ski-out to mid-station.

The top of the Red Chair at the cusp of the treeline became Whistler's alpine hub. On the adjacent knoll the Roundhouse offered spectacular views in all directions, and the addition of the Blue and Green (now Emerald) Chair in 1970 allowed skiers to descend in any direction from the top. Opportunities to ski down in different directions from the summit expanded with Whistler's addition of the Peak Chair in 1986, the Harmony Express in 1994, and finally the Symphony Express in 2006, bringing Whistler's total skiable terrain to 1,925 hectares (4,757 acres) and its lift capacity to 32,295 skiers per hour.

In the late '60s and early '70s, as leather lace-up boots gave way to plastic buckle models, and old wooden skis to metal and fibreglass ones with releasable bindings, more and more skiers learned to manage the huge mountain. It was soon recognized as a true skier's mountain, offering endless challenges and long cruises—five miles long on the Olympic Run from the top of Ridge Run to the base of the future village where a bus returned the waiting skiers to Creekside. The range of slopes along with the varied Coast Mountains snow conditions created a culture of talented skiers who could handle anything the mountain threw at them. That culture included those who religiously drove up from Vancouver every week, a growing community of locals, and interested visitors who began to arrive from farther and farther afield.

Above: **When the weather is cold and clear, the snowmakers work overtime.** TK

Below: **Whistler was soon recognized as a true skier's mountain, offering endless challenges and long cruises.** TK

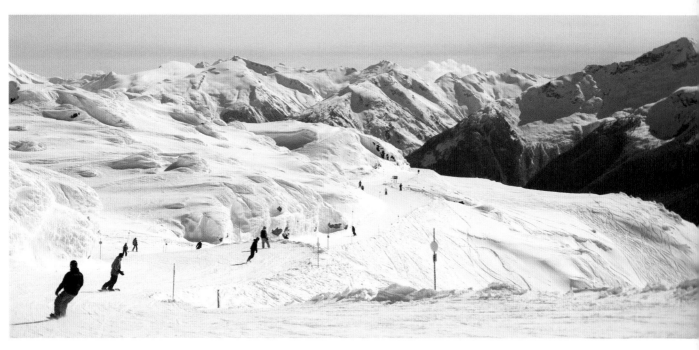

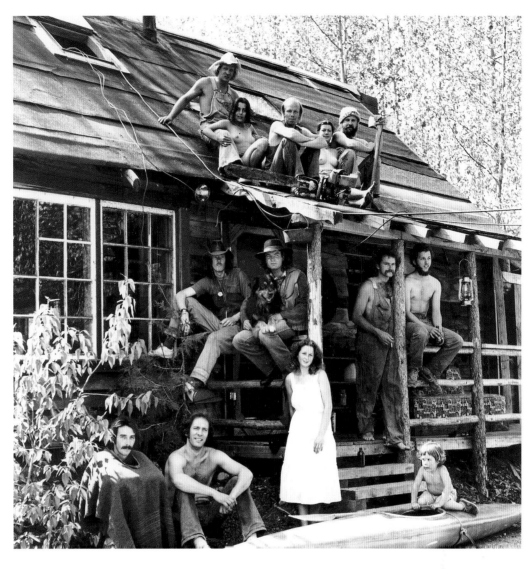

That's the official story of the beginning of Whistler as a ski resort, but as is common in this valley, there was a whole other layer of life fermenting below the surface. It all started in the mid-1960s after all, with an emerging counterculture that preferred to live a free and easy life underground, beneath the radar of the dreamers and schemers with their Olympic resort plans. Young people came to Alta Lake not only from Vancouver and the Lower Mainland, but from Ontario and Quebec and anywhere that they might have heard mention of the place. They were not so different from the early pioneers who came to the valley to get away from a mainstream life, except that these were the baby boomers, and their impact on every facet of life in the valley over the next few decades would prove considerable by sheer dint of their numbers.

While it may have been Garibaldi's new ski lifts that originally enticed so many young people to Alta Lake, it wasn't necessarily what held them here. The notion that one could find or build a squatters' cabin on forested Crown land and, once the hard work was done, eke out a rough existence in the woods while skiing most days on the notorious UIC (Unemployment Insurance Commission) Ski Team was highly agreeable to many. It not only beat "workin' for the man" or navigating the structured halls of academe, it fit well with the whole "drop out, tune in and get back to the land" ethic of the Woodstock generation. In terms of the community of Alta Lake, the new long-haired guys and gals also created a kind of cultural continuum with the early trappers, prospectors and lodge owners—chopping firewood for the winter, getting water from a nearby

creek and tromping through the snow to the outhouse—much the same as Phil and Dorothy Tapley were still doing at Barnfield Farm.

Two of the favoured locations for squatters' cabins in the 1960s were along the Cheakamus River near Function Junction and behind the garbage dump along Fitzsimmons Creek. The former sat just upriver from John Millar's old trapper's cabin; the latter, were they still standing, would be worth many millions of dollars snuggled in the trees at the very centre of the overall village area. The geographic arc, from Millar's original shotgun shack at the south end of town to the centre of Whistler's tourist economy, corresponds perfectly with an arc in time from the arrival of the first ski-bums in the 1960s to the present. It's a story of sweeping changes in the valley and a generation with one foot in the back-to-the-land movement and the other in the multimillion dollar world of international real estate.

There were several cabins next to Fitzsimmons Creek in the village area, the best of which was built by Andy Munster and featured a front porch, French windows and a wood-heated sauna beside the river. Legendary "full moon" parties featured bands playing on the deck, bathtubs full of punch, and whacked-out hippies dancing under the moonlight. Down at the Cheakamus River sat another cluster of cabins with a hand-built cable car to cross the river.

Here, ski-bum and creative artist Charlie Doyle lived in a trapper's cabin that had been passed down from one squatter to the next. He and his girlfriend Robin Blechman comprised the Skunk Cabbage Review and could be heard around town belting out tunes by the Stones and John Hiatt as well as their own Alta Lake hits such as "Skunk Cabbage (It Don't Smell So Bad)." It was from Charlie's cabin at the Cheakamus River that the first issues of the *Whistler Answer* also emerged. (The *Whistler Question*, still in existence today, was launched by Paul Burrows the previous year.) Despite its humble origins, the *Answer* had a funky, professional look and gave a voice to the counter-culture that was beginning to bump up against the more official strains of valley life.

Ski-bum squatters weren't the only members of Whistler's gradually expanding community in the 1970s, but they were certainly one of the more colourful components. And it wasn't only young people in their twenties who had dropped out and tuned in. Every youth movement has its gurus, and in Whistler they came in the form of characters such as Al Davis. T-shirt Al could be seen in the summers skimming the waters of Alta Lake on his sailboard (white hair, black Vuarnets, clothing-optional), and chugging around the valley in his white bread truck from which he churned out silkscreen T-shirts whose slogans captured the emerging ski-bum culture: *University of Whistler—Faculty of Mogulology*, or, in the warm and washed-out ski season of 1976–77: *Garibaldi's Pissler Fountain*. John "Rabbit" Hare was another colourful, bearded hippy from this era who remained true to the ski-bum lifestyle until he passed away in 2001.

When Alta Lake officially changed its name to Whistler in 1975 there were two distinct layers of culture in the valley: the movers, shakers and developers with dreams of an international resort (many of them from out of town), and the counterculture of hippy ski-bums personified by the long-haired squatter. For a time they worked symbiotically: the squatters provided some colour and spirit to the place and also a cheaply housed workforce to fill the low-paid seasonal jobs. There was, of course, some crossover between camps, but by and large the squatting community existed as the underbelly to the more official version of Whistler. Perhaps both had pie-in-the-sky ideas of how life might be lived in the valley, but by the late 1970s the two layers of existence came into inevitable conflict. As investment dollars flowed into the new resort, land became too valuable to have these peace-loving gurus of gravity free-loading on what was now perceived as prime real estate. Action had to be taken, and over the winter of 1977–78 agents from British Columbia's Lands Branch located forty sites by helicopter and posted eviction notices. The squatters won a one-year reprieve with the support of Whistler Council, but in 1979 the cabins were burned to the ground or cut through with chainsaws, winched apart and left to rot in the forest.

Prime Minister Pierre Trudeau kibitzes with Whistler character Fast Eddy Khubyar.
Photo courtesy Colin Pitt-Taylor

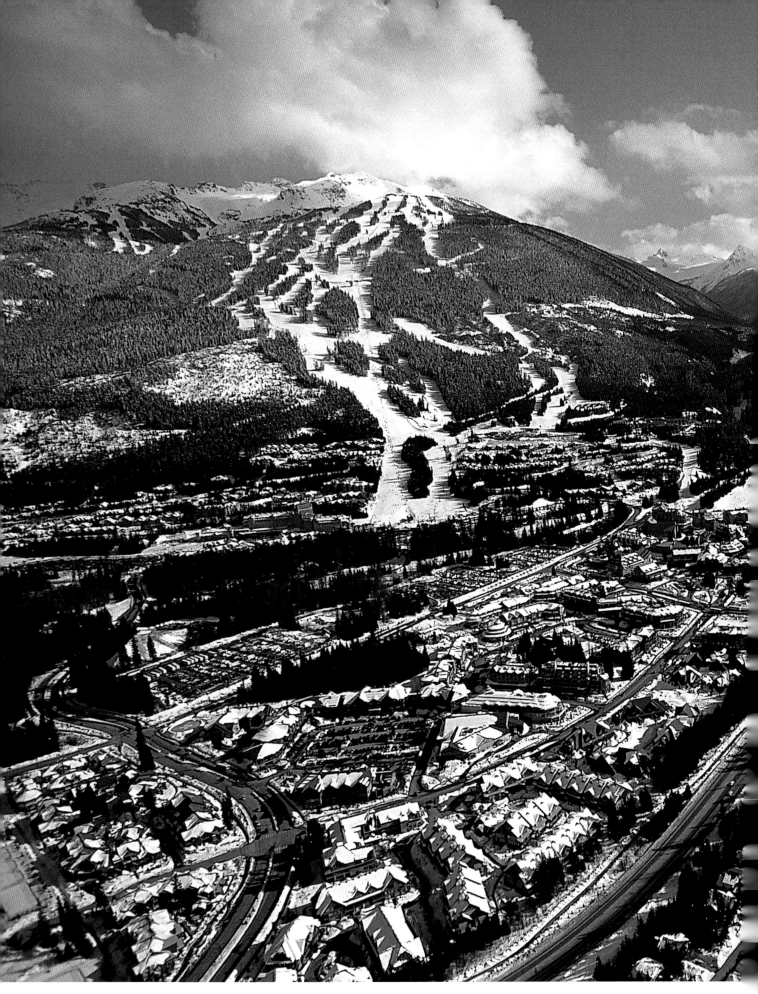

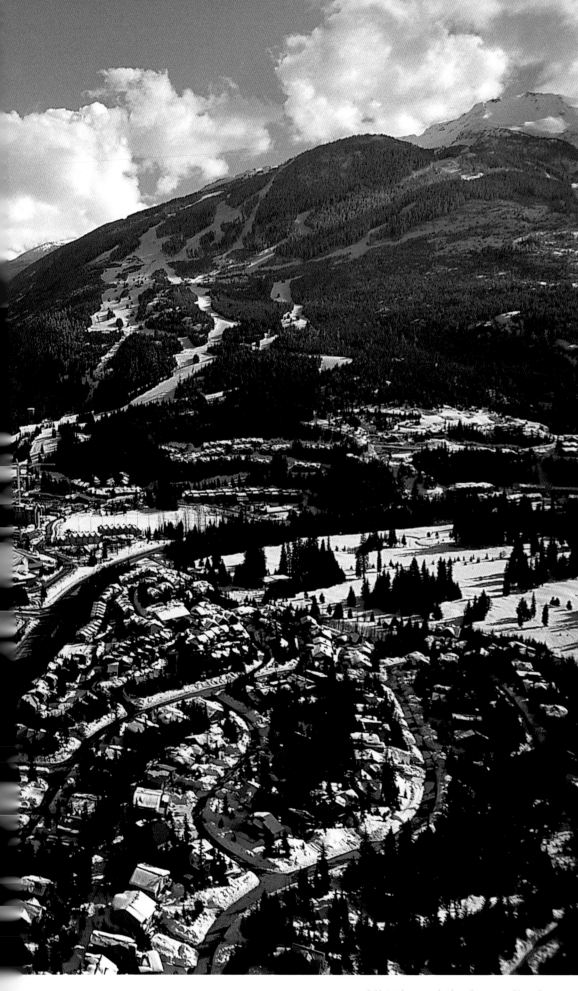

Whistler today is the result of a 1970s government decision to create a "single centred" village at the foot of Whistler and Blackcomb Mountains. TK

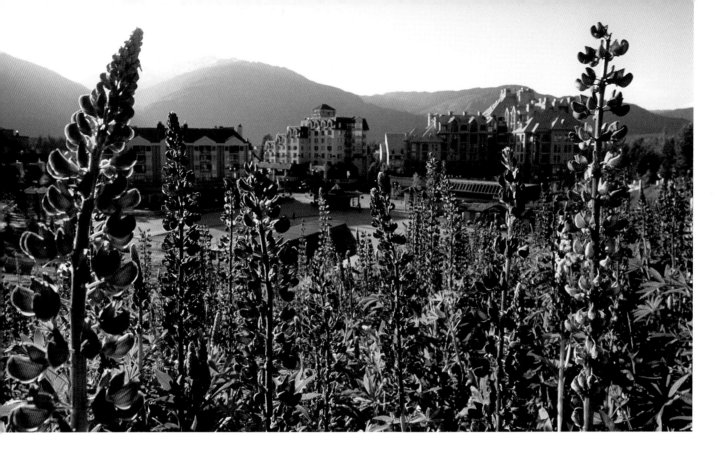

Wild lupins frame the Whistler skyline. BM

The Resort Municipality of Whistler

By the late 1960s and early 1970s, the bold experiment of Garibaldi's Whistler Mountain had already proven itself a success. On weekends, thousands of Vancouver-area skiers arrived and lined up, sometimes for over an hour, to ride to the top and disperse on the mountain's vast terrain. Word of the legendary skiing also spread to eastern Canada where those who could afford it (many of them friends of Garibaldi's jet-setting directors) began flying out for holidays. The fact that Prime Minister Pierre Elliott Trudeau graced the slopes, often accompanied by Franz Wilhelmsen and Garibaldi Ski School director Jim McConkey, lent a certain cachet to the emerging resort.

Still, from late May until mid-November, and from Monday to Friday throughout the winter, Whistler remained a small backwoods BC town with a few hundred residents—a town that just happened to have some of the best skiing in North America. With the highway paved from Vancouver and the burgeoning interest in skiing, the market for recreational properties took off. Subdivisions sprang up throughout the valley and speculators and developers bought large tracts of land to develop commercial properties with hotels and resort facilities. Locals saw what the sprawling development and growing number of septic tanks were doing to the valley's environment, and some began agitating the provincial government for municipal status.

British Columbia's left-leaning NDP government of the day was strongly opposed to letting developers have free reign in the Whistler valley. In 1974 Minister of Lands Bob Williams instituted a moratorium on development until a community plan could be drawn up. James Gilmour of the provincial Ministry of Municipal Affairs planning services conducted a study recommending that a community plan should be embarked upon immediately with a "single-centred" community rather than a "multi-centred" approach, and declared that the town centre or village should be developed on Crown land where the garbage dump sat at the foot of Whistler and Blackcomb mountains, the latter of which he noted for potential ski development. Both the Alta Lake Ratepayers Association and the Whistler Chamber of Commerce supported the plan, though private developers with land holdings elsewhere in the valley—notably, John Taylor at Creekside and Norm Patersen at Green Lake—opposed it and formed their own Whistler Development Association.

Above: **The much-loved Shoestring Lodge and Boot Pub, an early Whistler landmark, was torn down in 2006.** BM

Far left: **Village Gate Boulevard is the main entrance to Whistler Village, and the divide between the original village and Village North.** BM

Left: **John "Rabbit" Hare survived the 1960s to become something of a Whistler landmark himself.** BM

Gilmour also suggested that Whistler adopt a local form of government with a strong planning department to control development—a unique form of government that would serve the needs of residents, absentee property owners and visitors to the resort. In the spring of 1975, this new form of municipal government was ratified by the provincial legislature via the Resort Municipality of Whistler Act. That summer, president of the Whistler Chamber of Commerce Pat Carleton was voted in as Whistler's first mayor. At the swearing-in ceremony at the base of Whistler Mountain, Municipal Affairs Minister Jim Lorimer stated, "Whistler is an experiment, and if it is successful, we expect to incorporate other communities that have similar problems, places such as Tofino that have a small residential community but thousands of visitors in the summer."

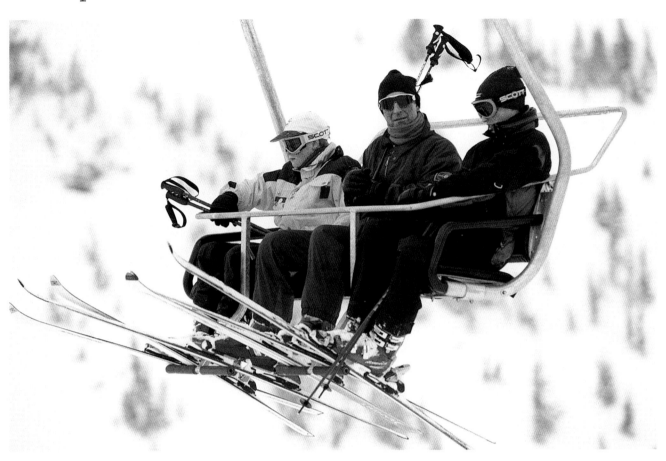

The Royal Princes ride the Red Chair. Celebrities find it relatively easy to blend into the casual Whistler lifestyle. BM

Lorimer also announced that Al Raine, former national ski team coach and husband to Olympic and World Cup skiing champion Nancy Greene, would be the province's representative on Whistler's new council. While the Raines were based in Burnaby at the time, with Al still travelling to Europe with the ski team in the winter, their off-seasons were spent at their cabin in Whistler with Nancy coaching at the Tony Sailer Summer Ski Camp on the Whistler glacier. Both of them took a keen interest in the development of Whistler from the early stages. When Al Raine's proposal for a ski area south of Whistler at Powder Mountain was denied, the provincial government recognized his expertise in the area of ski resorts and tourist development and appointed him BC's first coordinator of ski development. The idea of a pedestrian-oriented town centre, the potential for skiing on Blackcomb Mountain, and the notion that ski-area operators could earn development rights in exchange for building lift capacity, all originated with Al Raine's work for the provincial government, much of it finding its way into Gilmour's study.

With nothing more than a gavel donated to Mayor Pat Carleton by Squamish-Lillooet Regional District chair Slim Fougberg, Whistler council got to work drafting bylaws and creating an official community plan. Al Raine oversaw the engineering of the valley's sewer system while work toward planning the village and developing Blackcomb for skiing moved forward. Then in the fall of 1975, the NDP government called an election and lost. Suddenly, Whistler's planned resort municipality with a central village was at the mercy of the Social Credit Party—a party keen on undoing many of the previous government's initiatives. The renegade Whistler Developers Association was first to meet with the new Minister of Municipal Affairs, Hugh Curtis, urging him to kill the NDP plan, but in one of the more surprising turns of BC politics, Curtis rejected their advice and encouraged Whistler council to continue work on the community plan and the village.

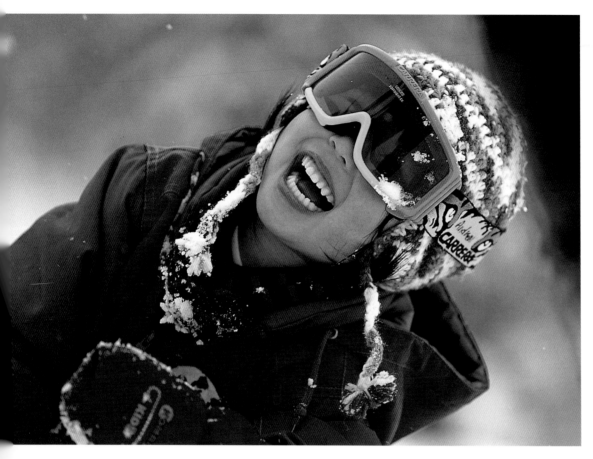

Three-year-old Kaede Kawano with a big smile after her first day of skiing. TK

Whistler Village

The first obstacle in building Whistler Village was that the chosen garbage-dump site sat on the Fitzsimmons Creek flood plain. The provincial government didn't allow villages to be built behind dikes, yet it was the only site that could access both Whistler and Blackcomb mountains. A plan was devised to move the dikes back from the river and refer to them instead as "training walls." Cabinet approved the plan and struck a steering committee with aldermen Al Raine and Garry Watson and three provincial bureaucrats to move the process forward. The first thing the steering committee did was create the Whistler Village Land Company (WVLC), a non-profit development corporation owned by the municipality that would give Whistler greater control in the design of its village. The province donated the fifty-eight acres of Crown land to the WVLC with provisions for repayment as the parcels were sold for development.

From the beginning, the idea behind Whistler Village was to attract both visitors and locals on a daily basis. The WVLC was able to put covenants on the development parcels that stipulated not only design guidelines, but also fundamental uses that went beyond zoning requirements. The covenants ensured that the first phase of the village not only had hotels, restaurants and bars, but a post office, grocery store, hardware store and liquor store as well. The condo/hotel units above the shops were also required to go into a rental pool when not used by their owners to ensure that the village remained a busy people-place.

The project-management team of Doug Sutcliffe, Neil Griggs and Jim Moodie was hired in 1977 to create an initial development plan, and then the architects Blair Macdonald and John Perkins came up with a final design. Al Raine's vision for a ski village in BC had been informed by his travels in the European Alps. But while the ambience of a European village was meant to be

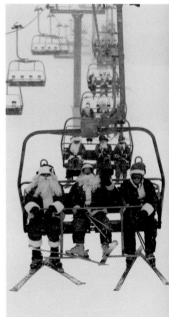

At the Annual Santa Ski, showing up in costume earns a free day on the lifts. BM

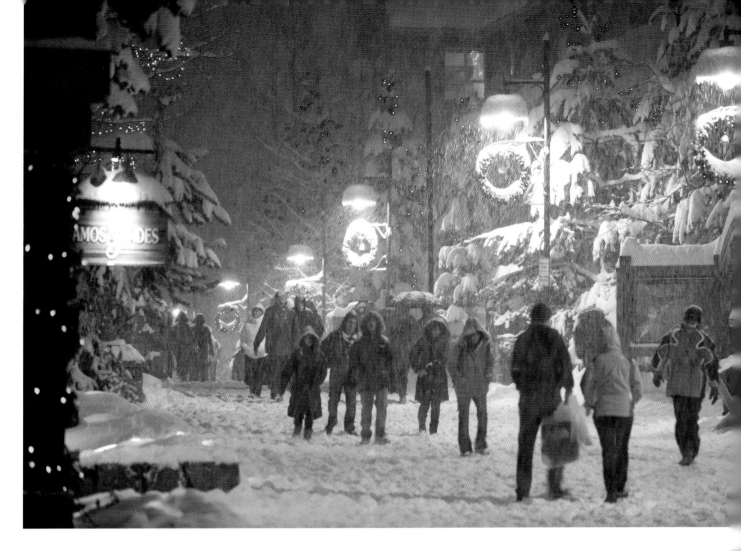

emulated through narrow cobbled streets, arches and plazas, a West Coast motif was also incorporated through the use of local rock and wood. The first sketches for Whistler's new centre, however, looked more like a shopping mall than anything from the Old World or the West Coast.

On trips to Vail, Colorado, Garry Watson and Al Raine had come across San Francisco-based landscape architect Eldon Beck. The Whistler aldermen weren't completely happy with the village design yet, and they brought in Beck to make some final but critical changes. Beck wanted to bring a greater sense of place to the village, to tie it in with the surrounding mountains through well-placed view corridors, and to encourage informal seating on steps, planter-bed walls and lawn areas. The end result of the Village's differing influences is that it still carries its informing European dream, a smattering of West Coast design, a hint of shopping mall without a roof, and a general feeling of Fantasyland.

In the spring of 1978, the Garibaldi Lift Company committed to building lifts from the village up the north side of Whistler Mountain. Then in October, Fortress Mountain Resorts, a subsidiary of Aspen Ski Company and the Federal Business Development Bank, won the right to develop Blackcomb Mountain. Another piece of the village puzzle came together when the federal and provincial governments announced the creation of the Travel Industry Development Subsidiary Agreement, which would offer forgivable loans for tourism development. Of the $25 million that went to BC, Whistler received $10.5 million, which became the working capital for the village. Successful bidders for the first twelve village parcels were chosen from over a hundred bids and announced at the end of the year.

By the spring of 1979, excavators were removing the town's old garbage and replacing it with underground parking. Construction continued in the spring of 1980, and by late fall, the first phase of the village opened along with Whistler's north-side lifts and a whole new skiable mountain on Blackcomb. The snow wasn't great that year, and the village was as much a construction zone as a people-place, but the skiers arrived in full force and, five years in the making, Whistler Village had arrived, too.

Like the change of government in 1975, the recession that began in late 1981 nearly stopped Whistler dead in its tracks. Soaring interest rates led to a sudden drop in investment money—from $18.5 million by the end of July 1981, down to $3.85 million during the same period in 1982. The WVLC had begun construction on the $5.8 million Resort Centre with an Olympic-sized ice rink, swimming pool and restaurant, as well as the Arnold Palmer-designed golf course. With no one buying the next phase of village parcels, however, WVLC found themselves with a $7-to-8 million debt and nearly $20 million in liabilities. The sale of the next nine village parcels would get the land company out of debt, and many believed that if Whistler completed the Resort Centre, it could weather the worst of the recession. But as they looked for a buyer, backroom deals were also underway with the province.

In early 1983, the Bill Bennett government announced the creation of Whistler Land Company (WLC) Developments, a Crown corporation that would assume all assets and liabilities of WVLC. They would borrow $21 million to complete the Resort Centre (which was changed to a conference centre) and the Arnold Palmer Golf Course. The Crown corporation's return of investment would be realized through sales of the Village North lands. Critics viewed the deal as a government bail-out for the rich—a sentiment expressed in a *Vancouver Sun* editorial cartoon depicting Premier Bill Bennett in a rocking chair with the caption "Whistler's Mother." Nonetheless, Whistler Village was back on its feet, and the provincial government was involved in a land deal that ultimately saw a tenfold return on its investment—not to mention a healthy flow of tax revenue from a thriving resort.

Opposite top: **A Christmas snowfall softens the light on Village Stroll.** TK

Opposite bottom: **When the winter sun sets, Whistler Village springs to life.** BM

A morning gift, yet to be unwrapped! BM

Fall colours enliven the
view over Sightlines Bridge
in Village Park. TK

The Village Today

Outdoor life in Whistler Village went through a sudden transformation in 2000. It had little to do with the new millennium and everything to do with the new smoking ban in restaurants and bars. While the village patios had always been full of people in the summer, suddenly they were crowded with festive revellers year round. The smokers led the way, but many others (aided by well-placed propane heaters) soon joined the party.

Wandering from one patio or establishment to the next for a drink here and a bite there is a great way to enjoy the village festivities. In fact, with the car safely stashed beneath the hotel, or left at home altogether, there are few places more suited for a good pub crawl. Losing one's bearings in the labyrinthine twists and turns of the village is par for the course—with or without the pub stops—but perhaps getting a little lost while on holidays is the whole idea. While I've heard a theory that the plazas can be understood in terms of linked crop circles, I'll leave that paradigm for future archaeologists trying to make sense of late twentieth-century mountain resorts.

The general lay of the land goes something like this: from Skiers' Plaza at the base of Whistler Mountain (where the bands play and the "Big Air" event is held during the World Ski and Snowboard Festival and Crankworx), the village stretches northward. The highway is off to the left, and Fitzsimmons Creek, the day-skier parking lots, Upper Village and Blackcomb Mountain are on the right. There are plenty of lively patios in Skiers' Plaza where you can watch skiers and riders descending to the village. On the other side of the crescent-shaped Carleton Lodge (named for Whistler's first mayor) is Mountain Square. Over on the left (that's west if you're working by compass or the sun) is Gallery Row in the Hilton Resort, where various galleries feature local, national and international artists, and occasionally host artists' opening receptions.

If you're carrying northwards on Village Stroll you've already got the hang of things. A little dip off to the right can take you into the closest thing Whistler has to a back alley. On the ring road

Above: **A pair of kittens enjoy a village event.** TK

Below: **Snowboarding champion Ross Rebagliati returned to a warm Whistler welcome in Village Square following his Olympic gold medal in Nagano.** BM

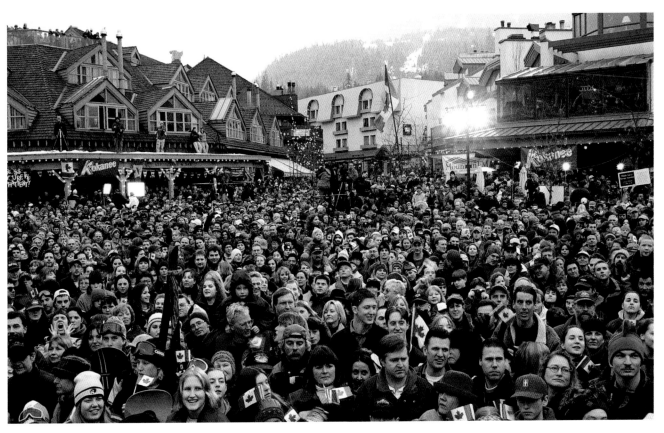

behind the hotels you might catch a glimpse of some dishwashers sitting on milk crates having a chat or a smoke, municipal workers hauling garbage in a tiny pickup truck, or in the off-season, roofers throwing shakes down to a Smithrite bin—all reminders that a resort village depends on a community of workers to make it run.

For a different sort of behind-the-scenes story, duck to the left off of Village Stroll down the stairs between the former Nancy Greene Lodge and the Crystal Lodge. Just up the street on the left is the Bearfoot Bistro, where the food is superb and the wine list unmatched. It's one of Whistler's finest dining establishments, and home to the Champagne Bar where international con artist Christopher Rocancourt managed to swindle everyone from seasonal employees to the wealthiest jet-setters while pretending to purchase a $10 million chateau overlooking Nita Lake. After being arrested by the RCMP in Victoria, Mr. Rocancourt is now dealing with bars of a different sort.

Whistler's open pedestrian spaces make for lively street life; on any given day one may encounter Ukrainian and First Nations dancers, stilt-walkers, Canada Day celebrants and even RCMP horsemanship.
Photos BM

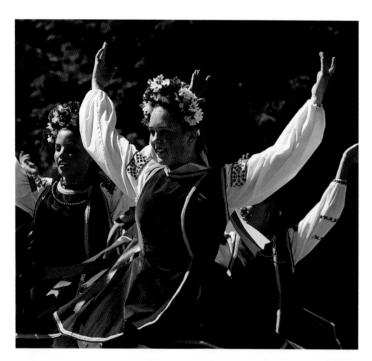

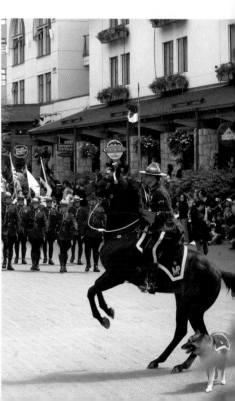

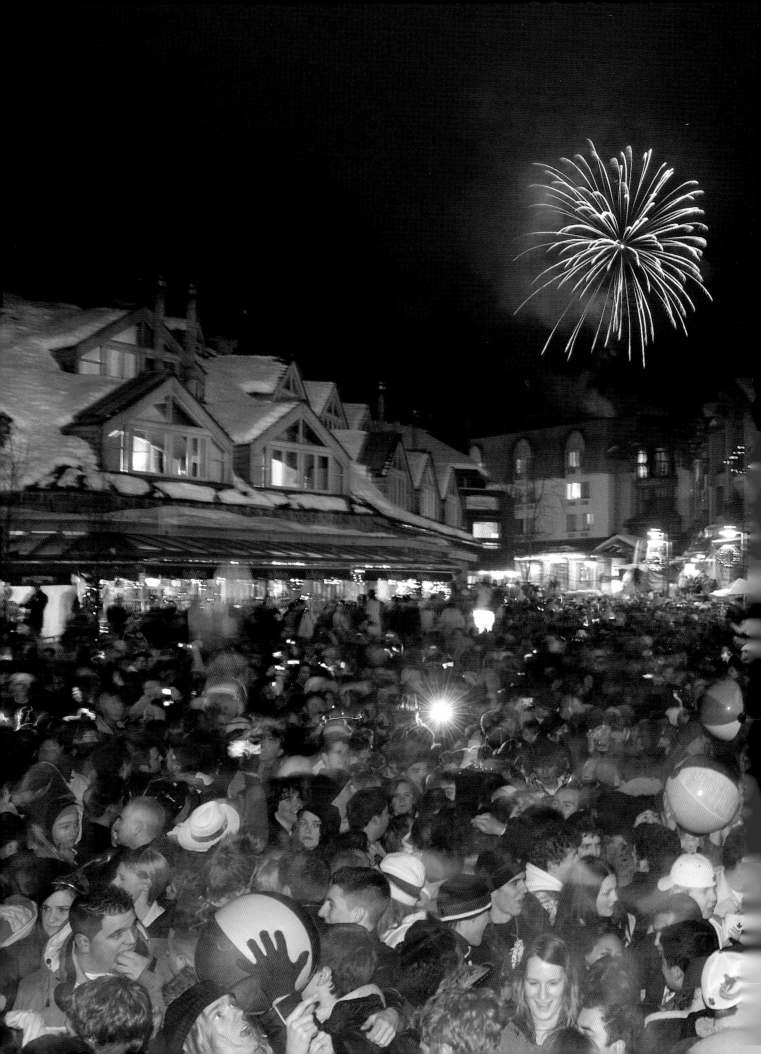

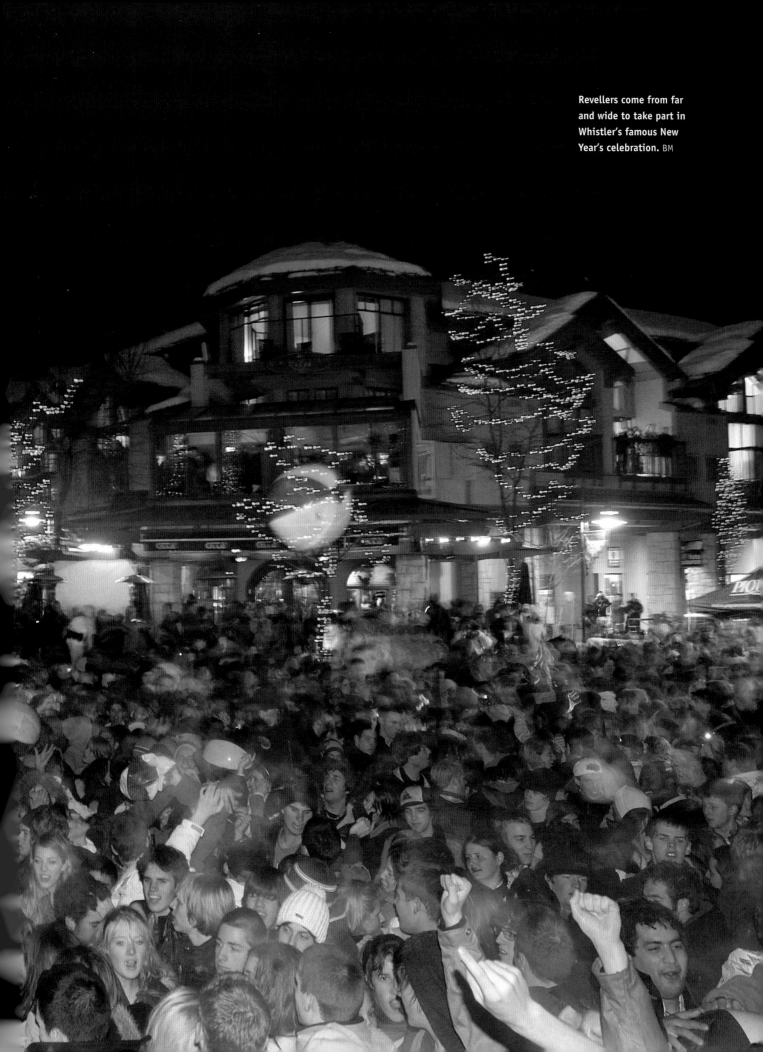

Revellers come from far and wide to take part in Whistler's famous New Year's celebration. BM

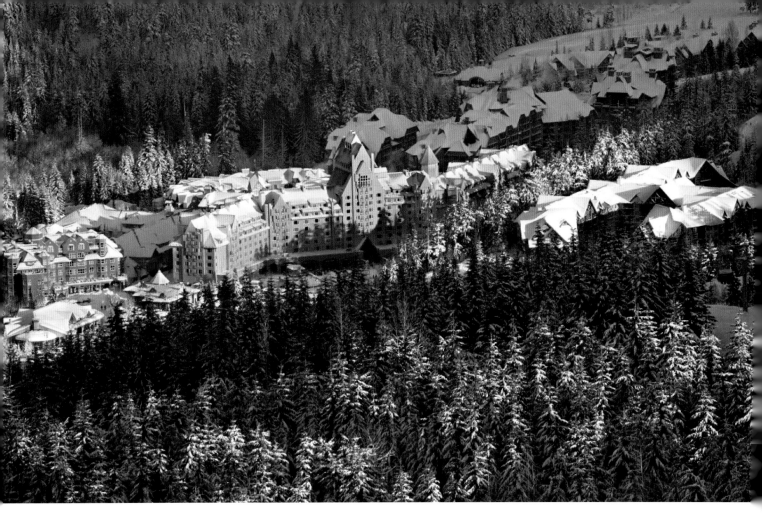

The impressive Fairmont Chateau Whistler catches the morning sun at the base of Blackcomb Mountain. BM

Straight ahead on the Village Stroll is Village Square, a decidedly round shape with a wealth of see-and-be-seen bars, patios and restaurants. It also boasts a liquor store, grocery store, book store, pharmacy, and hardware store. Entrances to various night clubs are only steps away from the square. Through the underpass at the other end is the main entrance to the village with a taxi loop, bus station and Visitor Centre; off to the left on Golfer's Approach is the Conference Centre and the venerable Tapley's Pub where Whistler's tradespeople maintain the town's infrastructure of stories.

Tapley's Pub

While you may be in Whistler on a ski holiday, if you happen to need a window fixed, a floor tiled, an electrical socket installed, or just want to know who won the hockey game, you should stop in at Tapley's Pub. Tapley's is a second home to many of Whistler's building trades and is situated at the very centre of the village between the grocery store, liquor store and the conference centre. Housed in the copper-plated and well-windowed semi-circle that juts from the Hearthstone Lodge, Tapley's was one of the first structures to be built in the village.

Because a typical Tapley's patron has been frequenting the place for a quarter of a century, the pub has become Whistler's bar of record. Anything that has happened in the valley—over the past twenty-four hours, twenty-four years or into the annals of Alta Lake history—is contained in the collective consciousness of the Tapley's mind. It is the place where Whistler's stories ferment and ripen into a finely aged brew; a place where one can ask about a local who hasn't been seen for ten or twenty years and somebody will know whether he or she is living on a deserted island in Fiji, selling time-shares in Peru or doing time in California.

I've occasionally witnessed a priceless Whistler scene unfold when visiting delegates from a summer conference (perhaps dental hygienists or insurance salesmen) spill out of the Conference Centre next door and walk right past the Tapley's patio. The two camps—those who built it, and those who came—look at each other through the drifting cigarette smoke as though briefly

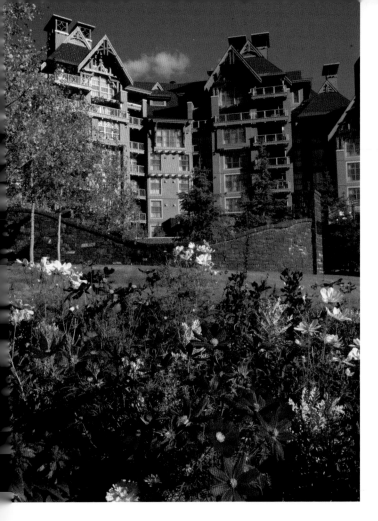

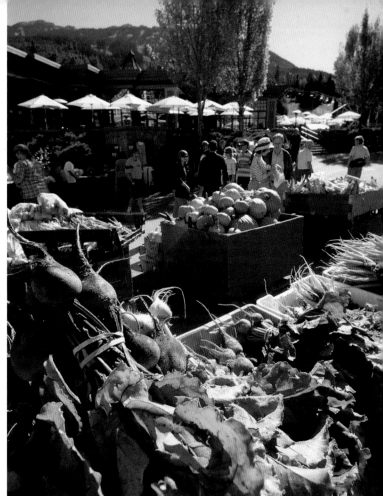

peering into a different reality. Then a goal will be scored on the screen, a cellphone will jangle a tune or a song will start up on the sound system, and the clock will swing back into motion as the spell is broken. The delegates will head en masse to their next meeting and the locals will return to their beers and conversations and the important task of maintaining the town's infrastructure of stories.

Walking to the right out of Village Square, with Blackcomb and Wedge Mountain in your sights, the next crop circle you'll hit is the Village Common with its Village-8 Cinema and more shops, cafés and restaurants. Now there's a choice to make. You can exit the common on the far right and climb the stairs that will take you to a crosswalk, a bridge over Fitzsimmons Creek next to Rebagliati Park, and across to Blackcomb and the Upper Village. From Merlin's Bar at the base of Blackcomb, the main flow runs to the left with more shops and cafés, and a Sunday Farmers' Market from June through October.

At the end of the Market Stroll on the left is BBK's, famous as Whistler's smallest pub. Directly across is the resort's largest hotel, the Fairmont Chateau Whistler (formerly CP Chateau), and a little farther on, the Four Seasons Resort. All of the biggest hotels, including the Hilton Resort and the Westin Resort at the base of Whistler Mountain where we started, are entertaining to stroll through. With shops, galleries, spas, restaurants and bars, each one is a mini resort unto itself. At the Chateau's Mallard Lounge you might catch Doc Fingers rolling out some New Orleans Jazz on the piano, or young local chanteuse Ali Milner doing the same at the Four Season's 52-80 Bar. Across the street is the Squamish Lil'wat Cultural Centre, offering not only cultural tours and displays, but West Coast cuisine in conjunction with the Four Seasons' kitchen.

Back at the Village Common, you might instead want to carry on to Village North. Before getting back on the main stroll and crossing the pedestrian bridge over Village Gate Boulevard,

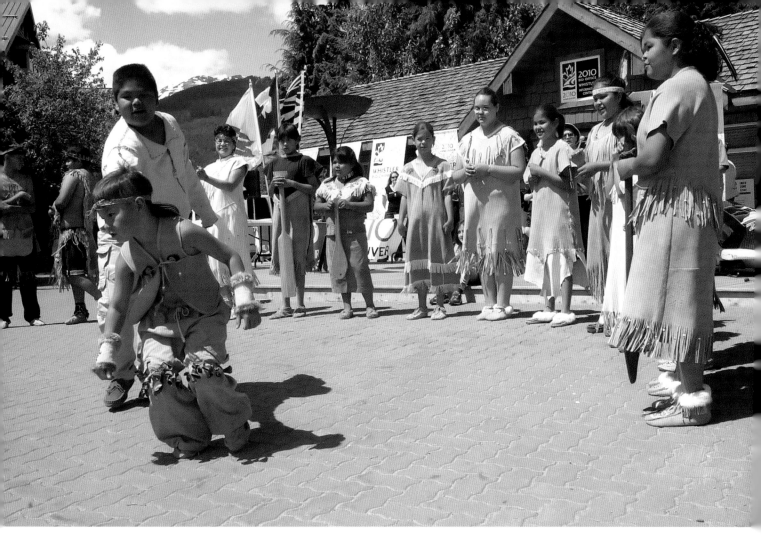

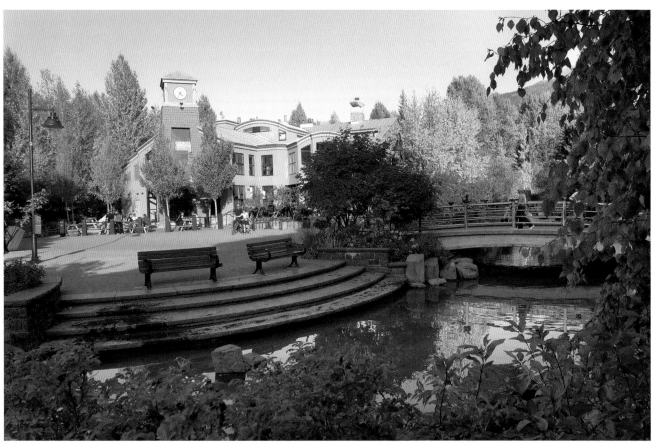

consider exploring some of the little back alleys and plazas at the back of the Village Common. Or once you cross the bridge, there are walkways and underpasses on both sides leading to hidden-away courtyards that eventually lead back to the main stroll. The town plaza up ahead has a gazebo that sometimes features live music or other entertainment and is, of course, surrounded by patios.

The main entrance to the Whistler Public Library is just off to the left from the gazebo on Main Street, but let's keep heading north, and downhill, for now. Sightlines Bridge over the little creek features some small conceptual art pieces, and off to the right is MY Millennium Place Theatre where all things cultural and performance-oriented happen. Directly across the creek is the Brewhouse where barley-and-hop-induced activities occur.

Sightlines Bridge is the departure point for exploring Village Park. Head left on either side until you reach Main Street. Differing from most towns, Whistler's Main Street is horseshoe-shaped and relegated to the far side of the village. Such are the challenges facing designers of a pedestrian-oriented town centre. Cross Main Street and walk down the meandering path through the beautiful and cool stretch of forest. There are clearings and seats here and there, and old stumps with springboard notches attesting to the town's logging history. The forest is just below the library, and one of the most soul-satisfying, and free, things to do in Whistler Village is to take out a library book and read in the forested park. Following the path westward takes you to a Petanque court built in honour of the late Joel Thibault, one of Whistler's most loved restaurateurs, and eventually across Northlands Boulevard to the Storyteller's Chair.

If you keep walking north from the bridge on Village Stroll, the area to your right is the final piece in the puzzle of Whistler's plazas. The Olympic Medals Plaza was built on a once-forested piece of property at the northwest end of the village to accommodate eight thousand people for the Olympic and Paralympic medals ceremonies during the 2010 Games. Beyond it is the Market Place with a post office, medical centre, large grocery store, liquor store, candy shop and all the other essentials. Off to the left is the end of Main Street with a host of small locally owned shops, cafés and bistros.

Here at the north end of the village, one can walk out to Lorimer Road, turn right on the Valley Trail and loop back toward the Upper Village. Walking in circles becomes second nature after a few days in the Whistler village. The only time you might get completely lost is when the holiday is over and you need to find your car.

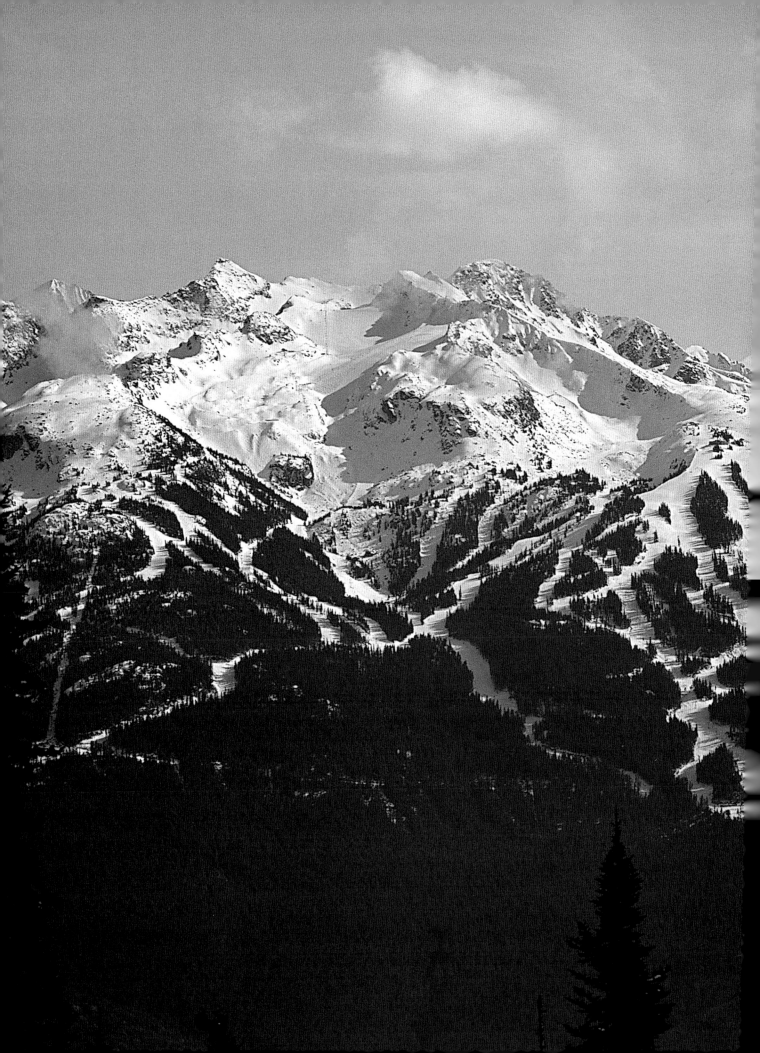

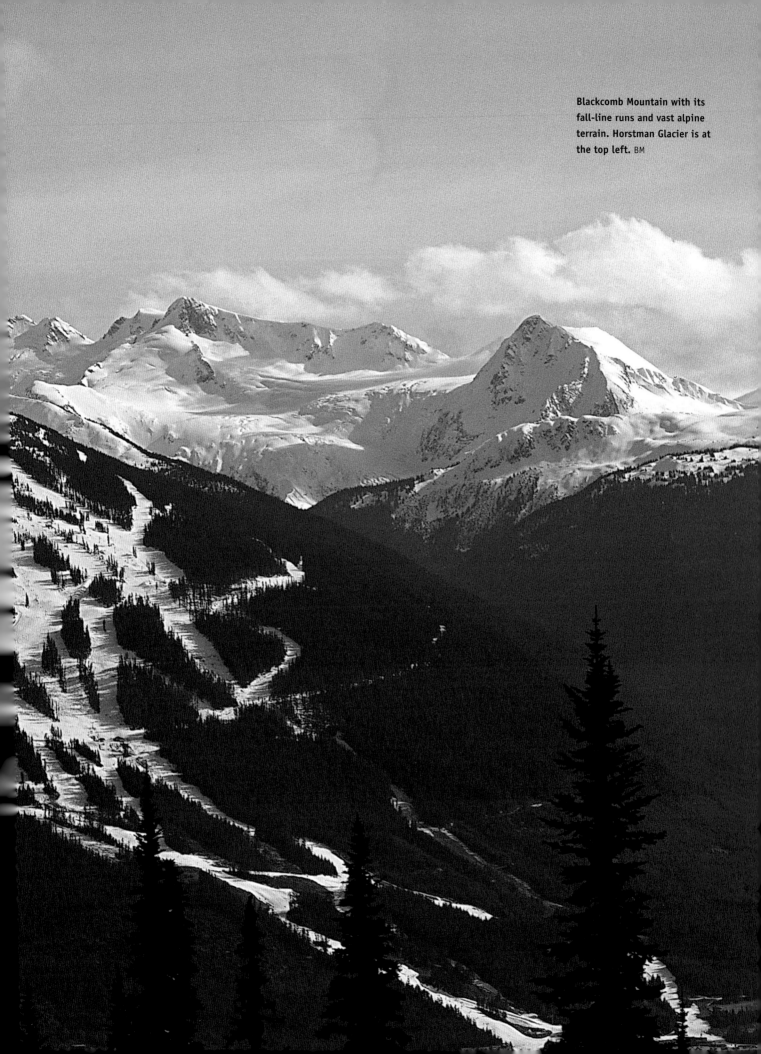

Blackcomb Mountain with its fall-line runs and vast alpine terrain. Horstman Glacier is at the top left. BM

A promising morning at the base of Blackcomb. BM

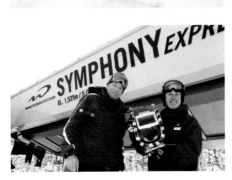

Blackcomb's tireless developer, Hugh Smythe, (left), with Doug Forseth at the new Symphony Express in 2006. BM

Hikers make their way along the ridge above 7th Heaven as Blackcomb Peak basks in the winter sun. BM

Blackcomb

Although Whistler Mountain opened for skiing nearly fifteen years before Blackcomb, when it comes to geology Blackcomb is by far the more senior neighbour. Formed during the Jurassic period some 150 million years ago, its hard granitic rock tilts up from the valley in one nearly continuous slope. Far less sculpted by the ravages of receding ice sheets than Whistler's softer shale and volcanic formations, Blackcomb's geologic history had everything to do with the type of fall-line skiing it would eventually offer.

In the winter of 1978–79, young entrepreneur and skiing enthusiast Hugh Smythe, with a Tucker Sno-Cat and a few friends and colleagues, explored Blackcomb's forested slopes on skis, looking for the subtle contours that would suggest where lifts and runs should be placed. At the age of thirty he'd already paid his dues in the ski industry, serving on Mt. Baker's volunteer ski patrol as a teenager, on Whistler's volunteer and pro patrol starting in 1966, and then at the age of twenty-six as manager of operations for Fortress Mountain outside Calgary. Smythe got Fortress back up and running after a previous bankruptcy, and when its owner, the Federal Business Development Bank (FBDB) was ready to sell, he convinced Aspen Ski Company to buy a 50-percent share.

Back in Whistler, the call for bids to develop Blackcomb Mountain went out in 1978, and Hugh Smythe's good friend Paul Mathews, owner of Ecosign Mountain Resort Planners in Whistler, asked Smythe if he was interested in putting together a bid. They formed Blackcomb Ski Corpora-

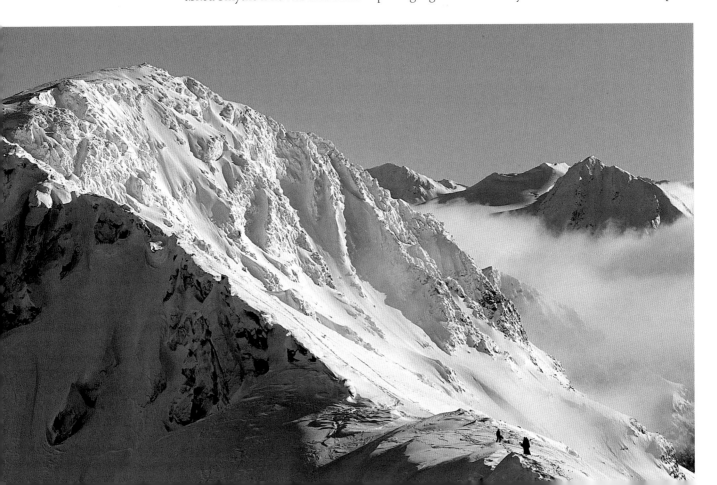

tion with Aspen's owners as potential financial backers. When Aspen backed away, Alberta multi-millionaire and owner of the Cascade development and insurance group Allan Graham stepped in, seeing the huge potential for real estate development at the base of the mountain.

As it turned out Aspen Ski Company hadn't completely lost interest in Blackcomb. When asked by Al Raine if they'd consider submitting a bid, they contacted their man in operations at Fortress, Hugh Smythe, to see what he thought of the venture. With one foot in each camp, Smythe had an important career decision to make. Given the opportunity to work with the biggest player in the North American ski resort business, he threw his hat in with Aspen and the only competing bid to the Blackcomb Ski Corporation. Knowing the provincial government was looking for Canadian involvement, Aspen strategically submitted its bid under Fortress Mountain Resorts, which was still partly Canadian-owned.

Before the successful bid was announced, Paul Mathews and Hugh Smythe agreed to build a road to the top of the mountain so that snow depth and terrain studies could get underway. As Garibaldi Lifts had done in the 1960s, they hired Seppo Makkinen to cut the road, agreeing that the winner of the bid would reimburse the other for the investment. On October 12, 1978, the BC government announced Fortress Mountain Resorts Ltd. as the successful bidder, and Hugh Smythe found himself back in Whistler with a Tucker Sno-Cat, a pair of skis and a mountain to build in two short years.

Sunset at the top of 7th Heaven with Black Tusk in the background. BM

Over the summer of 1979 and the first ten months of 1980, Smythe and his team opened up 350 acres of skiable terrain on two dozen runs. Names such as Choker, Springboard and Gear Jammer were derived from logging terms. The mainly intermediate fall-line cruisers levelled off toward the village, offering easily accessible beginner slopes. Fortress also installed four numbered triple chairlifts climbing in succession from the village to the 6,200-foot level. They built their main day lodge—accessible by car on a winding mountain road from the village—at the base of Chair No. 2, and an on-mountain restaurant at the top of Chair No. 4.

From the beginning Hugh Smythe set out to differentiate Blackcomb as a customer-service organization, training staff members—whether in ski school, rentals or lift operations—to manage the skiers' total experience. The food service, contracted to the Parsons family who had worked a concession at the PNE in Vancouver since 1929, was a cut above anything Whistler offered. While Blackcomb still lacked access to the vast alpine terrain available at Whistler Mountain, some skiers preferred the direct fall-line runs to Whistler's twisting and meandering pitches. Others were drawn to Blackcomb by the new breed of courteous well-trained staff, and the lack of lift lines. In its inaugural season, the particularly bad snow year of 1980–81, Blackcomb attracted only 54,200 skier visits compared to a projected 225,000, and Whistler's 315,000. But the fact that it opened on time and on budget, greatly expanding Whistler's ski experience, was a success in itself.

Despite the incoming recession, Blackcomb's skier visits rose in its second season to 215,000, one third of total resort visits. Recognizing that Blackcomb would always be the underdog if it couldn't match Whistler's varied terrain, Hugh Smythe began a series of expansions and improvements that would gradually see a shift in the dynamic between the two mountains. He began with the addition of the Jersey Cream Chair in 1982, opening the Jersey Cream Bowl and slightly increasing the mountain's vertical drop. In the fall of 1985, Smythe made the bold last-minute decision to move a T-bar from Fortress Mountain and install it on Blackcomb's south-facing alpine region. Aspen wouldn't bankroll the project, but Smythe decided to try to finance it through pre-sales of season's passes. With the new marketing slogan of "The Mile High Mountain," the passes sold and the mountain's seventh lift opened up the vast area of 7th Heaven, including the south-side runs of Southern Comfort, Panorama, Halo and Sunburn, over the saddle to Horstman Glacier and Saudan Couloir, runs such as Pakalolo, Secret Bowl and Secret Chutes, and other

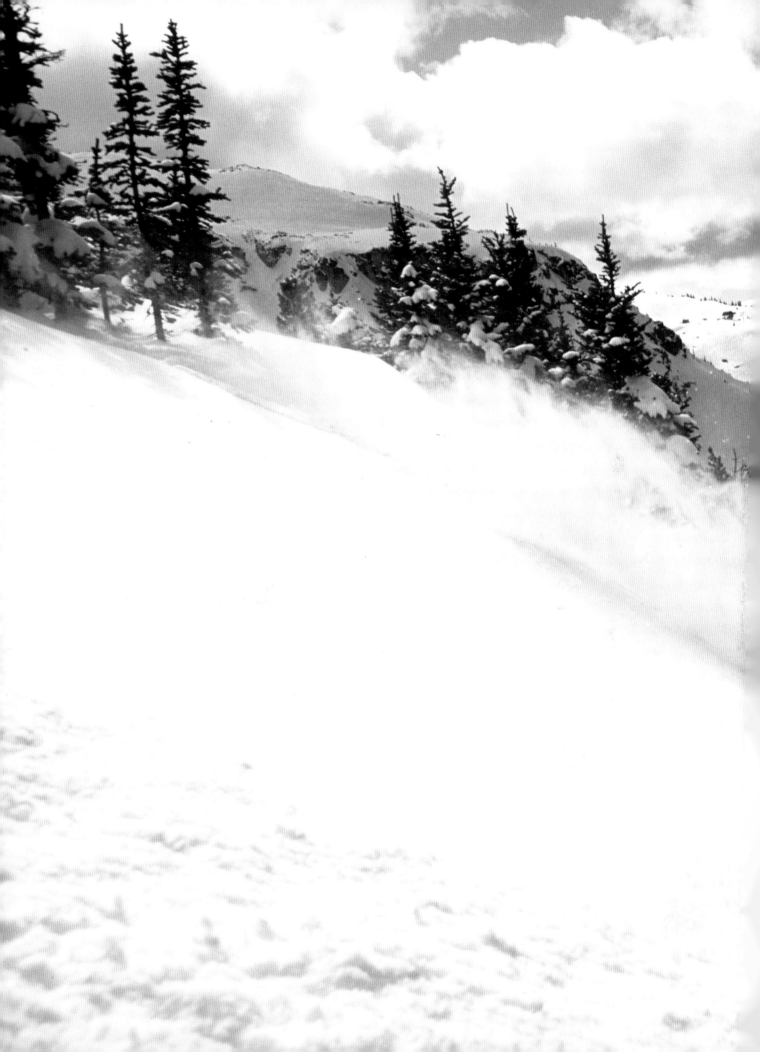

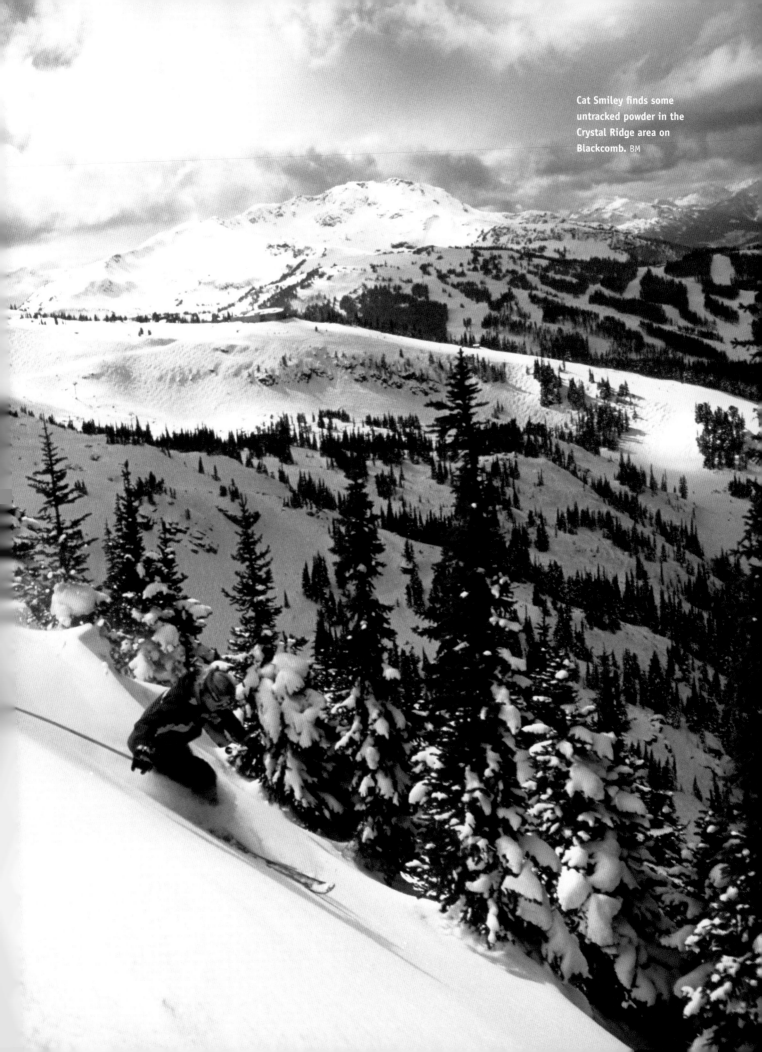

Cat Smiley finds some untracked powder in the Crystal Ridge area on Blackcomb. BM

areas that powder hounds could now hike to more easily. Along with a mile of vertical skiing, Blackcomb could finally boast of the kind of expansive and varied terrain that Whistler had always been known for.

But all of this was only the beginning of a much larger transformation about to unfold on Blackcomb Mountain. In 1986, Whistler still had 60 percent of skier visits, Aspen wanted out and Smythe began looking for the right investor. He met Joe Houssian at a Young Presidents' Organization meeting in Vancouver. Houssian owned Intrawest, a Vancouver-based urban real estate development company, and so far his only involvement with Blackcomb had been learning to ski on its beginner runs. He'd also attempted to buy the entire Whistler Village and Village North in 1984, but Whistler council didn't want to create a one-company town.

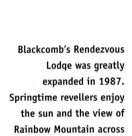

The Glacier Express rises from the Jersey Flats to Horstman Glacier, exactly where Al Raine had envisioned a lift in the 1970s. BM

Hugh Smythe was careful to present the current investment opportunity as not only a matter of real estate, but real estate and skiing, so that the whole resort package would evolve together. The real estate included 250 acres at the base of Blackcomb (nearly five times the size of the original Whistler Village), with zoning and development rights for 7,500 beds.

After a year of working out a development plan with design input from Paul Mathews at Ecosign, the money began to fly. While Whistler had put in a chair to the peak in 1986, and would add a high-speed gondola from the village to the Roundhouse in 1988, Intrawest now dumped $26 million into Blackcomb's operations. They began with three high-speed detachable quad chairlifts—the Wizard, Solar Coaster and 7th Heaven—reducing the riding time to the renamed and expanded Rendezvous Lodge at the top from thirty-seven minutes to fourteen minutes. They built a new lower base at the bottom of the Wizard with a day lodge, Merlin's Bar and Kids' Camp building; erected the Horstman Hut at the top of 7th Heaven; and bought new groomers and expanded snowmaking equipment. Skier visits in 1987–88 rose from 329,000 to 570,000, the largest increase in the history of North American

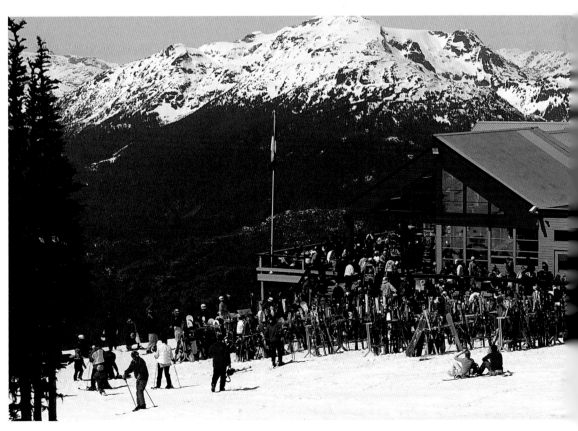

Blackcomb's Rendezvous Lodge was greatly expanded in 1987. Springtime revellers enjoy the sun and the view of Rainbow Mountain across the valley.
BM

skiing. Everything suddenly doubled, from revenue to the number of employees, and for the first time Blackcomb surpassed Whistler with 54 percent of skiers.

That same year, CP Hotels announced it would build a 337-room $50 million chateau at the base of Blackcomb—its first in Canada in many years—providing an anchor for Intrawest's real estate development. The Upper Village area also saw construction of Le Chamoix and the Glacier Lodge among other hotels, while condominiums sprawled across the Blackcomb Benchlands, up along the Wizard Chair, and over toward the Chateau Golf Course where some of Whistler's most expensive multimillion-dollar vacation homes were built. Intrawest's return on investment through the development of real estate at Blackcomb numbered in the hundreds of millions of dollars.

And with more and more skiers and boarders staying near the bottom of the lifts, they continued with on-mountain improvements. The Showcase T-bar gave access to Blackcomb Glacier, and the Crystal Chair opened up another 568 acres of terrain to the north. The new Crystal Hut offered spectacular views from the lift's top station, and the Jersey Cream Express replaced the old Jersey Cream Chair. When Nippon Cable Company purchased 23 percent of Blackcomb in 1993, they invested a further $25 million into Blackcomb over five years. The Glacier Express—placed exactly where Al Raine had envisioned a lift in the late 1970s—rose from the Jersey Flats high into the alpine above Horstman Glacier, with the Glacier Restaurant sitting at its base. The final pieces in Blackcomb's high-speed lift system were the Excalibur Gondola and Excelerator Express, offering greater access from Whistler Village.

Whistler Mountain kept pace by adding its own high-speed lifts—two detachable quad chairlifts from the Creekside to the Roundhouse, the Harmony Express to the peak of Little Whistler, and a much shortened eight-minute ride on the new Peak Express. In December 1996, Intrawest announced its purchase of Whistler Mountain Ski Corporation from the Vancouver-based Young and Barker families. Whistler Mountain was not only suffering from a tragic accident on its Quick-

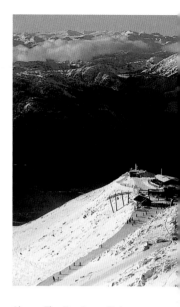

Above: **The Horstman Hut beside the 7th Heaven Express is perched at the top of the world.** BM

Below: **Yukiko Kaneda in the trees on a perfect February morning.** TK

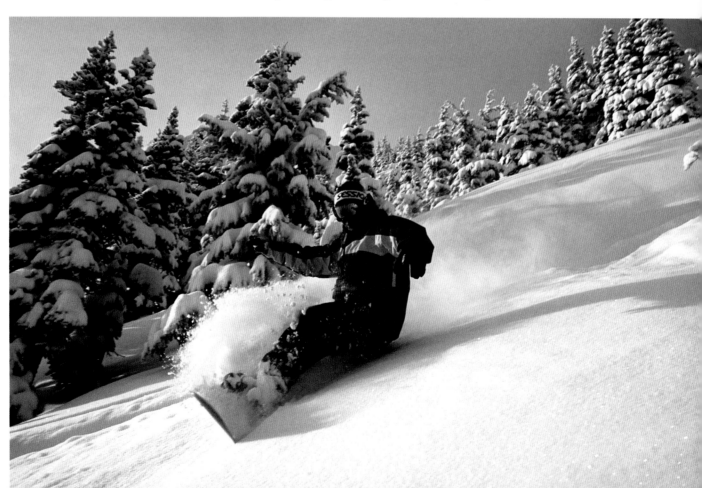

silver Chair in late 1995, but it also didn't have the deep pockets and real estate savvy of its mountain neighbour. Having maximized development on the Blackcomb Benchlands area, Intrawest's purchase of Whistler gave it further development rights at Creekside and farther south at Spring Creek. From there it went on to acquire or partially own fourteen mountain resorts across North America and Europe, a golf and beach resort in Florida, a luxury adventure travel company operating in over one hundred countries, the world's largest heli-skiing operation, and a private resort club with nine locations in North America.

Intrawest took the development of skiing from an on-mountain sporting enterprise into the high stakes real estate game of international resort development. This formula of on-mountain investment coupled with base real estate sales became the modus operandi for resort developers the world over. The final transformation from ski-hill operation to international finance occurred in 2006 when Joe Houssian brokered a deal that saw the publicly traded Intrawest sold to the New York-based investment management firm Fortress Investment Group LLB (no relation to Fortress Mountain Resorts) for a cool $2.8 billion.

Clockwise from top left: **A young visitor from San Diego shows promising form on the beginner terrain at the base of Blackcomb.** TK

Third generation Whistlerite Bobby Bunbury slides a rail in the terrain park sporting his grandpa's retro '80s ski suit. BM

A Whistler Kids ski school class admires Black Tusk from the top of Harmony Chair. TK

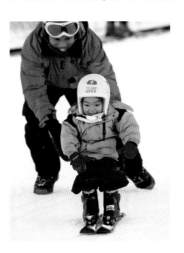

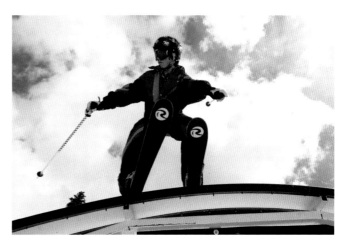

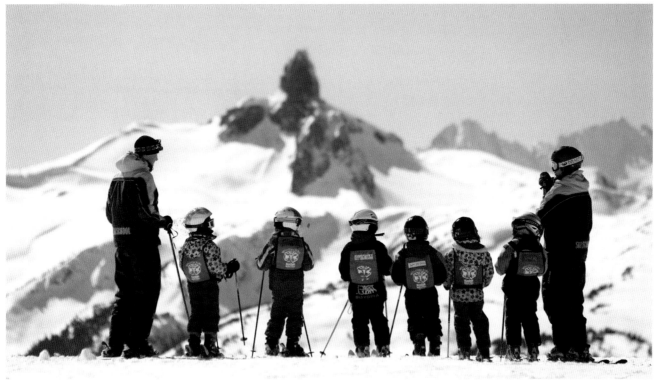

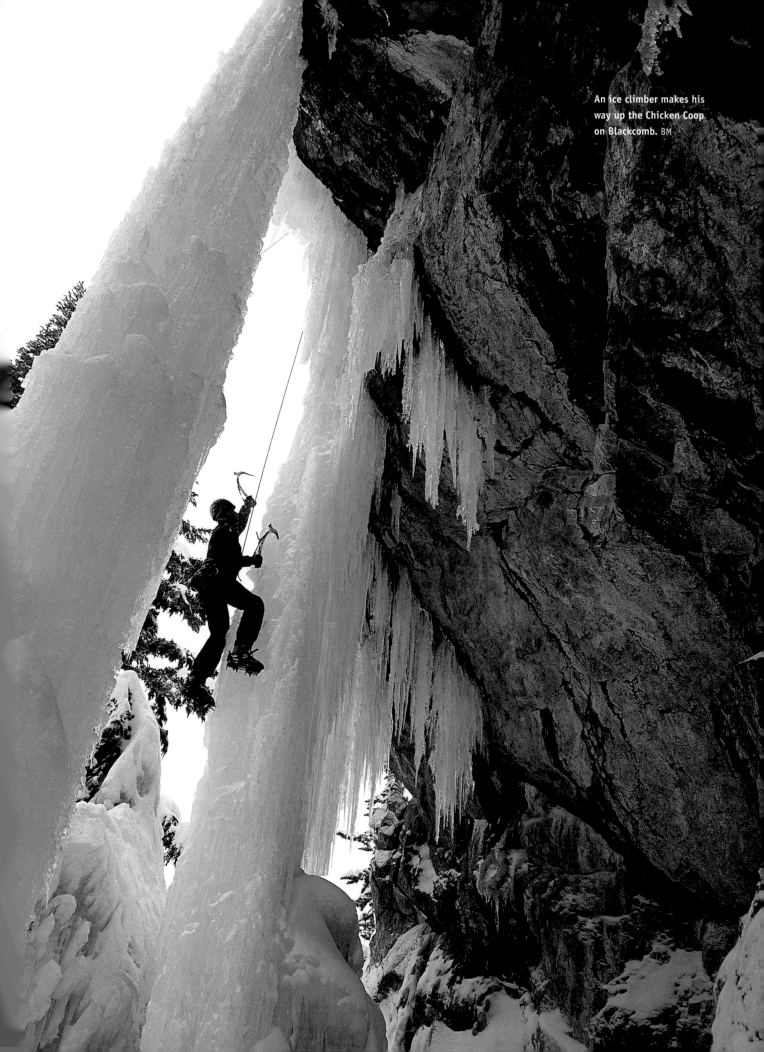

An ice climber makes his way up the Chicken Coop on Blackcomb. BM

The Whistler Vernacular

Along with the development of the two mountains, residential development of the land around their base and throughout the valley had an equally transformative effect on Whistler. As soon as memories of the 1980s real estate crash faded, developers got busy promoting the town as an ideal place for those with sufficient disposable income to establish a recreational villa, and buying and selling condos and chalets became the hottest game in town.

At the outset, these part-time Whistlerites included middle-class families of modest means, but skyrocketing land values soon began to eliminate all but those who could spare at least a hundred grand for a condo and upwards of a cool million for a chalet.

The new Whistler attracts another level of homeowner for whom money is no object, however. Builder Vic Beresford has dealt with many of these wealthy clients over the years, and only one had to go to the bank for money. "For the wealthiest, where the family fortune has been around for generations, the money doesn't mean anything to them anymore," he says. And that one percent of the wealthiest people find Whistler a good place to lose themselves in, to lose their celebrity and not have to explain or justify their existence.

"They all know each other and like to party together," he says. "And a lot of them like the connection they get, through myself or through my crew, to Whistler locals. Because these locals are also people who have stepped out of the mainstream and lead a different kind of life. We're another kind of one percent."

The influx of monied people who can afford to own expensive real estate they only occupy a few weeks of the year has had a number of effects on the town's character, and one has been to make it an architectural showcase. As money poured in and Whistler's corps of creative builders and designers gave free reign to their talents, they evolved a recognizable building style that some refer to as "The Whistler Style." It combines some elements of the old West Coast post-and-beam-and-glass style, some elements of the traditional high-gabled chalet and some elements of the sixties hand-built house. Trademark features are abundant use of such natural local materials as river rock, fractured granite, edge-grain fir and especially rough cedar logs, typically used as columns with intact root systems flaring out at the top.

I recently joined Vic in his red convertible BMW M-Roadster for a driving tour of some of Whistler's residential showpieces. We parked on the heated driveway of one impressive piece of work at the base of one of the mountains where Vic was installed as caretaker. It was packed full of rare hardwood, valuable art, Renaissance tapestries, refrigerated food elevators and, above all, beautifully designed and executed workmanship. "This house is appraised at ten million dollars," Beresford said. "With taxes, heating, maintenance and everything else, it takes about $200,000 a year to keep it running."

"It's my house eleven months of the year," he said, obviously getting a kick out of that fact. "It's theirs for one month. But these people actually ski every day that they're here. It's a place where their whole family comes together." The owners with this much money don't even think of it as a real estate investment, he said. They look at it in terms of generations; they want the house to last a long time.

We drove the Beemer into another hidden-away street with one beautiful house after another. It's the combination of design talent, craftsmanship and money, he said, that has generated the Whistler vernacular, the architecture we see: "I used to work for guys like Glen Lynskey and Matheo Durfeld. They're talented people who are still very much involved. It's the single-family home that has been the expression of great architecture in this valley."

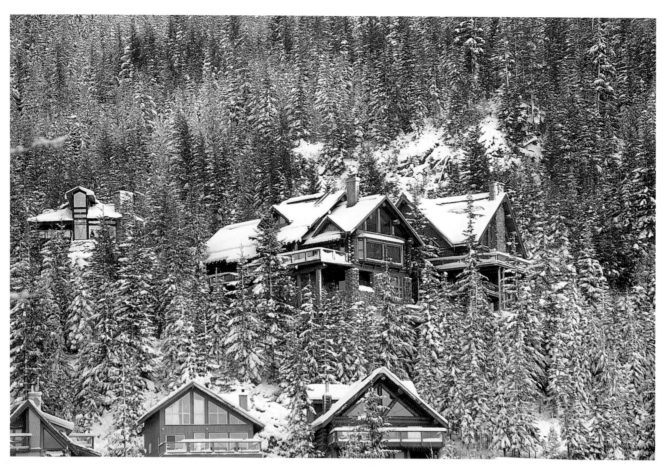

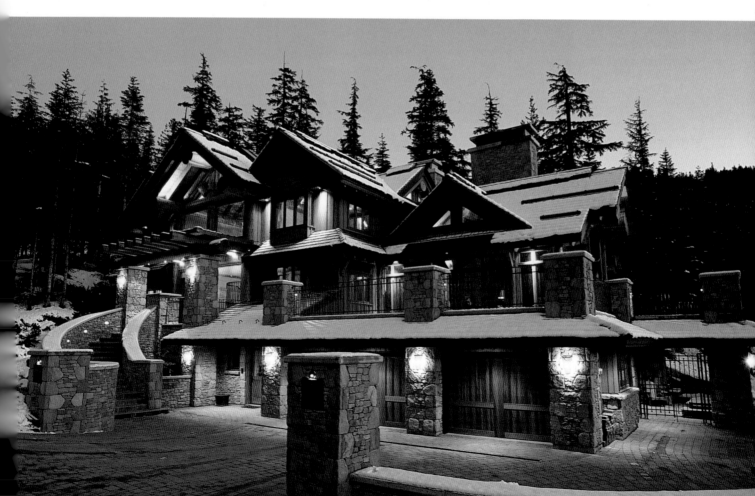

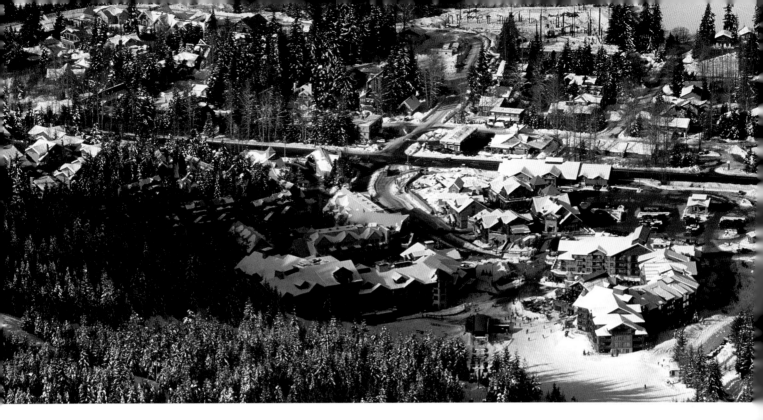

Above: **Lower Franz's Run and the Dave Murray Downhill deliver skiers to Whistler's Creekside. Unlike Whistler Village, Creekside evolved slowly and organically over many decades.** TK

Right: **The rebuilt Dusty's Bar at the Creekside base sports a somewhat Disneyfied western theme.** BM

Far right: **The wooden playhouse at Alpha Lake Park in Creekside.** BM

Creekside

If any part of Whistler feels like a real town, or at least a real ski town, it's Creekside. "The Creek," formerly the Southside, has a gas station and a train station, a hillside worth of lower-income housing known as the ghetto, a convenience store that's open 24-7, a few pubs and restaurants and a gondola. It's the original base of Whistler Mountain, and its authentic townliness may stem from its slow and organic growth—at least on the west side of the highway.

The Husky Station (formerly the Union 76), was once the daytime social hub of Whistler—a place to buy not only gas and groceries, but to shoot the breeze and maybe a game of pinball. The Southside Lodge across the street began as Le Magazine du Ski, went through various incarnations and hit its most famous mark with the Southside Deli (run by Herschel and Cal). It later became the Southside Diner with a hostel upstairs.

If there's any doubt as to whether the Creek has soul, one need only set foot in the Whistler Creek Lodge. The big wooden structure with the shake roof was built in 1980, and along with forty-four hotel rooms sports a large rustic restaurant and bar that over the years has operated as the Creek House, Las Margaritas and Uli's Flipside to name just a few of its incarnations. It had

long been rumoured that the Whistler Creek Lodge was home to a ghost, and in 1995 *Pique Newsmagazine* co-founder Kevin Damaskie laid the matter to rest by touring the rooms with a psychic ghost buster in hopes of an otherworldly interview. Psychic Diane Mills found that indeed a ghost inhabited the building—a logger by the name of Bill, who in the 1930s had experienced a life steeped in violence and drinking. After releasing Bill to the light, Mills made brief contact with another ghost named Coralene.

There are other buildings in the Creekside that are, if not haunted, at least full of character. The Highland Lodge is home to the Rim Rock Café, one of Whistler's finest restaurants and once home to Sunday-night jazz and a rafter-hanging contest that netted the winner a bottle of tequila. Hoz's Pub in the Whistler Resort and Club has also seen many a lively night—as Hoz's, Florentina's and Dos Señoritas—over its three decades of existence. Hoz's patio once looked out on tennis courts and the old Jordan's Lodge built in the 1920s. Now the Whistler Resort is dwarfed by the new five-storey Nita Lake Lodge, the anchor to Creekside's redevelopment. But even the big new hotel and the train station around the corner only add to the diversity that has always characterized the Creekside.

Workers at Function Junction's cement plant can keep an eye on Whistler's peak. TK

Function Junction

Function Junction was named in a rhyming word game by Florence Peterson, Kelly Fairhurst and three other school teachers, nearing the end of a five-hour trip from Vancouver to their cabin at Alta Lake in the 1950s. It earns the second half of its name in many ways: Function is the junction of Millar Creek and the Cheakamus River, of Highway 99, the old Alta Lake Road turnoff and the railway tracks, and of an entire valley's worth of sewage that congregates at the Whistler sewage treatment plant.

Once home to John Millar's trapper cabin and B&B, then to a lumber camp and later a squatter community, it is now Whistler's southernmost habitation, cottage-industry enclave and industrial park. Function has everything from a ski and snowboard factory, commercial bakery, newspaper office and TV station to gardening shops, cement plants, auto garages, art galleries, building-material outlets, graphic designers,

The Re-Use-It Centre is full of treasures that once went to the landfill, but now raise funds for Whistler Community Services. TK

welders, cafés, and best of all, the Re-Use-It Centre. While Whistlerites once trod through the landfill just up the hill to find everything from VCRs, skis, furniture and enough building materials to construct a good-sized house, now these items are all diverted to the Re-Use-It Centre where thrifty shoppers can pick up whatever they lack and support Whistler's Community Services with their minimum donation. In a town with some of the best-looking garbage in the world, it's a win-win for everybody involved.

In 2006, construction of the Olympic Athletes' Village began on the site of Whistler's (second) former garbage dump just above Function Junction. The development includes affordable housing as well as recreational and community facilities, making the junction more functional than ever.

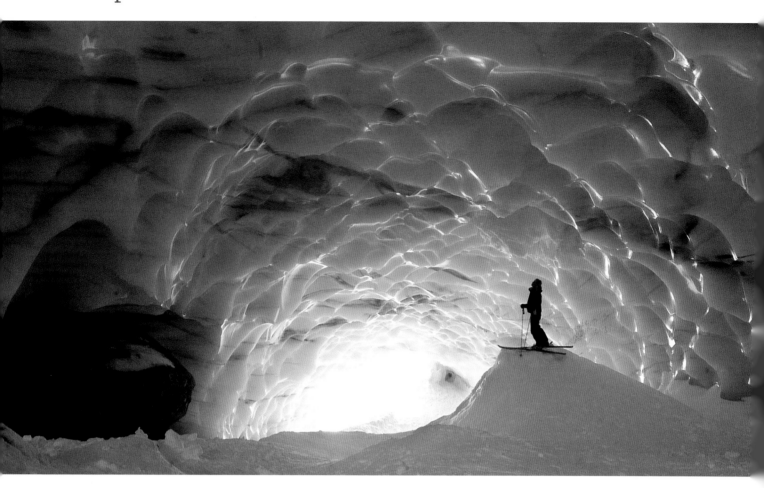

Skiers, Squatters and the Boomer Revolution

And what happened to the generation who'd dropped out of the rat race to live unassumingly in the woods and play with gravity? Only a few hardy souls continued trying to live a low-key, underground existence in the midst of the bulldozers. Squatting was no longer part of a community, but a furtive enterprise undertaken at the fringes of the municipal boundaries. Jobs were never hard to find, though places to live had become scarce and expensive. A number of young Whistlerites, embarking on their own echo baby boom, bought land at Tapley's Farm and subdivided it into Whistler's first affordable housing initiative. Purchased under the company name of Mountain Development Corporation, MDC soon stood for Mothers, Dogs and Children, who could be seen happily, along with dads too, spilling out onto the aptly named Easy Street.

Lost Lake Dock

I don't know how long the nude dock at Lost Lake has been in existence, but it was already there in the 1970s when I paddled a raft across the lake and witnessed for the first time the local wildlife: naked ski-bums in all shapes and sizes. Boom boxes, barbecues and a healthy party scene were par for the course on a summer afternoon.

The surrounding view is still one of forested mountainsides with the peaks of Whistler and Blackcomb hanging above. While the majority of swimmers flock to the beach on the other side of the lake, the dock has remained continuously and nakedly inhabited. To sit on its well-worn wood with one's legs in the water is to enter a kind of time out of time. There's a feeling of community, as though everyone in attendance is doing their duty to keep a vestige of Whistler's counterculture alive.

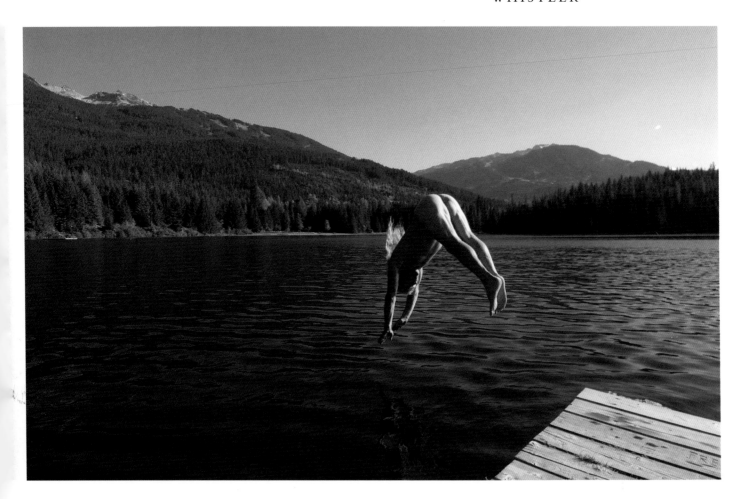

But while some were content to simply establish a home in the valley, others jumped on the development bandwagon and, like their baby-boomer brethren across North America, accelerated the process with their mass capitulation. When the dust settled after the bankruptcy scare of 1982, there they suddenly stood, torn jeans and long hair traded in for a power blazer and a Beemer, granola and home-cooked beans for frogurt and sushi. It was the 1980s. The subculture had miraculously flipped and become the mainstream culture overnight.

The irony of it all was that the relaxed, laid-back lifestyle of the previous decade proved the most marketable commodity of all: mountain lifestyle, an elixir that could be bottled and sold with the ever-escalating real estate. Throughout the 1980s and 1990s Whistler was the glamorous young starlet of the ski-resort scene. Accolades were heaped upon it year after year in the form of No. 1 rankings in the ski magazines. Movie stars and pop stars came to revel in the buzz of the happening new resort. The hotels and condos were full, even in the summer as was previously only dreamed of, and the village continued to sprawl to the north and east with each new phase of development. Skiing's popularity had plateaued, but now snowboarding brought in a whole new generation of snow sliders. Extreme sports, especially the winter ones, had gone mainstream. Clothing, sunglasses and beer ads were all about being young, pushing the limits and living an adrenaline-fuelled life to the fullest. Cutting-edge marketers counselled resort executives on how to cross market with music and fashion trends—how to co-opt the kids' scene while it was still underground and hip.

Real life continued to burble somewhere beneath all the hype. A community was struggling to assert itself in the midst of its overwhelming success as a resort. The Resort Municipality of Whistler (RMOW), swamped by development proposals, tried to mitigate growth and develop a

Above: **Sushi Day at Myrtle Philip Community School.** BM

Top: **Suitless swimmers perpetuate Whistler's nonconformist spirit at the Lost Lake nude dock.** BM

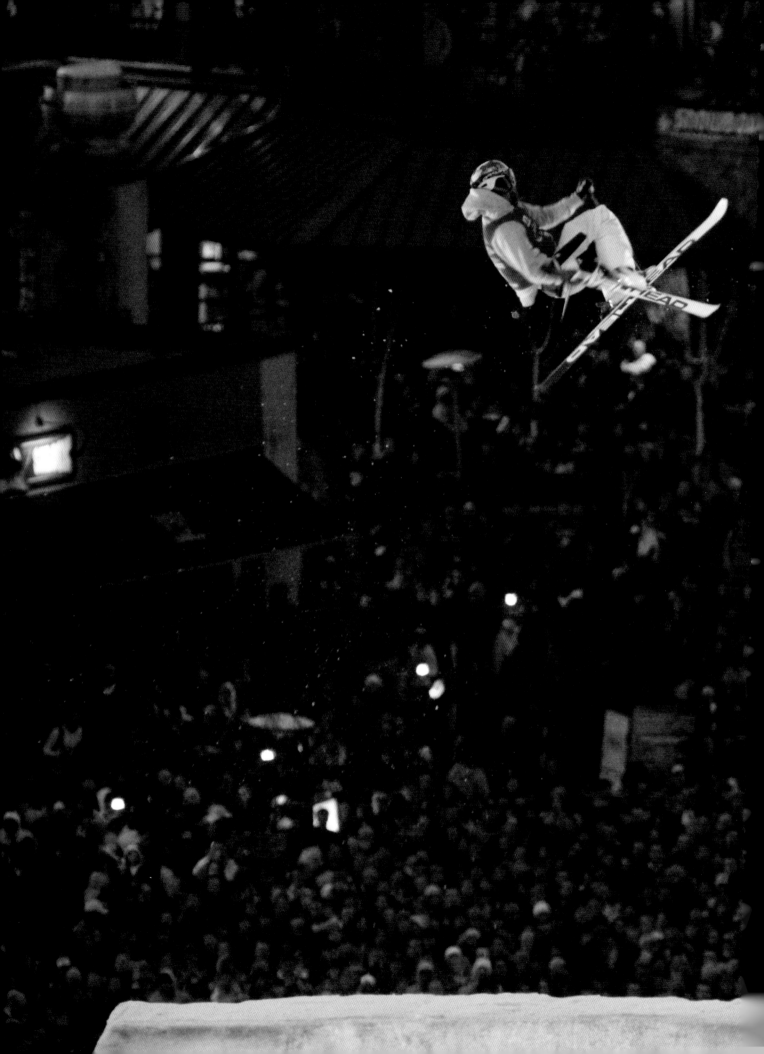

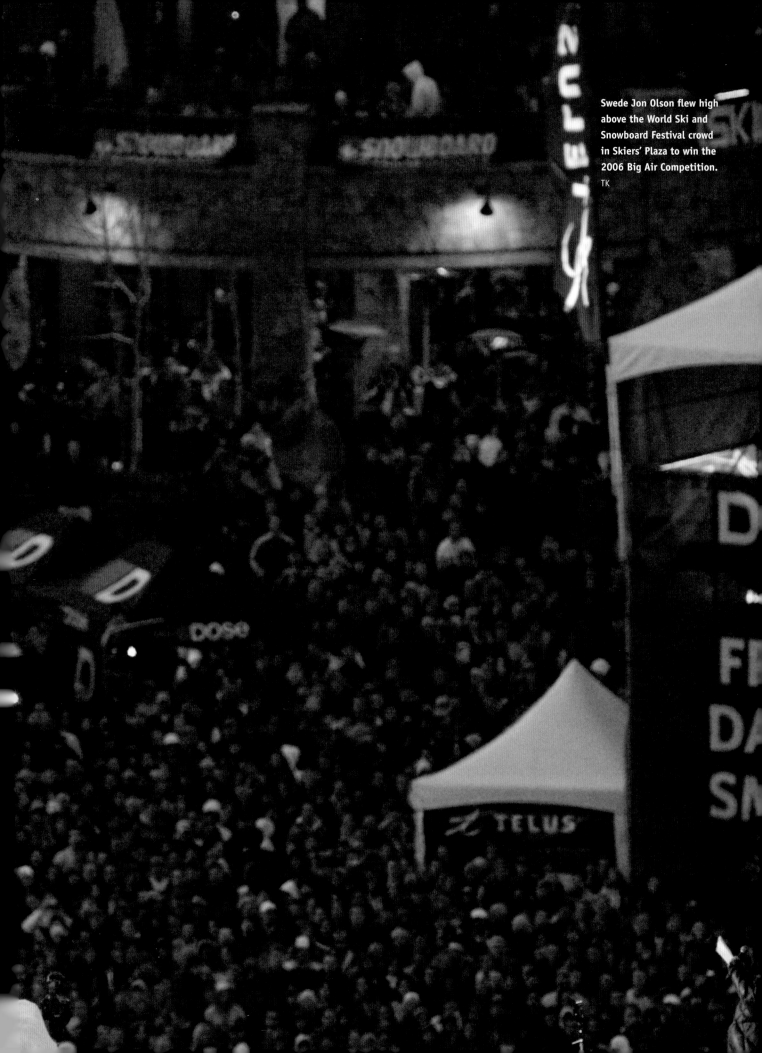

Swede Jon Olson flew high above the World Ski and Snowboard Festival crowd in Skiers' Plaza to win the 2006 Big Air Competition. TK

Top of the Pass

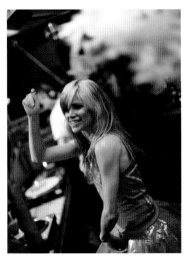

Above: **Creative tour-de-force Ace Mackay-Smith at her 11th annual Good Ol' Fashioned Rave.** TK

Top: **Pressure Drop! Toots and the Maytals always get Whistler dancing to the reggae riddims.** BM

Right: **Fergie of the Black Eyed Peas heats up the Main Stage during the World Ski and Snowboard Festival.** DM

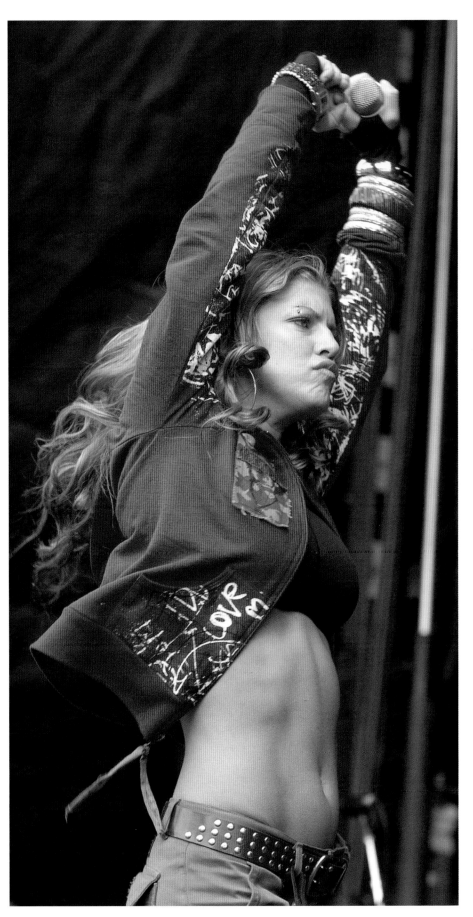

Whistler and the Sea-to-Sky Country

planning framework that served the community as well as the resort. The rapid pace of development and high cost of living caused many locals to leave the valley, but just as many settled in to their new surroundings and found a way to make a living. And there were benefits to the new lay of the land too. Leading up to the 2010 Olympics, the town was now home to a permanent population of nearly ten thousand; young people still flocked to the place every year from all around the world; Whistler had become a tiny cosmopolitan city perched in the Coast Mountains; it now had movie theatres, fine dining, a raging nightlife and still some of the best skiing in the world.

The arc Whistler has carved over the last quarter-century might best be described by the changing shape of its season-ending festival. May Day Madness, celebrating the last weekend of skiing in the mid-1970s, involved the legendary Snow Earth and Water Race in which team members skied and hiked down the mountain, then canoed, biked and ran through the valley to the finish. The Christianna Inn on Alta Lake was one of the central party locations where I recall the Cement City Cowboys playing naked on the patio during the wet-T-shirt and belly-flop contest while hundreds of revellers crowded onto the sagging roof of the old lodge. The entire long weekend was dedicated to pure mayhem and drunken revelry, a celebration to usher the ski season out and the slow summer season in.

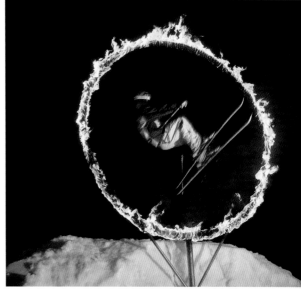

Every Sunday night during winter, visitors are treated to the Fire and Ice show at the base of Whistler. BM

Today's World Ski and Snowboard Festival takes place in April and covers much of the same territory. Ski and snowboard competitions draw some of the hottest young skiers and boarders in the world, culminating in the Big Air event at the base of Whistler. While the athletes launch themselves into the air above the crowd, internationally popular bands such as Black Eyed Peas and Toots and the Maytals take the stage along with the hippest Los Angeles and New York DJs. The party scene over the ten-day festival is exhaustive and epic and is twined with cultural events such as the seventy-two-hour Filmmaker Showdown, Words and Stories, and the Pro Photographer Showdown. The festival fills formerly vacant end-of-season hotel rooms and brings over $20 million into the resort.

Thousands jam Skiers' Plaza following the 2007 Big Air event. TK

The Modern Resort: Sports as Religion

Those who named Whistler's first church the Skiers' Chapel prophesied a local phenomenon that perhaps even they weren't fully aware of. The chapel was built in 1967 at the base of the old Creekside Gondola using the same A-frame construction style as most ski cabins of the day. It was Canada's first ecumenical church, open to adherents of all world faiths. But while the church held many varied and wonderful services during its thirty-three years of existence, it was the placing of the word *skiers* in the context of religious worship that presaged an underlying theme in the growing community of Whistler. Going downhill, whether on skis, a board or a bike, brings out a passion among initiates that, like any good religion, erases social divisions and brings a unifying force to the populace. This is an important phenomenon in a town comprised of so many different layers of existence.

Whistler boasts one of the most highly educated populations in Canada. It draws the finest from across the country and around the world and encourages them to tack their diplomas or degrees on the wall to pursue something completely different. Like their predecessors from three or four decades ago, new arrivals in town are also the people who end up on the front lines: they serve your coffee, adjust your bindings, load your chairlift, pour your merlot and turn up your linen. The young people arrive to ski, party and work, and at the end of the season most go home or move on while a few remain, unable or unwilling to extract themselves from the Whistler experience. Locals who park themselves for a long period of time sometimes manage to combine a chosen profession or trade with a life in the mountains. Doctors and dentists, contractors and cabinet makers, graphic designers, environmental engineers, lawyers and journalists have all managed to build careers in Whistler and can be seen on the ski slopes as much as any seasonal devotee of sliding.

Above: **Ex-ski-bum Derek Rhodes stayed in Whistler by opening Profile Ski and Snowboard Services. There's plenty of work, and mornings are still free for riding.** TK

Top: **Pat "Puzz" Rowntree has worked at one of Whistler's finest restaurants, the Rim Rock Café, for over twenty years.** TK

Right: **Yosuke Hamazaki in the Blackcomb Halfpipe.** TK

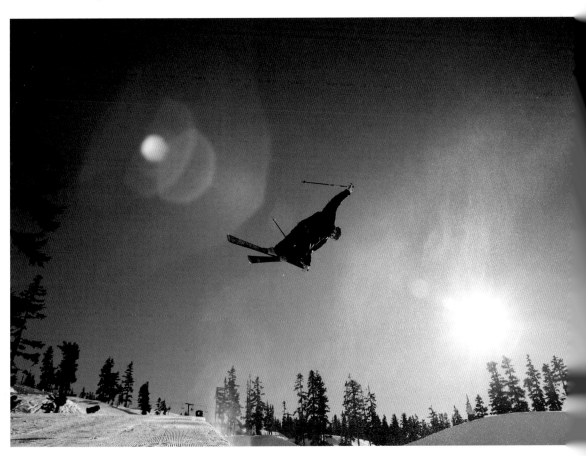

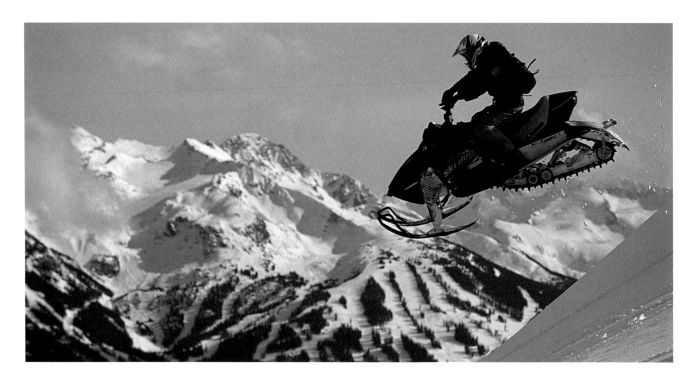

Jason Smith takes
air on a snowmobile
in Whistler's
backcountry. BM

Whistler's Words for Snow

While the Inuit are said to have anywhere between nine and one hundred words for snow—depending on which linguistic factors one takes into account—Whistler's words for snow and snow conditions are generally related to sliding.

Boilerplate — bullet-proof ice.

Butter — soft, smooth layer over firmer snow in spring.

Cementimetres — depth measurement of elephant snot, schmoo, wet cement, et al.

Corduroy — just like the pants. Pattern imprinted on the snow by the groomer's tiller. Also *Roy*.

Corn — granular snow softened by spring sun.

Crustaceous — evil crust, like skiing on prawns.

Death Cookies — frozen chunks of snow left on a groomed run. Also hidden avalanche debris under fresh powder.

Dust on Crust — new, thin layer of snow on top of old layer of ice or boilerplate.

Elephant Snot — wet heavy snow that doesn't want to let you turn.

Garbanzo — corn consisting of larger sized granules, for which Garbanzo Run on Whistler's west side was named.

Graupel — snow pellets or soft hail 1-7 mm in diameter, formed in strong updrafts of cold air. From the German word for *barley*.

Schmoo — heavy snow with a high water content (also the state of your legs after skiing it all day).

Snorkle snow — you laugh, but I've seen it done!

Soap flakes — light, big-flaked powder.

Squeeze — Deep powder. Also light, fluff, smoke, sparkle, head deep, and good shit.

Upside Down Powder — hard crust on top of powder.

Velvet schmoo — thin layer of heavy snow over hard pack. Also good deep corn snow.

Zastrugi — Also *Sastrugi*. Long parallel ridges formed by wind. (Originally on the plains of Russia.)

"The only way the skiing could have been any worse was if the snow had actually been on fire" –Graham Tutt, *Blackcomb Ski Patrol*

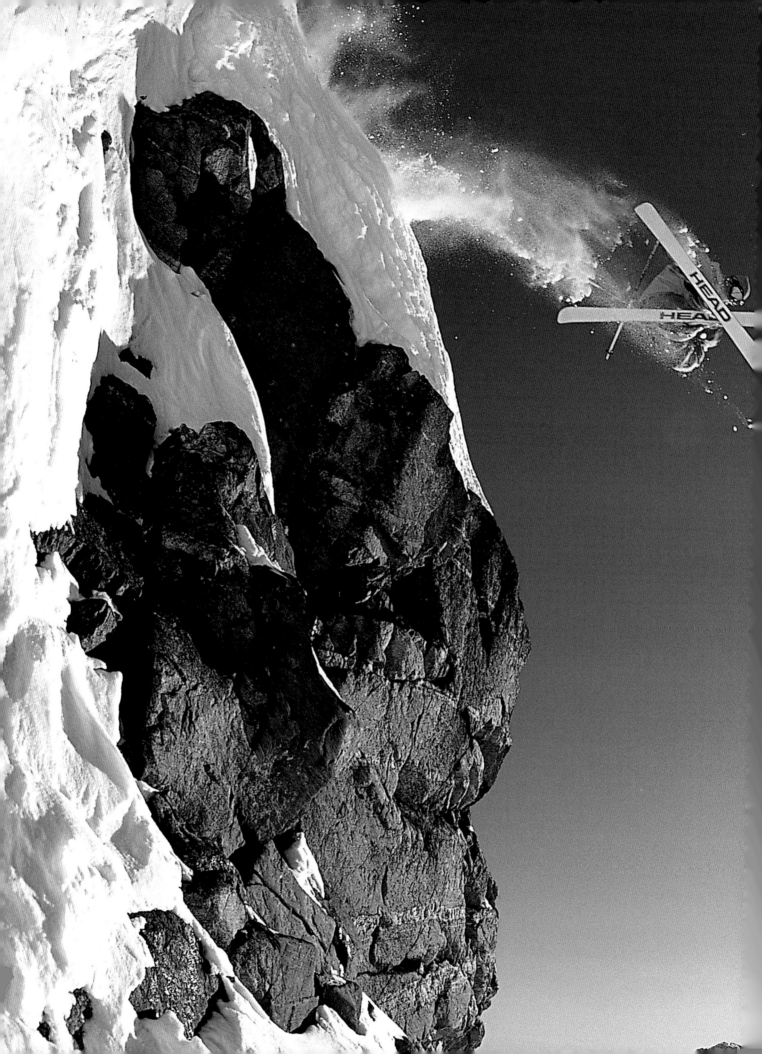

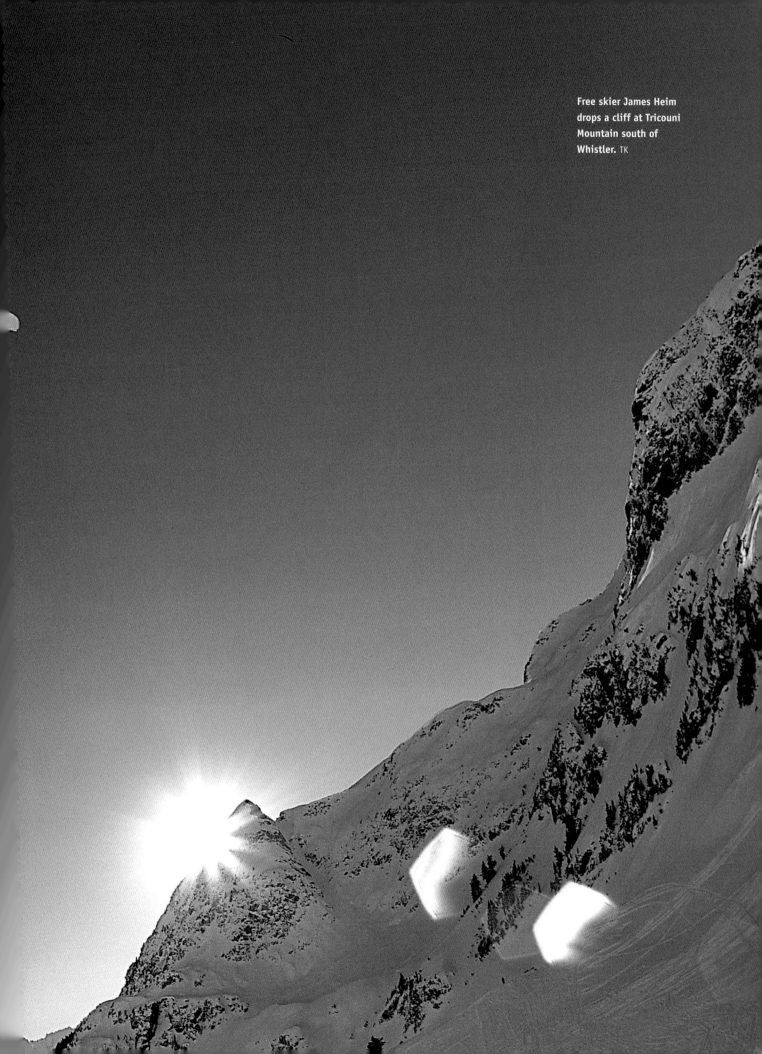

Free skier James Heim drops a cliff at Tricouni Mountain south of Whistler. TK

Above: **Ken Read inspects Whistler's Dave Murray Downhill Course at a World Cup race in the 1990s.** BM

Whistler and Blackcomb have produced some of the best competitive skiers and boarders in the world for two simple reasons: huge mountains with endlessly challenging terrain, and snow conditions ranging from rotten schmoo to champagne powder with every possible gradation in between. Jordan Williams, a ski coach with the Whistler Mountain Ski Club for twenty-five years, says Whistler-based skiers develop good touch and feel for different snow grains. "If you look at those who do well, they're all great free skiers with a love for skiing in any condition," he says. "It takes a great skier to make a half-decent racer." And in his coaching career, Williams has seen plenty of racers—from Christina Risler, Mike Giannelli and Allison Forsyth to Manuel Osborne-Paradis, Robby Dixon, and Britt and Michael Janyk—develop from the club level to the World Cup circuit.

The Whistler Mountain Ski Club was started in 1968 after a group of young skiers began training gates with local skier Joe Czismania. Williams, who also raced for Whistler as a youngster in the seventies, says it was a true club in every sense. "What you put into it was what you got out of it. There were families who were really committed: the McLennans, the Wohlgemuths, the Parsons, and in later years the Janyks, among many others." As well as developing young ski racers, the Whistler Club has a tradition of hosting well-run races—from the annual Garibaldi Spring Slalom and Parsons Downhill to its first Canadian

Above: **Four-time overall World Cup Champion Hermann Maier,** *The Herminator,* **in Whistler for a World Cup Downhill race.** BM

Right: **A young Dave Murray (right) hoists the Shell Cup at the Canadian Championships.** Whistler Museum & Archives, 95-6-232

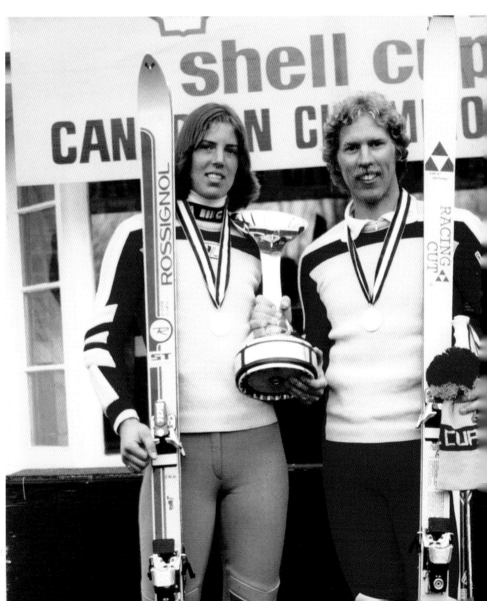

Championships in 1969, numerous World Cup races, and the prestigious Air Canada Whistler Cup annually showcasing the best junior ski racers in the world.

Dave Murray was a local hero who grew up skiing Whistler Mountain, both racing in the gates and exploring the steep and deep trees and bowls every chance he had. Travelling up from Abbotsford to stay at the family cabin overlooking Alpha Lake, Dave was a passionate free skier long before he started racing at the age of sixteen. As a member of the Crazy Canucks, "Mur" took his Whistler-honed skills across Europe and North America, racking up World Cup podium finishes and providing a laid-back Whistler style of leadership for the team. After retiring in 1982, he started the hugely successful Masters Group with Don McQuaid, and the Dave Murray Ski Camps, bringing the thrill and training possibilities of ski racing to the many high-level recreational skiers from Whistler, Vancouver and farther afield.

After losing a battle with cancer in 1990, Dave Murray has been sadly missed by the entire Whistler community. His legacy lives on not only through the downhill course named in his honour, but in the memories of the many skiers with whom he shared his knowledge and passion for the sport.

World Cup and Olympic champions have always felt at home in Whistler. Here they're surrounded by talented local and Vancouver-based riders who share their passion for playing in the mountains. Following her Olympic and World Cup victories in 1967 and 1968, Nancy Greene came to Whistler to coach at the Tony Sailer Summer Ski Camp on the Whistler glacier. With her

Rob Boyd's daring line made him the first Canadian male to win a World Cup downhill in Canada. BM

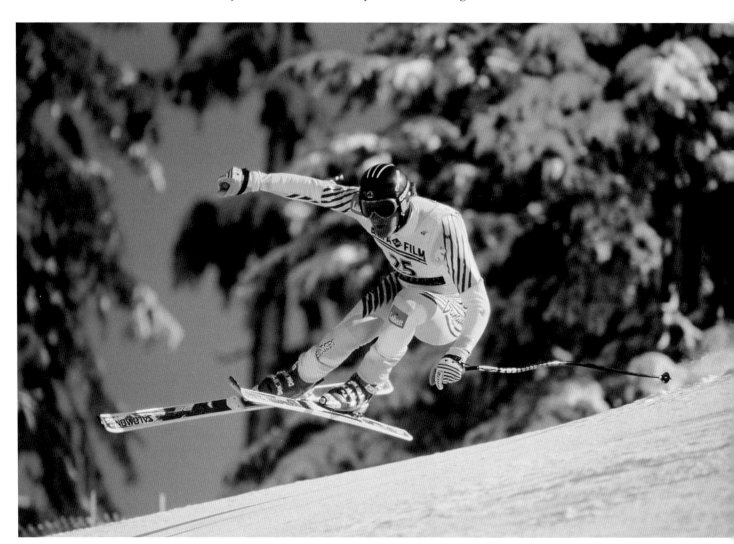

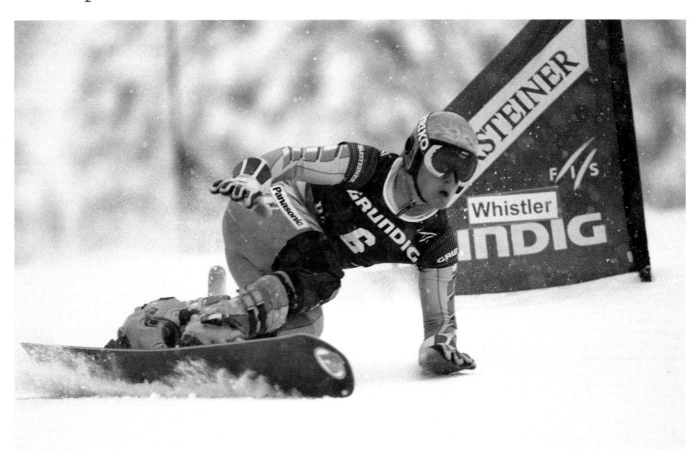

Above: **Whistler's Olympic gold medallist Ross Rebagliati doing what he does best in a World Cup race on Blackcomb.** BM

Right: **Nancy Greene Raine and Steve Podborski found their way to Whistler after spectacular careers on the World Cup circuit.** BM

husband Al Raine deeply involved in the planning and development of both Whistler Village and Blackcomb Mountain in the mid-1970s, the Raine family became full-time members of the Whistler community for over fifteen years. As well as opening the Nancy Greene Lodge in Whistler Village, Nancy became Blackcomb's first Director of Skiing, showing visitors around the mountain and acting as a true ski ambassador.

Steve Podborski, Canada's most successful male ski racer to date, also found his way to Whistler eventually. After winning eight World Cup downhills as well as a bronze medal at the 1980 Winter Olympics, Podborski secured the 1981–82 World Cup downhill title with a second-place finish on Whistler's northside course. Following his retirement in 1984, Steve and his wife Kathy looked for a suitable place to settle down and raise a family. Whistler offered the right mix of small-town resort, good skiing and easy access to Vancouver. The Podborskis set themselves up on the venerable Easy Street in Tapley's Farm.

Canadian ski legend Rob Boyd moved to Whistler with his family in 1982, the year he was named to the BC Ski Team. Living in the mountain manager's house (a position his dad took on with Whistler Mountain) next door to the gondola barn, Rob could roll out of bed and be on the lift before both eyes were fully open. The Dave Murray Downhill—on which he would make Canadian ski racing history in 1989 as the first Canadian male to

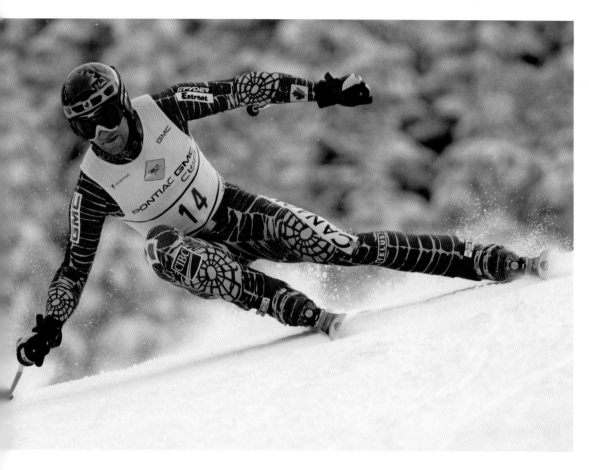

Whistler's Michael Janyk carves a clean line in the Super G at the 2006 Canadian Championships on Whistler Mountain. BM

win a downhill in Canada—was literally his backyard. But before moving to Whistler, Rob's backyard was his parents' Tillicum Valley ski hill where he would chase his older sister Sue through moguls and narrow trails in the tight trees, developing smart feet and quick reflexes.

Boyd's 1989 victory combined disciplined technique with free skiing flare and all-out commitment. His innate sense of the terrain—its every nook and cranny by then almost a part of his DNA—enabled him to push beyond what the course might have afforded another skier. His too-straight line on Fallaway Corner nearly threw him out of the course, and the daring air he took on Fortna's Corner lower down shaved precious time from the clock and clinched his victory.

Over the 1990s, snowboarding moved from a fringe activity, outlawed in some ski areas, to a mainstream Olympic sport. A young boarder by the name of Ross Rebagliati was busy training gates on Blackcomb when he wasn't climbing up Spanky's Ladder to catch some powder on Blackcomb Glacier or elsewhere on the mountain. Rebagliati's dedication to the emerging sport paid off with his Olympic gold in Nagano that resulted in thousands of people packing Whistler's Village Square to celebrate.

Mogul skier John Smart is another World Cup medallist and Olympian with deep roots in Whistler. Growing up in Lions Bay, he spent every spare moment working the moguls on Whistler's Chunky's Choice with a herd of other dedicated teenage bump skiers. After pulling in two World Cup gold medals and a fifth in the '92 Olympics, John and his wife Julie moved to Whistler to raise their two boys and to pass on the art of mogul skiing at John's Momentum summer camps on the Horstman Glacier.

So who will be the next World Cup and Olympic skiers and boarders to emerge from Whistler and the Sea-to-Sky area? "The ones who succeed, work at it really hard," Jordan Williams says, "whether it's mountain biking, doing dry-land or playing soccer for training—and lots of miles

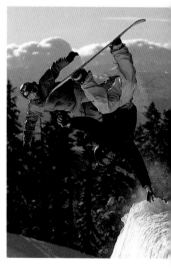

Canadian National Snowboard Team members Crispin Lipscomb (front) and Dan Raymond defy gravity in the Blackcomb Terrain Park. BM

on the skis, both in the gates and free skiing." The other important element Williams points to for young athletes is progressing to the next level at the right time. "Of the Whistler Club racers doing well on the national team right now," he says, "every single one of them stayed in the oven (on the BC team) one extra year. So when they got on the national team they were hungry and ready to perform." They also gained an extra year of playing on the slopes of Whistler and Blackcomb with a community of passionate skiers and boarders.

Sarah Burke in the Superpipe Contest at the World Ski and Snowboard Festival. BM

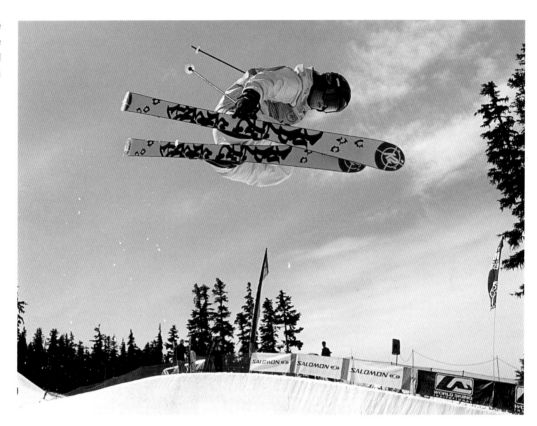

A racer in the CIBC Disabled Championships. Whistler is the site of the 2010 Paralympic Games. BM

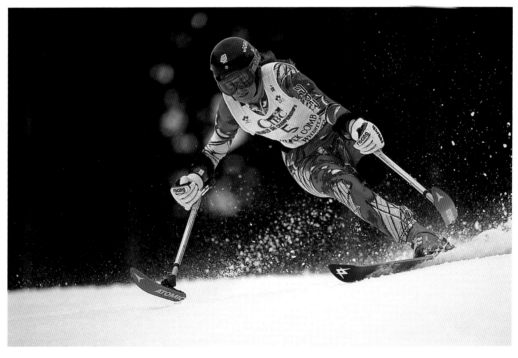

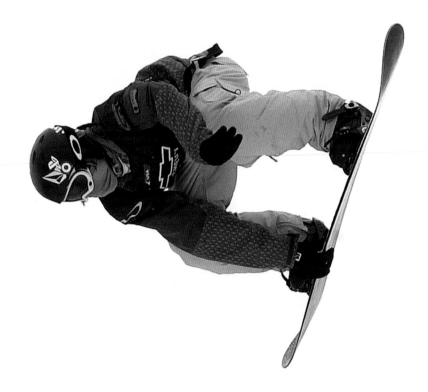

Torino Olympics gold medallist Sean White won the Global X-Games Championship halfpipe competition on Whistler Mountain. BM

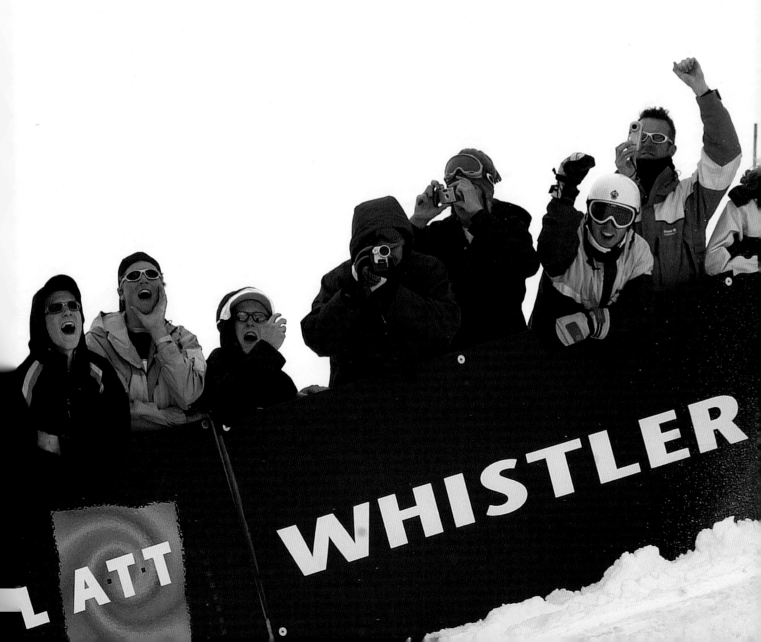

LATT WHISTLER

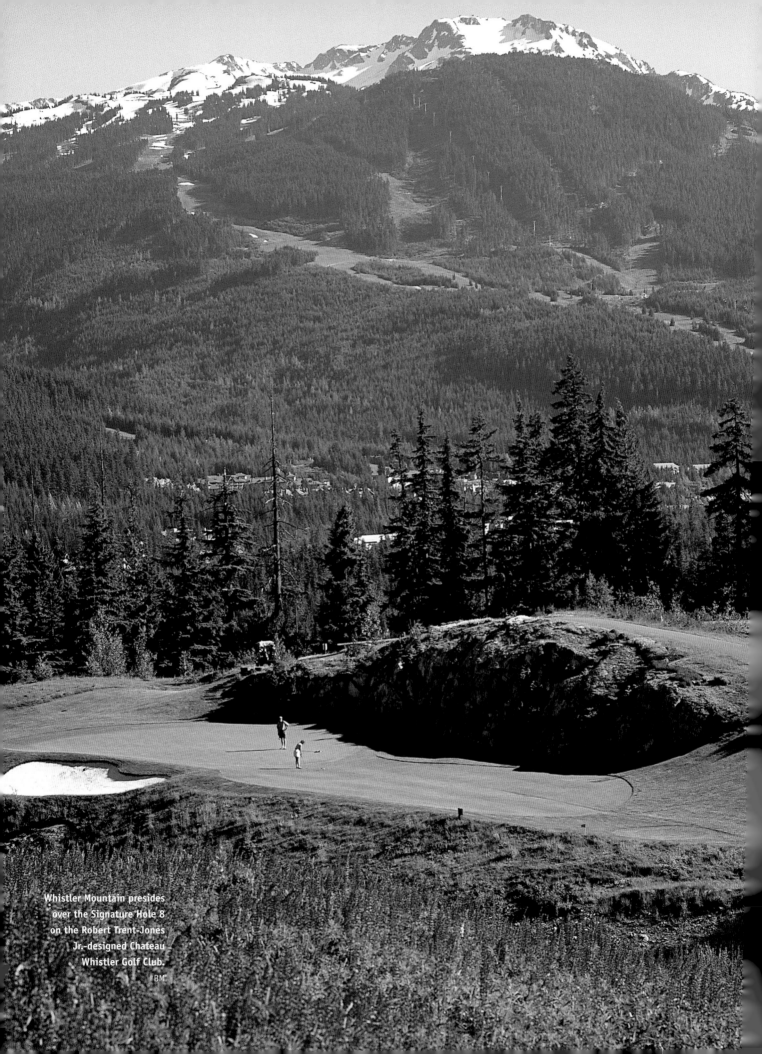

Whistler Mountain presides over the Signature Hole 8 on the Robert Trent-Jones Jr.-designed Chateau Whistler Golf Club.

BM.

In the late 1980s, the town of Whistler made a concerted effort to establish itself as a year-round resort. At the time, the game of golf was experiencing an upswing in popularity and it was deemed the perfect complement to the winter activity of skiing. Golf would attract well-heeled destination visitors from near and far, filling village hotel rooms as well as restaurants and bars. Proposals poured in from developers keen to provide amenities such as golf and tennis facilities along with the attendant development rights for high-end homes and townhouses. After all, golf without real estate is like, well, skiing without real estate. After considerable local opposition, Whistler's tally of eighteen-hole golf courses was increased from one to three.

Whistlerites have never shied away from new sporting challenges, and as the destination visitors arrived on the links, so too did some of the locals. The permanent population of young ski-bums was beginning to age, and golf offered a less extreme form of recreation where ex-gravity gurus could take their knee braces out for a spin and perhaps lower their handicap. The golf courses provided not only spectacular views of the surrounding mountains, but an excellent opportunity to discuss where the next wave of development rights might take the community.

Vijay Singh, John Daly and Jack Nicklaus joined up for the 2005 Telus Skins Game at the Nicklaus North Golf Club. BM

While images of fairways and driving ranges filled Whistler's summer brochures, another activity was quietly gaining momentum in the local forests. It involved only minor changes to the natural landscape and needed no development rights to fuel its growth. The first mountain bikes showed up in Whistler in the early 1980s and the sport quickly worked its way deep into the community. Locals who agreed with Mark Twain's assessment, that golf is a great way to spoil a nice walk, had found the perfect vehicle to explore the Coast Mountain forests and get their gravity fix at the same time. In Whistler, bikes are both viable transportation and pure pleasure. The

The Chateau Whistler Golf Club on the Blackcomb benchlands is bordered by luxury townhomes. BM

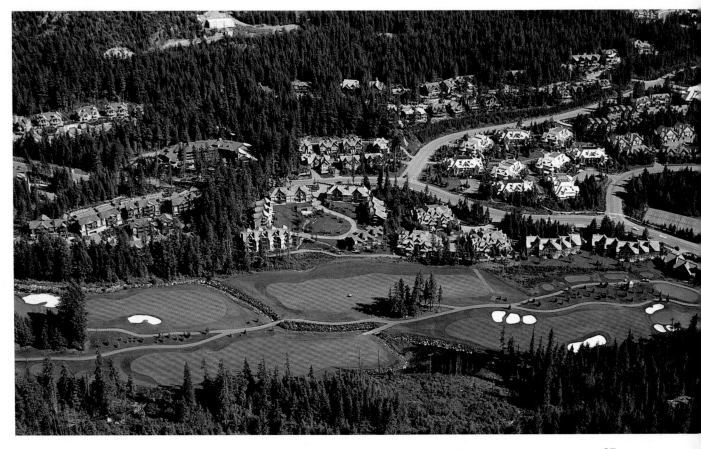

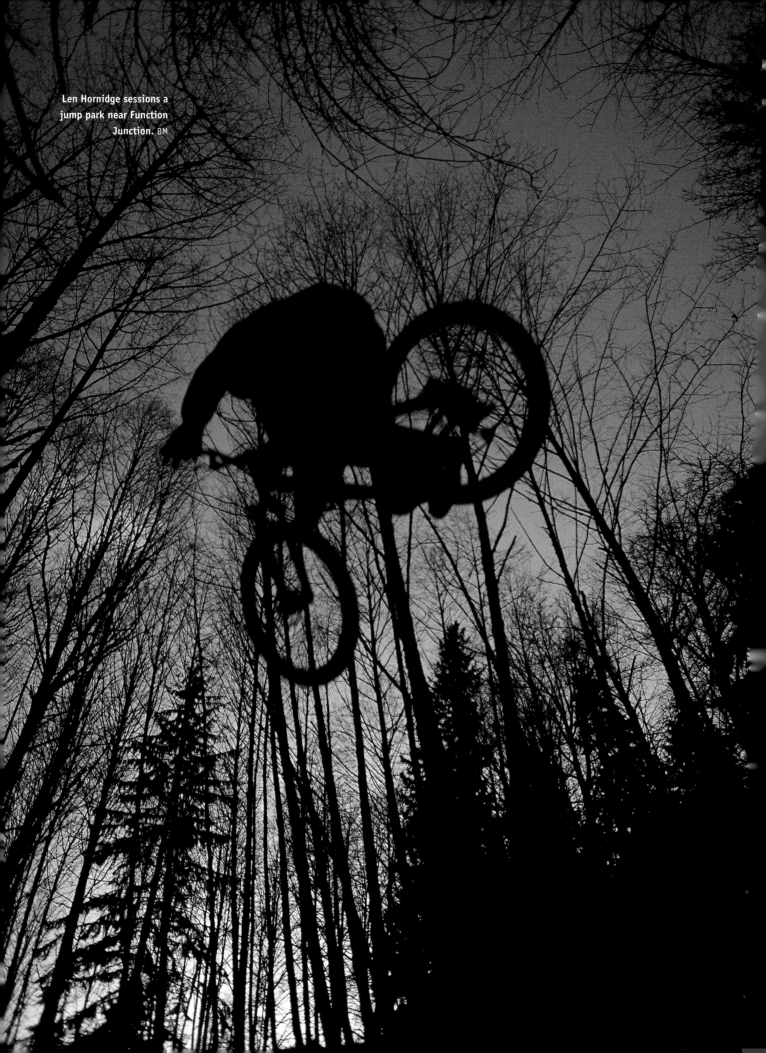

Len Hornidge sessions a jump park near Function Junction. BM

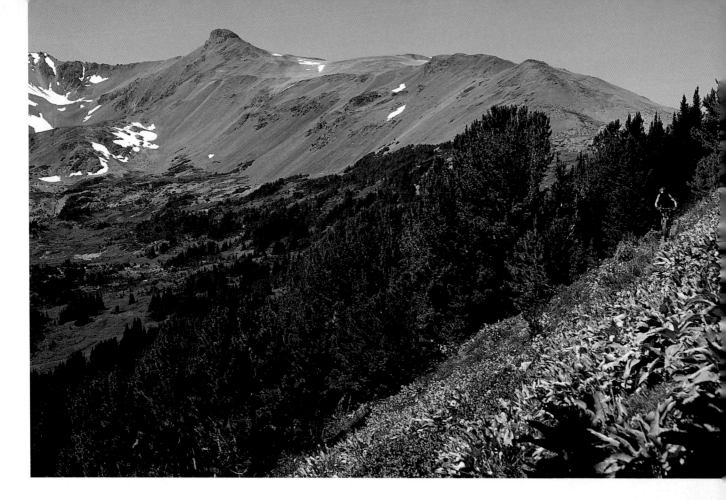

Valley Trail connects every neighbourhood from Function Junction to Emerald Estates and acts as a gateway to the many single track trails that climb and loop through the connecting mountains and valleys.

These trails were built and maintained primarily by volunteers who eventually formed the Whistler Off-Road Cycling Association (WORCA). To spend half an hour or an entire afternoon in the Emerald Forest or on trails such as Train Wreck, Trash, A River Runs Through It or Cut Yer Bars is to disappear into the variant greens of the coastal forest—its moss-covered ground, twisting root networks, gnarled ancient bark and old man's beard hanging from branches that filter the summer light. Wooden bridges and boardwalks were originally built to keep riders out of sensitive areas, but later grew into Dr. Seussian twists and turns, teeter-totters and bridges that, along with rocky climbs and descents, offer intense challenges of courage and balance to Whistler's summer gurus of gravity. Epic cross-country races such as the Cheakamus Challenge and Squamish's Test of Metal attract top riders from around the world.

To gauge the popularity of off-road cycling in Whistler one need only attend a Thursday-night Loonie Race put on by WORCA and a different local sponsor each week. Hundreds of helmeted worshippers of the wheel embark on a fun but competitively edged race that culminates with food and drink at the appointed finish. One of the reasons mountain biking is so widely popular is that the trails are free. A bike can cost anywhere from ten bucks at the bike swap or Re-Use-It Centre to more than the value of a decent car, but after the initial investment the sport is free except for the cost of a little maintenance. There's also less prep time for riding than for skiing as one can embark straight from home. During Whistler's long summer days it's easy to fit a ride in before, during or after work; or just as likely, to fit work in before, during or after a ride.

Even more surprising than the popularity of cross-country trail riding is the advent of downhill mountain biking on Whistler Mountain's bike park. Chairlifts that once sat idle in the summer now carry armour-clad bikers into the alpine. Downhill trails designed with ramps, jumps and other

Above: **Riders follow their bikes up the Fitzsimmons Chair in the Whistler Mountain Bike Park.** BM

Top: **A mountain biker traverses through alpine meadows north of Pemberton.** BM

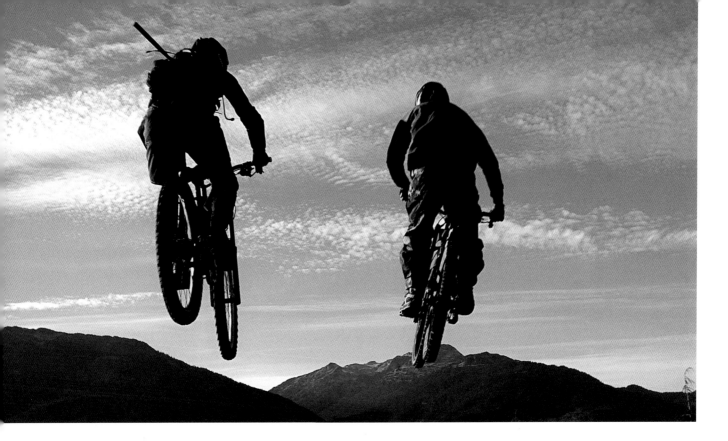

Two riders soar on their techno-steeds in the Whistler Mountain Bike Park. BM

features offer adrenaline junkies a run for their money back to the village. The day-skier parking lots are often full on summer days as young and not-so-young riders push their multi-thousand-dollar techno-steeds toward the base of the mountain. Riders come from all over the world to take biking camps and revel in the celebration of gravity and chunky tires. The Crankworx Freeride Mountain Bike Festival in July rivals the World Ski and Snowboard Festival with races, demonstrations, live music, film debuts and contests. At Harvest Huckfest, the world's best BMX and Freeriders (many of them from Whistler) fly high over the crowd with nothing more than a chunk of metal and two wheels for landing gear. Depending on one's perspective, the display may seem like a finely honed athletic trick or an act of pure lunacy.

Town planners in the early 1980s had the right idea in promoting summer recreation to make Whistler a successful year-round resort. They couldn't know at the time, of course, that in twenty years the most popular summer activity would take place on the ski runs and the forested mountainsides. Whistler's Skiers' Chapel may be ecumenical, but it still favours sports that worship at the temple of gravity.

Mountain-Biking Trails

The naming of mountain-biking trails in the valley has always been infused with humour and creativity to the point of approaching a local literary form. Here are a few favourites:

A River Runs Through It	Comfortably Numb
Whip Me, Snip Me	Kill Me, Thrill Me
Zoot Allures	Gee I Like Your Pants
Billy's Epic	Toads of the Short Forest
Bart's Dark Trail	The Torture Never Stops
Industrial Disease	Beaver Pass
Mel's Dilemma	Rick's Roost
Tunnel Vision	Bob's Rebob
Train Wreck	Ride Don't Slide

Left: **Hundreds of riders assemble at the start of the Cheakamus Challenge to ride the off-road course from Squamish to Whistler.** BM

Below: **A muddy but happy Sally Carmichael after the Cheakamus Challenge.** BM

Bottom: **Whistler's grassroots Loonie races host upwards of 300 riders every Thursday night, each paying a toonie for the ride and after party.** BM

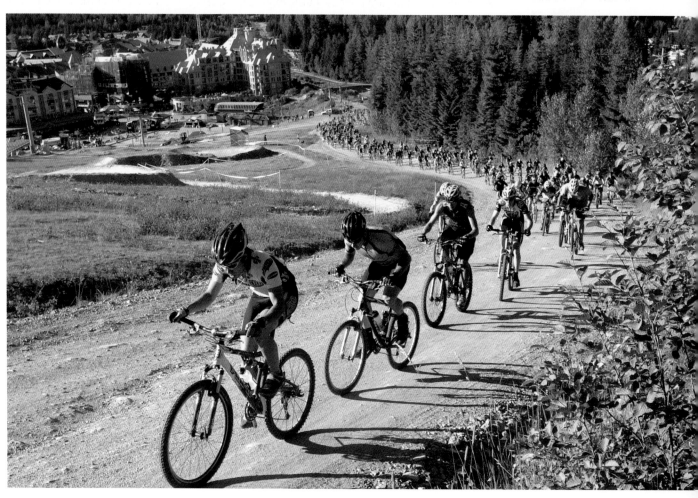

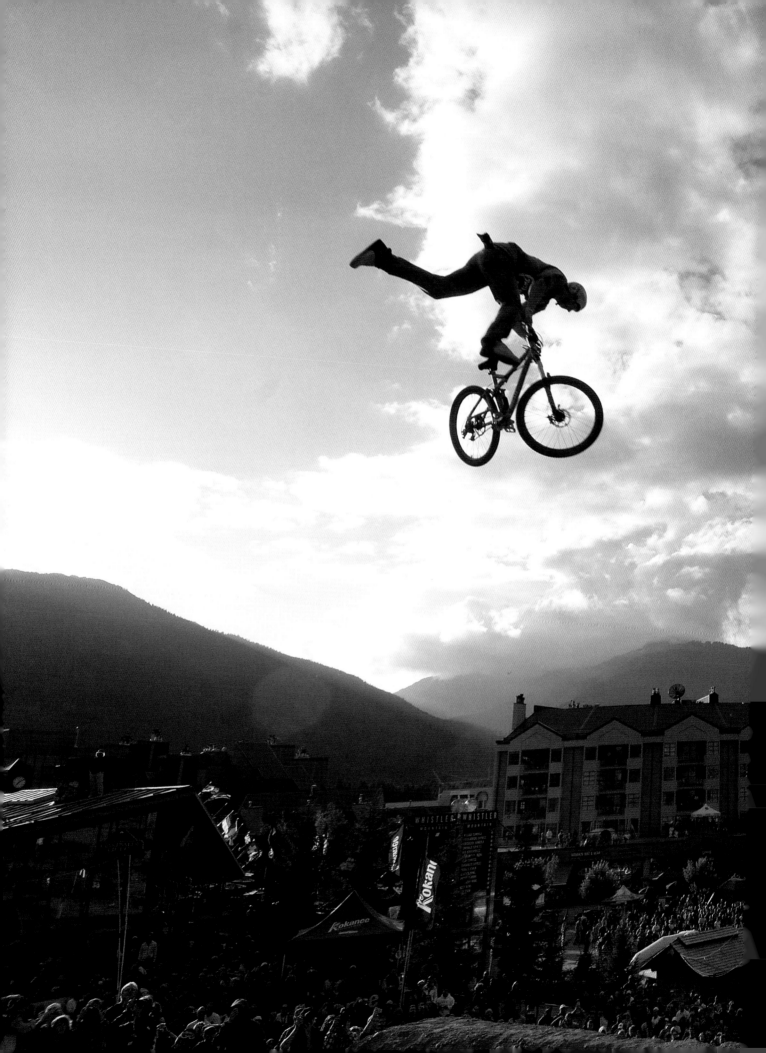

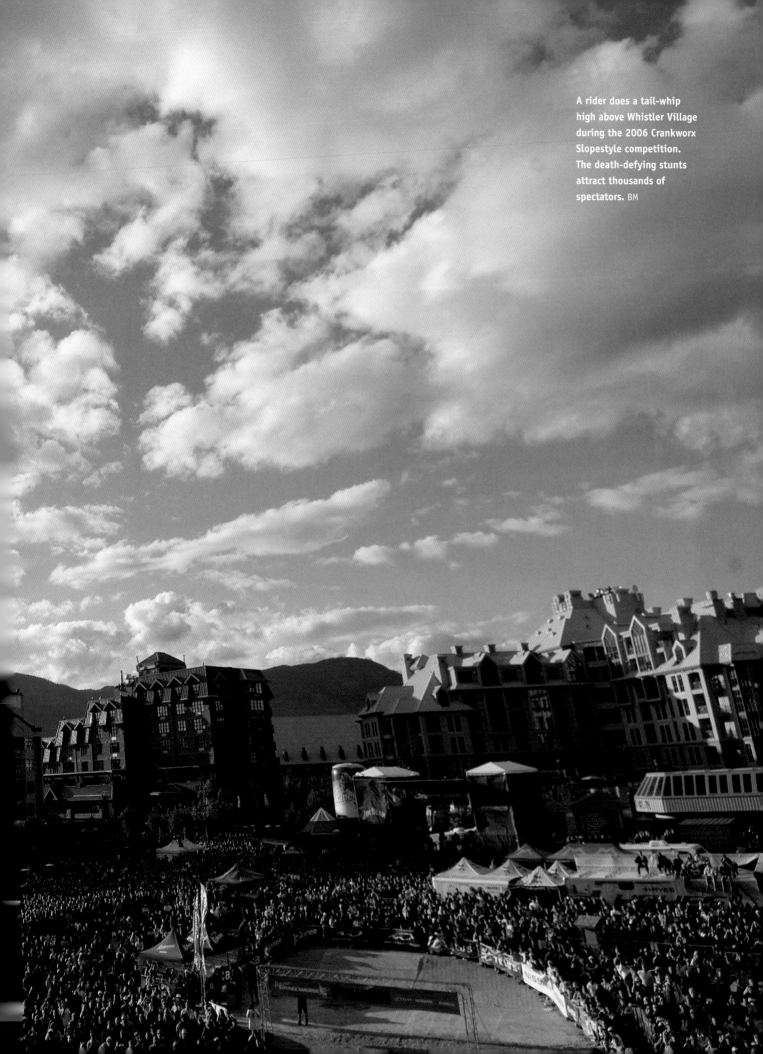

A rider does a tail-whip high above Whistler Village during the 2006 Crankworx Slopestyle competition. The death-defying stunts attract thousands of spectators. BM

Community

Building a lasting community in a place characterized by motion, whether up and down the mountains or in and out of town, is a challenging task. But community and culture have a way of

growing in spite of such difficulties. And the fabric of Whistler's community is woven from many cultural and geographic threads. Those originating from the West Coast tend to be in the minority. Quebecers and Ontarians, as though replicating their historic Lower and Upper Canada, have equal representation in Whistler. The French-Canadian element has long been an integral part of the Whistler community, to the extent that French is regularly spoken around town and there is both a Francophone school and a French immersion program for local students. There are farmers from Saskatchewan who gave up the John Deere combine for the Pisten Bully snow groomer, and Maritimers who may have come for the work but stayed for the lifestyle. There are Americans who dodged the draft or the dotcom frenzy and found solace in the Coast Mountains.

Above: **Mayor Ken Melamed talks with locals at a townhall meeting.** BM

Below: **Whistlerites go all out for Halloween.** BM

Of the droves of Australians who arrive every winter, a small percentage have stayed over the years to act as local down-under ambassadors along with their Kiwi neighbours. Japanese is heard spoken among families around town as commonly as French, and Myrtle Philip School boasts regular sushi days in lieu of the more traditional Canadian hot-dog day. And there are French, Swiss, Germans, Swedes, Dutch, Brits, South Africans, Peruvians, Mexicans, Brazilians, Argentinians, and so on who comprise Whistler's small but diverse community.

For all its international makeup, Whistler still has the close-knit feel of a small town. Locals bump into each other on a daily basis in the village, on the mountain, at Nesters Market or on the Valley Trail. And whenever a member of the community suffers a crisis, be it a house fire, a skiing accident or a loss of life, the people of Whistler pull together with the supportive spirit of a true mountain community. On a more day-to-day level, that spirit is expressed in other ways—through a shared gleam in the eye after a particularly good powder day, a collective breath of relief after a successful but exhausting holiday season, or a communal endorphin high after a gruelling mountain bike race.

The dynamic energy of the community also finds expression through an array of social organizations. The Association of Whistler Area Residents for the Environment (AWARE) has implemented environmental programs such as recycling and composting and helped preserve threatened ecosystems both within Whistler and in the broader region. The Whistler Arts Council has evolved from a volunteer-run community group into a professional arts organization producing festivals, events and programs throughout the year. There are sports clubs, church groups, a naturalists' society, Whistler Community Services, the WAG animal shelter, a social justice movement, the Waldorf Alta Lake School, a youth centre, two Rotary clubs and a variety of other groups.

From its inception as a resort municipality in 1975, the local government created a community plan that centralized business development in the village and kept condo and housing projects from sprawling unchecked throughout the valley and the corridor. While at times Whistler has been accused of being over-planned, locals and visitors alike would agree that it did a good job of avoiding the strip-mall sprawl characteristic of so many towns across North America. It also set for itself a limit—albeit one that has been raised on various occasions—to the amount of development that would ultimately occur in the valley.

While earlier planning efforts in the resort dealt with physical growth and infrastructure, the current focus is on matters social, environmental and economic—in short, dealing with the nearly built-out resort and the troubles that ail it. The document set to guide the community through its current challenges is the award-winning *Whistler 20/20 Comprehensive Sustainability Plan*. The key buzzword in the huge document is *sustainability*. While nobody's entirely sure what the euphemistic and malleable term really means, it's safe to say that it is the very antidote for everything unsustainable that has gone before. In terms of the environment, Whistler has become an early adopter of the Natural Step Framework devised by Dr. Karl-Henrik Robèrt, an approach that looks at the broad implications of a community's actions on the local and global environment.

Economically, Whistler's 20/20 document prescribes a diversified economy moving in the direction of education and the arts as well as other non-polluting small industries. Socially, Whistler's plan for 2020 and beyond envisions a community in which residents can not only enjoy the recreational and cultural amenities of the valley, but can afford to live in town. On the affordable-housing front, Whistler has already built or overseen a number of projects both for rental by seasonal workers and for purchase by long-term residents. While an *affordable* house in Whistler will still run to half a million dollars or more, townhouses and condominium units have proven to be within reach of locals and young families. But the demand for such housing still far outstrips the supply, and many young families continue to leave town.

Every Thanksgiving weekend, the Alta Lake School hosts the Harvest Soup Contest at the Farmers' Market. TK

Culture

"Locals know Whistler is more than just a ski town." This slogan from the sixth annual Whistler Film Festival offers a surprisingly insightful view of Whistler in the early twenty-first century. It hints at a possible broader future for the town and at the same time presents a challenge to the community.

Whistler's arts and cultural scene has grown considerably since the early 1980s. The Whistler Arts Council, with Doti Niedermayer at the helm, has evolved into a professional arts organization that puts on a full calendar of events including an annual performance series at Millennium Place Theatre, the Whistler Children's Art Festival, the summer ArtWalk featuring Sea-to-Sky artists in non-traditional gallery spaces throughout the village, Celebration 2010, the ARTrageous art exhibition and party, Whistler Art Workshops on the Lake, and a host of other events. The Whistler Film Festival debuts Canadian and international films every December and offers the largest Canadian prize for best new Canadian feature film with the $15,000 Philip Borsos award. The Vicious Circle Writers Group hosts the Whistler Writers Festival every September featuring workshops, a writer-in-residence program at the Alta Lake Station, and readings from some of Canada's finest authors.

Prior to the 2010 Olympics, funding programs such as Arts Now arranged for Whistler to feature local, Canadian and international performers during its three-week Celebration 2010 festival every February. Local filmmakers embarked on a collaboration with the museum to interview a broad variety of local citizens and chronicle the town's history. Photography exhibits and competitions, writers' events and dance shows also received support from Arts Now.

Below: **Renowned Canadian filmmaker Norman Jewison spoke to a packed house during the 2006 Whistler Film Festival.** BM

Below right: **The annual ARTrageous art show and party brings out Whistler's creativity in all of its colourful splendour.** BM

Bottom: **Artist Karen Love surrounded by landscapes of the Pemberton valley in her Pemberton studio.** TK

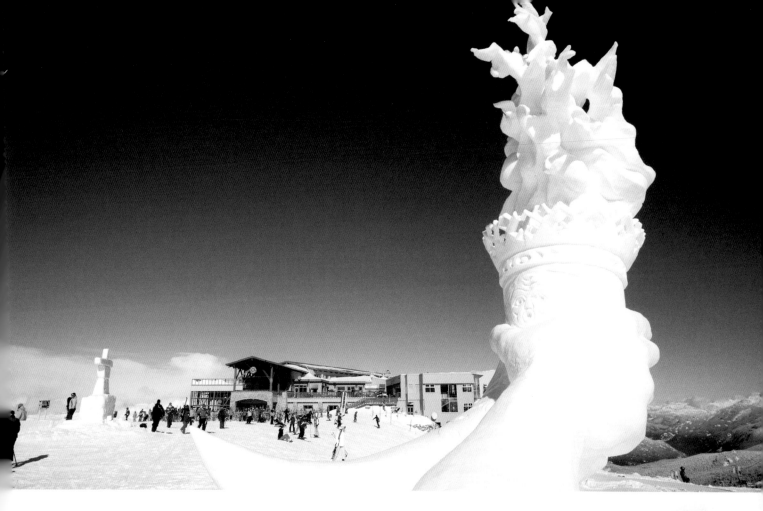

2010 Olympic Winter Games

Believing that athletic competition pleased the spirits of the dead, the ancient Greeks held the Olympic Games every four years as part of a religious festival to honour the gods. It's not surprising then that Whistler, a community that practises sports on a daily basis and with a religious devotion of its own, was finally named to host the Games. And as in ancient times, culture and arts were promised a prominent role in the twenty-first Winter Olympics and Paralympics.

But somewhere along the way, the Olympics have become much more than arts and athletics; they've become big business as well. Since the Garibaldi Olympic Development Association first submitted its bid in 1962, the Olympics have changed perhaps as much as the town of Whistler itself. The 1964 Innsbruck Olympics featured thirty-four sporting events and cost $20 million to put on. The Vancouver 2010 Games planned for eighty-six sporting events and an overall budget of $2.1 billion, not including a nearly one-billion-dollar upgrade to the Sea-to-Sky highway. But the Olympics aren't just about money going *out*. The international TV rights packaged for both the 2010 and 2012 Games sold for $2.2 billion. Sponsorship programs bring in close to a billion dollars in revenue, and the names Olympic™, 2010™ and Celebration 2010™ are all copyrighted and carefully guarded as part of the Olympic Brand.

Along with a large amount of money comes a large amount of hype. The moment Vancouver/Whistler's bid was declared successful in 2003, the Olympic public-relations machine rolled into town with bells and whistles, grants and incentives, advice and directives. It brought with it enough potential opportunities to whip a town into a feeding frenzy, and enough outside forces—both political and economic—to make local decision-making an exercise in optics.

Still, there's no denying that much can be gained by hosting the Winter Games. Whistler and Vancouver's association with the Olympic and Paralympic names will carry marketing clout for many years to come; small businesses positioned themselves to profit from the huge influx of

Above: **John Hewson can almost taste the 2010 Games as he celebrates the Turin 2006 closing ceremonies with hundreds of others in Whistler Village.** TK

Top: **One of the incredible creations of Peter Vogelaar and his Canadian Snow Sculpture Team at the annual competition on Whistler Mountain.** TK

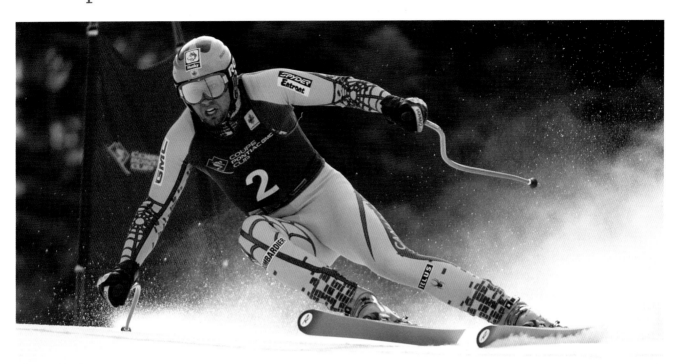

Above: **Local Olympic hopeful Britt Janyk celebrates her win in the 2006 Canadian Alpine Downhill Championship at Whistler.** BM

Top: **Rising Canadian star Manuel Osborne-Paradis at the Canadian Alpine Championships in 2007.** BM

visitors; local arts and culture organizations (not only in the Sea-to-Sky region but throughout the province and country) captured grants and were encouraged to develop their programs to a level fit for international audiences; and of course there was no shortage of construction-project announcements.

When the successful bid was confirmed in 2003, Whistler was just emerging from thirty years of intensive development. The town was close to its planned maximum build-out, and visitor numbers and occupancy rates were on a downward trend. With the winning bid for the 2010 Games, however, any chance of slowing down was instantly vanquished by the bright Olympic torch on the horizon. Physical construction was once again the name of the game with the need to build athletes' housing, event facilities and an upgraded four-lane highway.

A benefit attributable to the Olympics was the bringing together of distinct cultures within the Sea-to-Sky area. While on a day-to-day basis the differences between towns within a region can seem vast, an international spotlight such as the Olympics allows regional neighbours to see what they have in common and begin to build bridges between communities. The most striking example of this was the construction of the Squamish Lil'wat Cultural Centre in Whistler Village, showcasing the culture and history of the Squamish and Lil'wat peoples. The project made Whistler locals and visitors more aware of the history and culture of their First Nations neighbours on whose traditional lands the Olympics would be held. Connected with the Cultural Centre is the Sea to Sky Cultural Journey, a series of route markers, road signs and pullouts between Vancouver and Whistler that explore the landscape through Salish myth and culture.

But while culture forms an important part of the modern Games, the primary focus is still on sports. Canada secured a good position to do well in Whistler and Vancouver not only because it is a winter-sport nation, but because the federal government made a concerted effort to financially support its athletes through the $110 million *Own the Podium* program. In the years leading up to

2010, the men's and women's Alpine Ski Teams rose to the top of the World Cup circuit. Whistler skiers such as Manuel Osborne-Paradis, Michael Janyk and Britt Janyk, as well as other top Canadians Brigitte Acton, Allison Forsyth, François Bourque and Stefan Guay, all worked themselves into good position to bring home Olympic medals on the slopes of Whistler.

The Whistler Index

Amount Alfred Barnfield paid for 158 acres at north end of Alta Lake in 1912:	$158
Amount lots in MDC (Mountain Development Corporation—also known as Mothers, Dogs & Children) adjacent to the Barnfield property sold for in 1980:	$33,000
Amount a modest home or building lot on Easy Street in MDC sells for in 2007:	$900,000
Average price of skis at Whistler Re-Use-it Centre in winter 2007:	$40
Average price of skis at Whistler Village retail shop in 2007:	$681.28
Amount paid to Charlie Doyle for coining phrase "Sea to Sky" for Chamber of Commerce region-naming contest in early 1980s:	$1000
Number of sushi restaurants in Whistler:	8
Number of sushi days at Myrtle Philip Community School per year:	36
Cost of lift ticket at Whistler Mountain in 1966:	$4
Cost of Whistler/Blackcomb lift ticket in 2007:	$79
Percentage change in cost after adjustment for inflation:	+231
Percentage change in number of lifts over same period:	+1166
Number of retail shops in Whistler Village:	200+
Number of pubs, bars, lounges and restaurants in Village:	90+
Length of horseshoe-shaped Main Street in Village:	441 m
Lift riding time from Creekside to Roundhouse in 1966:	31 min
Lift riding time from Creekside to Roundhouse in 2007:	14 min, 47 secs
Length of unsupported span on Peak to Peak Gondola linking Whistler and Blackcomb mountains:	3.024 km
Total revenue generated from mountain-biking visits to Whistler in 2006:	$23.1M
Rounds of golf played in Whistler in 2006:	72,622
Cost of building Andy Munster's 500-sq.-ft. squatter's cabin next to Fitzsimmons Creek near village in 1974:	$50
Cost of Akasha, a 5000-sq.-ft. custom home he built and sold near village in 2000:	$7.9 million
Population of Whistler in 1976:	531
Population of Whistler in 1976 that lived in squatters' cabins:	60
Tons of waste produced in Whistler in March 2006:	1,983
Tons of waste recycled or composted in March 2006:	824
Maximum fine for swearing in Whistler village:	$2,000

Skier Kristopher Cormier catches some late afternoon turns above Zhiggy's Meadow on Blackcomb with Whistler and the Musical Bumps in the background. TK

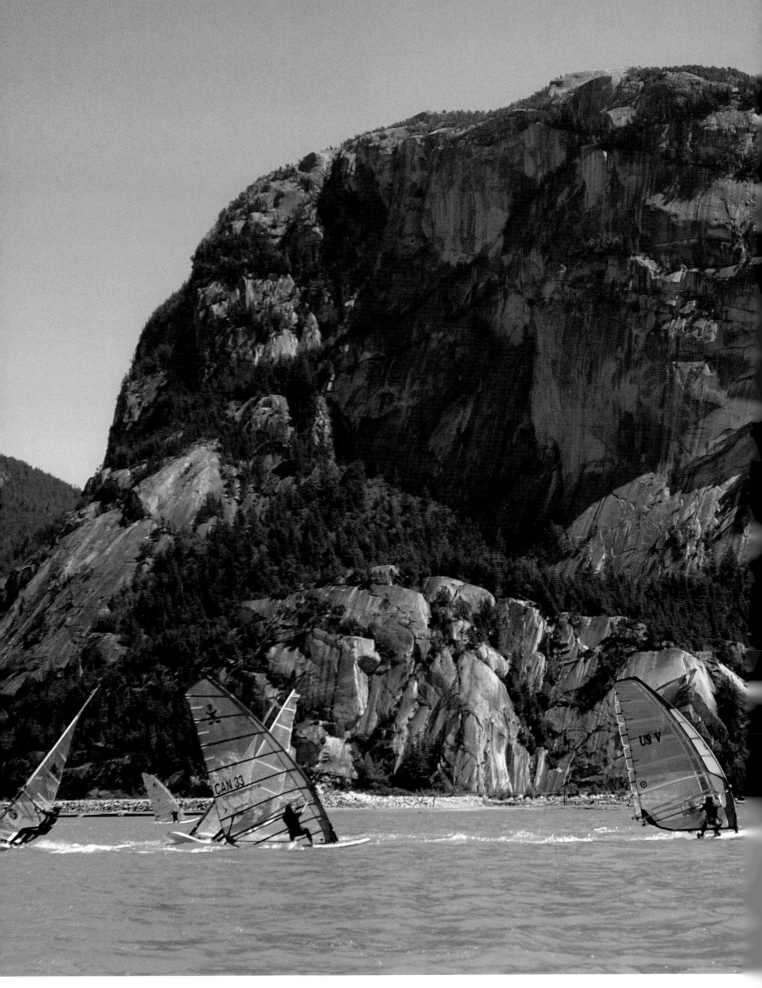

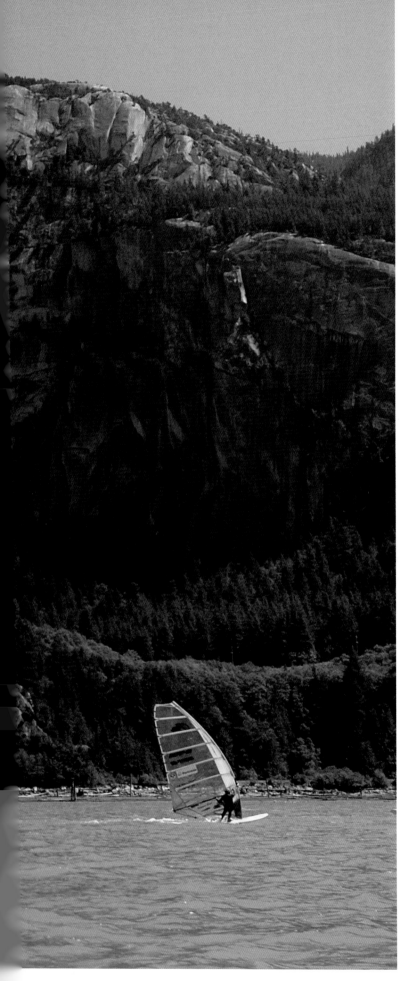

Squamish

*I*T'S NOT ONLY WHISTLER'S SOUTHERN FLOWING WATERS THAT CRASH DOWN THE CHEAKAMUS CANYON TO THE SQUAMISH VALLEY. THE ELAHO, SQUAMISH, CHEEKYE, MAMQUAM AND STAWAMUS RIVERS DRAIN AN ENTIRE COAST MOUNTAIN WATERSHED AND FLOW TOGETHER INTO HOWE SOUND FIFTY KILOMETRES SOUTH OF WHISTLER. WHERE WHISTLER IS THE DIVIDE, SQUAMISH IS THE CONVERGENCE.

To stand in downtown Squamish on a sunny spring day is to witness the valley at its most spectacular. The bottom half of the world is green with budding leaves and darker evergreens lit by the shimmering sound, while the surrounding peaks are still clothed in brilliant white. This is truly where the sea meets the sky; where the region's name is distilled in one place. The natural power of the surroundings is expressed not only in the winds that the town derives its Coast *Salishan* name from, but in the water

Top of the Pass

Previous pages: **Windsurfers head out on Howe Sound beneath the Stawamus Chief for the North American Formula Championships.** BM

itself, which has caused serious flooding on many occasions in Squamish's history.

The rivers are also the cause of the fertile valley soil which has supported huge stands of valley-bottom timber logged long ago, rich farmland and, more recently, the shaky ground of rising real estate values. The expansive valley is home to a string of distinct but connected communities from Stawamus Village, Valley Cliff and downtown Squamish in the south, to Dentville, Mamquam, Garibaldi Highlands, Brackendale and the Upper Squamish and Paradise Valleys in the north.

Walking south on Squamish's Cleveland Avenue, one eventually passes the Squamish Pavilion with its displays of logging heritage and First Nations sculptures, before arriving at the northern reaches of the estuary. This is where many of Squamish's first settlers arrived on the steamships that connected the town to Vancouver for over sixty years. While many of the early pioneers settled farther north at Brackendale, the downtown area initially grew into a picturesque mix of farms, houses and businesses. The cows, it is said, would graze in the estuary at low tide and occupy the wooden sidewalks of Cleveland Avenue at high tide.

Over a century's worth of economic waves have flowed through Squamish since land was first pre-empted in town in 1874: the thriving hop farms of the turn of the century; horse- and later steam-, rail- and truck-logging; the PGE rail line and BC Rail maintenance shops; the International Forest Products lumber mill; and the Nexen chemical plant that made sulphuric acid for the Woodfibre pulp mill across the sound. All of these industries were intimately connected to the Squamish waterfront, linked to the outside world at first by Mashiter's Landing, later a government wharf, and eventually through Squamish Terminals Ltd.

But while the mills and the railway shops have shut down and the logs and other resources going to port primarily originate from points farther north, Squamish is by no means in decline. The buzz of activity and growth is now centred around the allure of recreational pursuits such as mountain biking, rock climbing and windsurfing, the construction of the private Quest University above Garibaldi Highlands, housing growth fuelled by those escaping Vancouver's and Whistler's high-priced real estate markets, and the ever-present speculators who have roamed the valley since the first steamship landed.

Directly across the Mamquam Blind Channel, on the eastern shore of the sound, sits the Stawamus First Nations village with the Stawamus Chief towering behind. A dugout cedar war canoe leans against a battered shed and a totem pole stands at the water's edge looking out past the Squamish Terminals into the sound. Carved by Harold Baker, the pole was erected to welcome the visiting First Nations Tribal Journey canoes that

Above: **The Royal Hudson at the Squamish Railway Museum. The old steam locomotive is back on the track after a recent refit.** BM

Top: **The BC Museum of Mining is a testament to Britannia's copper mining history.** TK

paddled down the west coast in 2001, their first visit in over a hundred years.

"This place is one of the oldest settlements," says Harold's father, seventy-year-old Robert (Bob) Baker, pointing out his window toward the water. "Archaeologists had a little dig and found that the people were here thousands of years ago. There were seven longhouses here, each one for a different family or clan. The longhouse was our church, our kitchen and our dwelling. The stories were all around that place." He remembers the last longhouse still standing in 1939 or 1940. Many of his people had moved to the Catholic mission in North Vancouver near Lonsdale, and the longhouses in Squamish were replaced by tiny homes built by Japanese contractors.

At the age of seven or eight, Baker was sent to a residential school in Alert Bay, where nobody spoke his language. He married Pauline Bee from Turner Island before making his way back to

Left: **The Squamish Estuary, with the Stawamus Chief as its backdrop, is a rich habitat for both birds and birdwatchers.** BM

Below: **The two most prominent features towering above Squamish and Howe Sound are Mount Garibaldi (left) and the Stawamus Chief.** TK

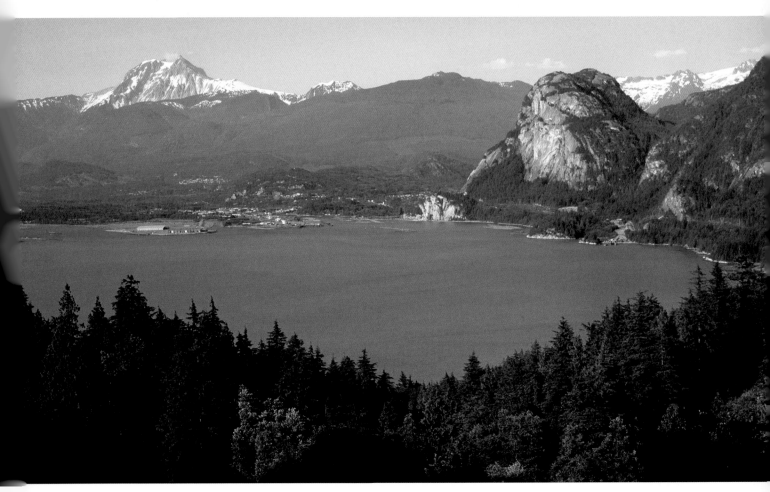

Top of the Pass

Right: **The impressive Squamish Adventure Centre stands beside the Sea-to-Sky Highway at the main entrance to Squamish.** TK

Below: **Inside the Adventure Centre, Squamish's logging history is carved into twenty-eight wooden pages.** BM

Bottom: **Sunset over Howe Sound.** BM

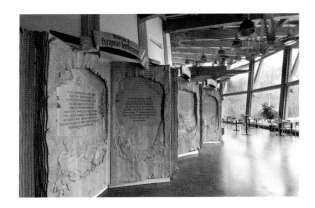

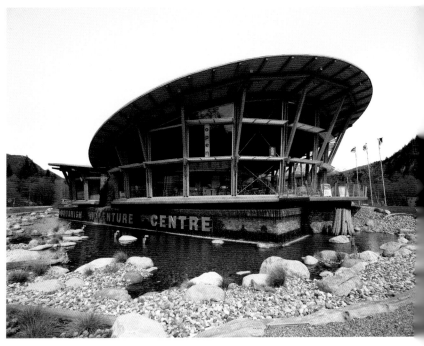

104 Whistler and the Sea-to-Sky Country

Squamish. "I logged and fished to support my family," he says. "I spent forty years out on the ocean."

Baker and his second wife Shirley still live largely off the land and the sea, canning their own fish and hunting. "Before we could hunt ducks and fish when we want," he says. "Now we can't shoot here. They say there's too many people. Same with the rivers—you can only fish at certain times and you need a licence."

Despite the lasting impact of residential schools and conflicts over land use, the Squamish culture continues to assert itself. A few houses away, Robert's son Harold carves in his studio as a fire burns in the woodstove. "A bunch of us grew up carving together," Harold says. "Instead of sitting around doing nothing we'd get together with Larry, Floyd's father, and carve." Floyd Joseph is another respected Squamish artist whose prints and carvings can be found in many collections.

Since completing the pole at the village shoreline, Harold has gone onto larger works, extending his shop whenever necessary. His carvings have gone to Japan, Switzerland, Germany and the United States.

Just north of the Stawamus Reserve, at the intersection of the Sea-to-Sky Highway and the entrance to downtown Squamish, sits the Squamish Adventure Centre. The impressive new building with its circular sloped roof lines, high windows and flowing waterfall is an emblem of the new Squamish. It sits on Loggers' Lane, a road built over the old rail line that originally delivered logs from Garibaldi Highlands to the waterfront.

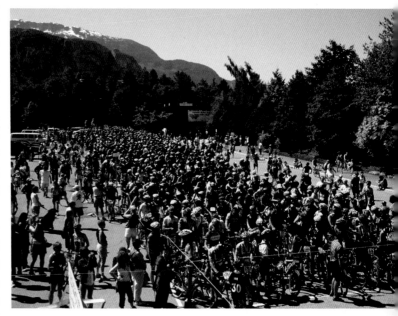

Along with offices, tourist information and a cafeteria, the Centre houses a twenty-eight-page carved wooden book of the Squamish Valley's logging history. The impressive four-by-seven-foot Douglas fir pages chronicle the early hand- and horse-logging, the move to steam donkeys and railway lines, and finally to high-lead operations with truck hauling—a carved record of a way of life that gave Squamish its shape and its wealth over the last hundred years.

The Test of Metal is the featured event at the Squamish Mountain Bike Festival. Every year the race's 800 available spots are snapped up months ahead of time in a matter of hours. TK

In the face of a challenging transition period, Squamish is also displaying a new vibrant and diverse energy. The focus on outdoor recreation has brought a younger demographic to the town: rock climbers and kayakers, windsurfers and mountain bikers. Squamish is full of people with things on the go. The close proximity to Vancouver and Whistler allows them to stay connected to both economies without being wholly dependent upon either. Mountain biking and the Test of Metal Mountain Bike Race brought in $1.7 million to the Squamish area in 2006. Other events such as the Mountain Film Festival, Wild at Art and Climbers Art create a buzz in the town that enriches both the local culture and the economy.

The kind of town Squamish grows into over the next twenty or thirty years will have a lot to do with the negotiations that happen now between local residents and those bringing new development to town. There are still serious flood issues in the Squamish Valley that must be considered in terms of any future development. In a flat valley bottom where so many rivers converge, building density is not only a matter of aesthetics, but of how much development a low-lying silt delta can support. While the people of Squamish work toward a vision of the town that maintains the quality of life that drew them here, the landscape itself might well have the final say in the shape and size of human habitation in the valley.

Top of the Pass

When he's not tearing around on his snowmobile, Curly Crosson has plenty of stories to tell about the old logging days in Brackendale. BM

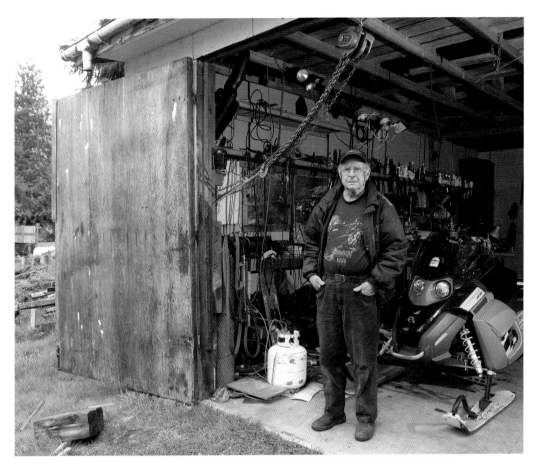

Brackendale

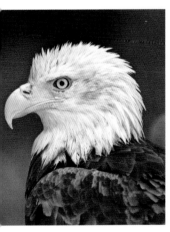

Froslev and Len Goldsmith were instrumental in establishing the Brackendale Eagle Reserve. Injured eagles are nursed back to health at the Eagle Aid Station adjacent to the gallery. BM

Further up the valley in Brackendale, the old stone fireplace and chimney from the Bracken Arms Hotel still stands next to Government Road while excavators prepare the surrounding land for a new batch of townhouses. Despite the recent growth, the area maintains much of its rural small-town feel. The general store sits next to the post office and bistro on Government Road while a few blocks away wintering bald eagles perch on tall cottonwoods next to the Squamish River.

Carl "Curly" Crosson, a retired logger and active snowmobiler at eighty-five years of age, built one of the first two houses on Depot Road in Brackendale. "Squamish and Brackendale were very separated then," Crosson says. "We'd go into Squamish for shopping on Saturday, then go to the beer parlour and wait til ten o'clock for the bus back. The doctor and the druggist were in the same building. If you wanted to take home a mickey of whiskey you had to get a prescription from the doctor and then the druggist would hand it to you out of the top window."

Crosson's work took him up and down the entire corridor. He built a cabin in the logging camp near Mons at Alta Lake. "Charlie Lundstrom would get in before we logged. He'd get cedar poles out by horse. The horse would pull and he'd stand on the log and ride it around. It was a well-trained horse." On Saturday nights they'd drive the gravel truck around to Rainbow Lodge for the dances, and sometimes take a tugboat over to Hillcrest Lodge. "That Alex Philip was an awful kidder. He liked to get that place full of people. During the war sometimes there were eighty-five women and three men at those dances at Rainbow."

Up in the Cheakamus valley, Crosson recalls working with Alvie Andrews, the Squamish First Nations chief at the time. "I was operating the machine and they called it chief engineer. He'd say, 'Hi chief,' and I'd say, 'Hi chief.' He was hungry one day and said, 'Mind if I take a few hours and

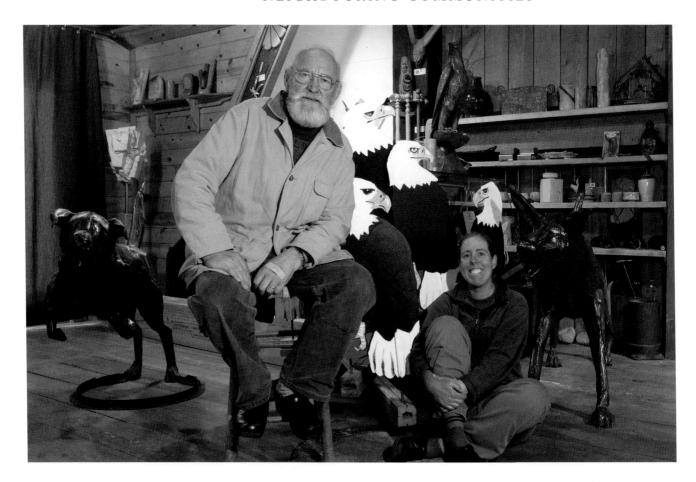

go get some grub?' He was back two hours later with a deer."

A couple of hundred metres from Curly Crosson's house sits the Brackendale Art Gallery on Government Road. When it opened, the barn-shaped gallery and café injected a whole new sense of vigour into Brackendale. Owner Thor Froslev bought the land with a thousand-dollar down payment and then began construction on May 15, 1972. "The artists were all helping make it happen," he recalls. "Seeing this anthill full of creators was all a bit strange at first for the people of Brackendale. They were hippies but they were also musicians, painters, architects, carpenters, engineers."

The Brackendale Art Gallery opened in 1973, but like most creative projects, it continued to grow and evolve. Over the years Froslev has added metal and wood workshops, studios, expanded the kitchen, built a theatre for musical and theatrical performances, and added a chapel for every-thing from weddings and baptisms to memorials and wakes. The outside wall of the theatre is covered in cast cement masks. "If you donate to a theatre you normally get a brass plate," Froslev explains. "We do these masks." The visages include musicians and entertainers such as Valdy, Jim Byrnes and Shari Ulrich, environmentalists David Suzuki and Paul Watson, artist Robert Bateman, and a host of local supporters.

As it was originally envisioned, the BAG continues to draw creative people together. The gallery itself displays art by West Coast artists. The Natural World Lecture Series brings in speakers including artists, naturalists and biologists, and the artist-in-residence program offers visiting artists a space in which to create.

Getting Brackendale known on the map as the winter home of the bald eagle was another plan conceived of by Froslev and his friend Len Goldsmith. On January 9, 1994, the annual Bracken-dale Winter Eagle Count recorded the historic number of 3,769 eagles. "Up until then, the Haines,

The Brackendale Art Gallery has always drawn artists from far and wide. Its creator, Thor Froslev, sits with sculptor and painter Christina Nick who divides her time between Brackendale, Whistler and southern France. BM

Top of the Pass

Alaska, record was 3,495," Froslev says. "We had more and so we ran it up the flagpole. Eagles became a big part of everyone's lives."

Where Froslev and Goldsmith were instrumental was in creating an eagle reserve to protect winter feeding habitat so that the eagles would continue to return in such large numbers. "We set out to map the area, 1,100 acres to be set aside, and sent it in to the roundtable discussion," Froslev says. In 1996, after much petitioning, Premier Glen Clark announced that the Brackendale Eagle Reserve was officially protected. "We asked him if the word 'reserve' could be changed to 'sanctuary' but the bureaucratic channels wouldn't allow for that," Thor recalls. "But what he did do was get Class-A provincial park status and added another four hundred acres!"

Hundreds of eagles can easily be seen roosting in the old cottonwoods and feeding along the sandbars of the Squamish River. Aside from a guided tour, the eagle-viewing dyke just south of Brackendale at Eagle Run is one of the best places to watch without disturbing the feeding habits of the birds. The Brackendale Art Gallery recently built the Eagle Aid Station where sick or injured birds are nursed back to health by the volunteer efforts of local veterinarians. Attracting the artists and the eagle watchers to Brackendale took a creative vision and a recognition of the natural beauty already inherent in the place. It's a truth that applies not only to this gallery and to Brackendale, but to the whole Squamish Valley.

Tadahiro Sato rappels down Starcheck in the Cheakamus canyon between Squamish and Whistler. TK

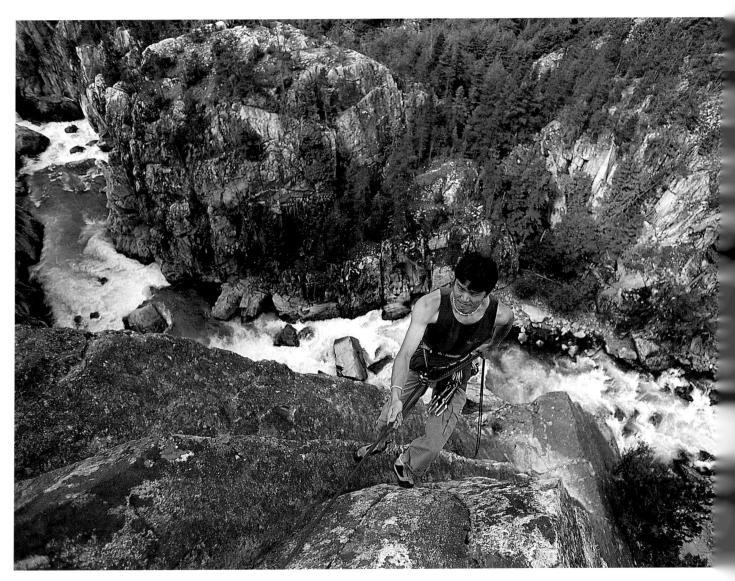

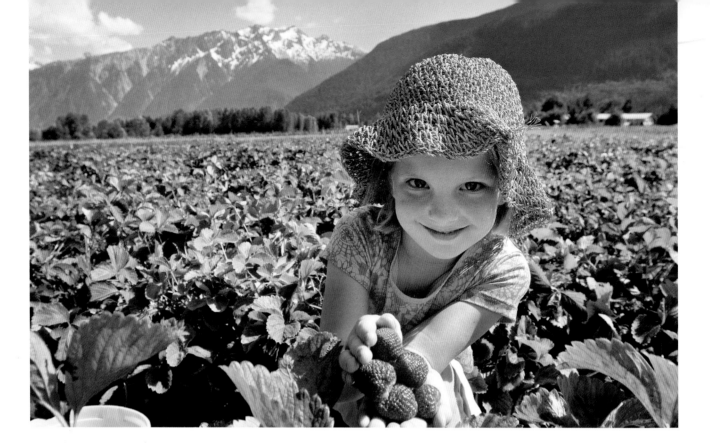

Pemberton

Pemberton is only thirty-five kilometres north of Whistler and yet it is an entirely different world. The Sea-to-Sky Highway follows the Green River as it leaves Green Lake and descends from 2,100 feet in elevation to just under 700 feet at the village of Pemberton. The idyllic rural valley juts for 100 kilometres to the northwest, protected by steep mountains on either side. At Pemberton, some of the Pacific storms have already been caught up in the peaks of the Coast Mountains, leaving the valley with a hint of the interior's drier climate. But whatever precipitation was trapped by coastal peaks eventually finds its way back to the valley floor. The meandering and flood-prone Lillooet River is the source of some of the richest glacial soils in the province. And while Pemberton has seen many changes since the Cariboo Gold Rush first brought settlers to the area in the late 1850s, it has remained primarily a rich agricultural producer.

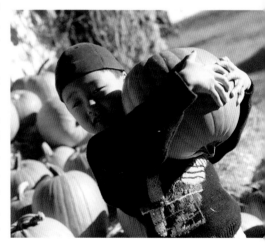

While farms still dominate the landscape of the Upper Pemberton Valley, the village itself has undergone tremendous change over the past couple of decades. The two blocks of Frontier Street next to the railroad tracks with the Pemberton Hotel at the south end are no longer the extent of the town. Single-family homes and townhouses have burgeoned from the village area toward the junction with the Sea-to-Sky Highway, housing hundreds of new residents—many with a Pemberton address and a Whistler job. Pemberton rushed into the new millennium as the fastest growing town in Canada. While growth has begun to level off, the community now finds itself home to both a farming-related and a tourism-and-recreation-related identity.

But Pemberton is no stranger to sudden bursts of growth fuelled by a new economy. The original town, known as "Port Pemberton," sprang into existence when Lillooet Lake and the portage to Anderson Lake became the main route to the Cariboo goldfields. The cost of packing food along the trail was exorbitant, and the ability to supply the travellers with produce en route brought rewards to the newly settled farmers to the tune of a dollar for a cucumber and seventy-five

Rory Ross-Kelly shows off the bountiful strawberry harvest at McEwan's Farm in the Pemberton Valley. BM

Kota Sukuda hefts a pumpkin at North Arm Farm. TK

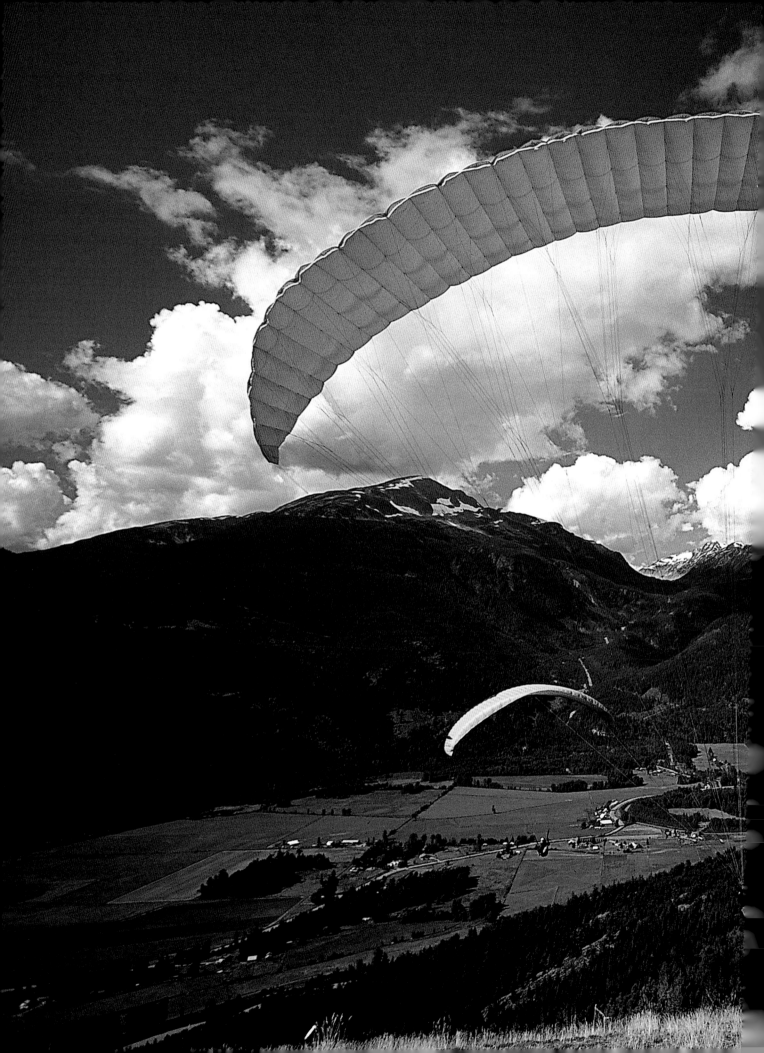

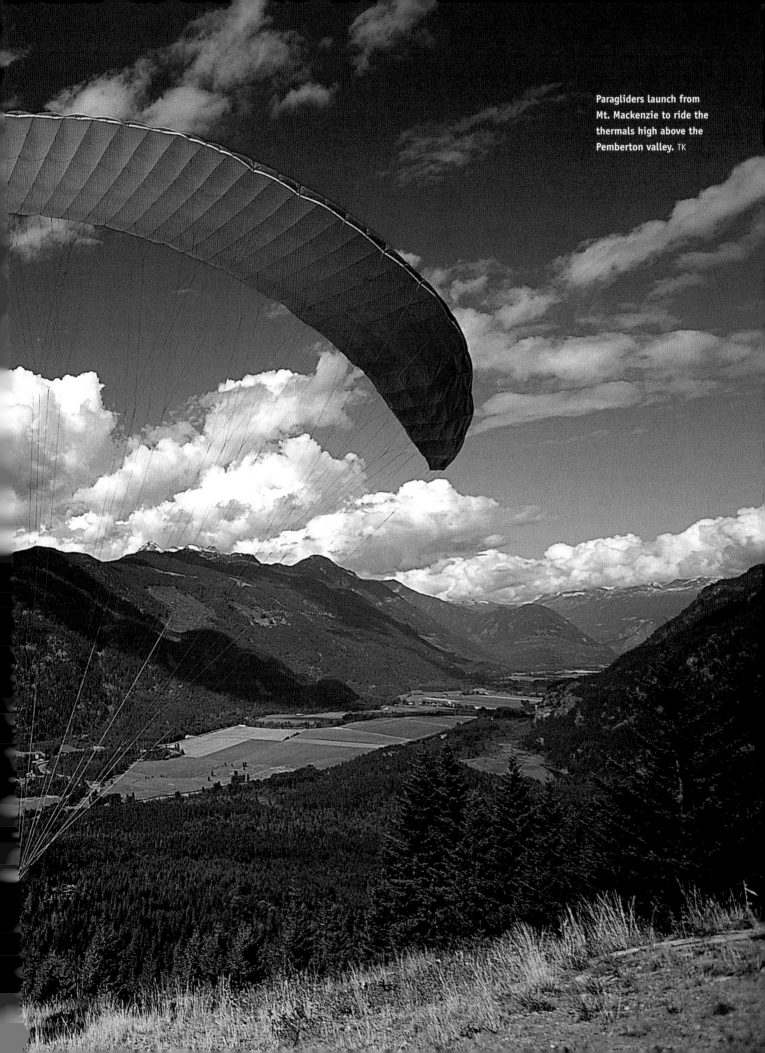

Paragliders launch from Mt. Mackenzie to ride the thermals high above the Pemberton valley. TK

Top of the Pass

Above: **Slow Food Cycle Sunday draws over a thousand riders to farms and food producers along the Pemberton Meadows Road.** TK

Below: **Angela Shoniker enjoys the view on Pemberton's Overnight Sensation trail.** BM

cents for a tomato—in 1859 prices! Located closer to Lillooet Lake than the current town, Port Pemberton boomed for three or four years until the main route to the Cariboo was switched to the Fraser Valley. By 1882 only a single person was listed as a resident of the Pemberton Valley.

The settlers who returned in the early twentieth century to form the community of Pemberton were hard-working farmers. They made arduous journeys into the valley with a few supplies and farm implements either up the trail from Squamish, along the deteriorating gold-rush route from Harrison Lake, or down from Lillooet through Seton Portage. Pemberton proved not to be a stopover en route to somewhere else, but a destination at the end of the road. While speculators bought up large tracts of the valley in the 1890s in anticipation of a rail route, the settlers recognized that Pemberton had riches of its own: lumber to build homes and barns, soil to support an abundance of crops and animals, and a beautiful pastoral setting in which to raise a family. Many of the earliest pioneering farm families—the Ronaynes, Millers, Rosses and Fougbergs among them—are still thriving in the valley today.

Pemberton Station on the PGE rail line brought new settlers, railway jobs and the beginnings

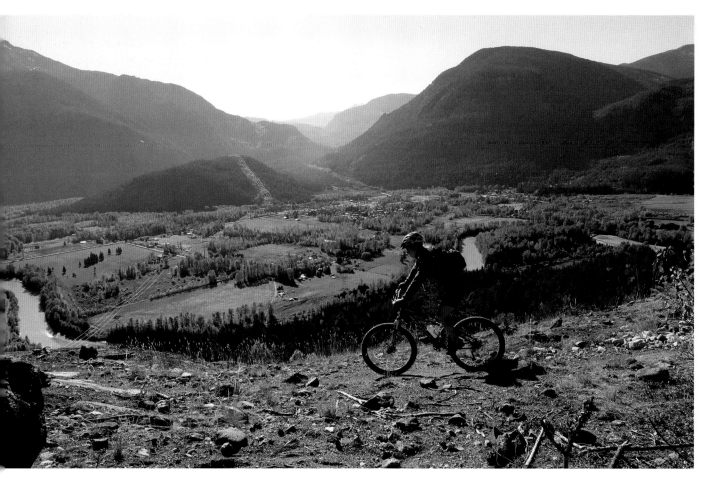

of the mechanized logging industry that would dominate Pemberton's economy in the second half of the twentieth century. But farming remained the backbone of the community. The relative isolation of the valley with its steep mountain walls allowed farmers to grow virus-free seed potatoes, which gained fame across North America and became the No. 1 cash crop for the valley. Again, Pemberton proved to be a place to dig one's heels in and survive on the natural riches rather than a passageway to somewhere else.

Jan and Hugh Naylor moved to Pemberton from Vancouver in 1968. While raising their two children, the young couple worked at various jobs, bought cows and chickens, and grew a range of crops, eventually settling on strawberries. Disappointed that there was no library in the village, Jan got to work starting one. The library was run primarily by volunteers in the early years out of a small building on the edge of town, before being included as a part of the new community centre.

While the Naylors were part of a small influx of new people to the valley in the late sixties, they were also connected to the older farming families in their desire to keep the agricultural character of the valley. The Agricultural Land Reserve Act brought in by the provincial NDP in the early seventies was a big part of it, Hugh recalls: "All of a sudden a whole bunch of people were ready to subdivide. There was the Kia Ora Trailer Park, and there would have been lots more. That [ALR] was a dramatic turning point in Pemberton. It established the value of agricultural land."

A huge amount of development did eventually spill over from Whistler to Pemberton, but the ALR restrictions kept new subdivisions close to the village and Highway 99 rather than sprawling throughout the farmland. The large influx of people in the late nineties, however, did put pressure on a way of life in the Pemberton Valley that had evolved with minimal interference for many

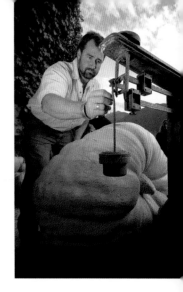

Above: **Farmer, ski patroller and Pemberton mayor Jordan Sturdy weighs a champion pumpkin at North Arm Farm.** BM

Below: **Bruce and Brenda Miller's Across the Creek Organic Farm supplies fresh produce to residents and restaurants in the Sea-to-Sky corridor.** BM

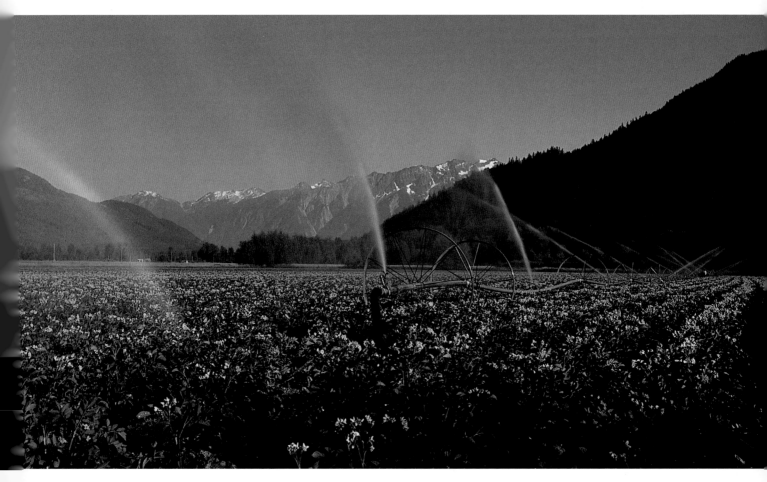

A classic Pemberton view from the Slow Food Cycle. TK

decades. "Some in Pemberton didn't want trespassers," Hugh says. "All of a sudden so many people were using the old trails." But while pioneering attitudes run deep in a community, he points out that one can't generalize: local history books tell of pioneer Jack Ronayne leading hikes up to Tenquille Lake in the 1920s, reciting Shakespearean poetry as he went.

When issues over trail use erupted in the community in the late 1990s, the Naylors and others formed the Pemberton Valley Trails Association. The Trails Association attained an annual budget to build and improve trails and trail access so that people could increasingly experience the beauty of the Pemberton valley on bike, foot or horseback.

Originally from Australia via Whistler, Lisa Richardson is another Pembertonian interested in blurring the boundaries between different communities within the Pemberton Valley. As a free-lance writer, ski instructor and rock climber in her thirties, she is a perfect example of a newer Pemberton resident who has fallen in love with the valley and adopted it whole-heartedly. Over a coffee at the Pony Espresso, Pemberton's funkiest bistro and café, Lisa tells me about the genesis of Slow Food Cycle Sunday. She and Anna Helmer, who operates Helmer's Organic Farm with her parents, hatched the idea in 2005 as a way to get people out to the farms to celebrate the valley's scenic beauty and bountiful harvest.

"We wanted to create an umbrella for the whole community to come out for a huge celebration," she says. "It was framed as an invitation to the farmers, to the bikers and riders and community members. There's no charge to participate as a farmer, and no charge to ride it." The Cycle promotes the notion of eating locally and supporting local farmers, and strives to remove barriers

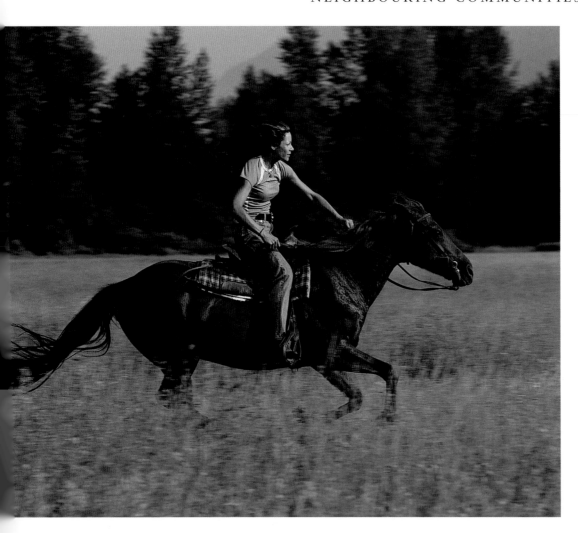

Above: **One of Pemberton's many attractions: the Meager Creek Hot Springs at the northern reaches of the valley.** BM

Left: **Colleen Gordy flies through the meadows at Wild Bill's Trail Rides.** BM

between farmers, recreationalists and visitors to the valley. The first year it drew four hundred people to twelve participating farms. In its second year, the event grew to over a thousand people visiting twenty-five farms or food producers with many riders coming up from Vancouver and farther afield.

Pemberton's arts community is also working to enrich the town and at the same time draw destination visitors. In 2006, painter Karen Love helped form the Pemberton Arts Council as a means of getting local artists to network and to begin to build a cultural identity. With the Olympics coming, part of the idea was to take stock of the artistic talent in the community and put it on display in the village. "People started coming out of the woodwork," Love says. "Artists from D'Arcy and Seton who have been around for a long time, and also new people moving here from all over the world. Artists used to typically move to the Gulf Islands, but now they're coming from England and Poland and Japan and making Pemberton their full-time home." The council is also working on the Pemberton Sculpture Project, which will place local, regional and international artwork at specific sites within the village. The project would set the foundation for an ongoing arts legacy designed to draw local and international attention.

Whatever happens in the years following the Olympics, Pemberton will always have its rich agriculture, its hard-working farmers and loggers, and its talented local artists. Perhaps its greatest chance of thriving economically and culturally lies in welcoming the outside world to appreciate those riches, and making the beautiful valley a destination in its own right.

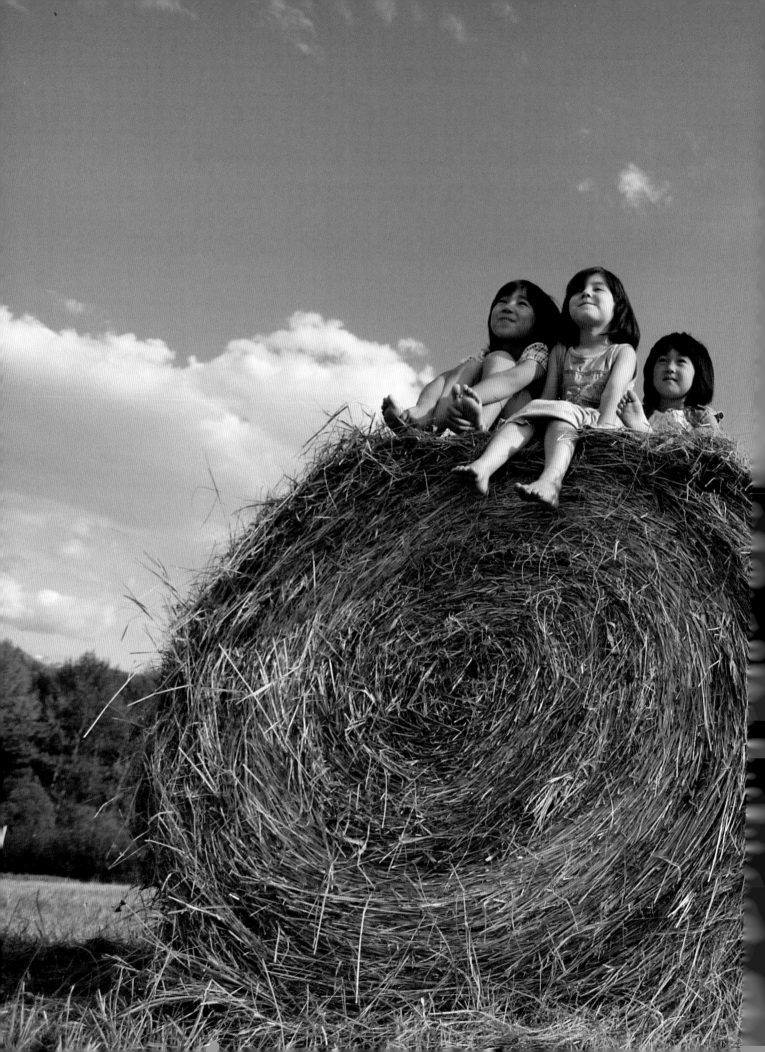

Sitting high on a Pemberton hay bale with Mount Currie in the background. TK

Top of the Pass

John Williams in front of his fish-canning equipment. TK

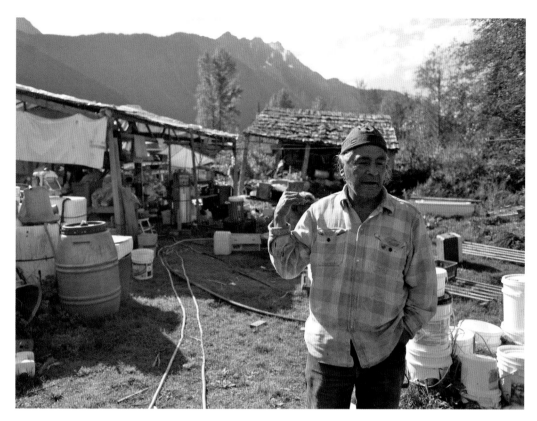

Mount Currie and the Lil'wat Nation

Mount Currie's Lil'wat Indian reserve, forty kilometres northwest of Whistler, is a quiet haven in contrast to the corporate bustle of Whistler Village. Its population of approximately 1,300, with another 550 off-reserve members, makes it one of the largest reserves in Canada.

John and Mary Louise Williams's yard, between the old reserve and the newer townsite on the hillside, backs onto the Birkenhead River. Alder and cedar smoke drifts from an old woodstove beneath brilliant orange sockeye salmon hanging from a drying rack. Closer to the river is the Williams's garden, and toward the house a pine pole structure covered in blue tarps houses the fish-canning equipment.

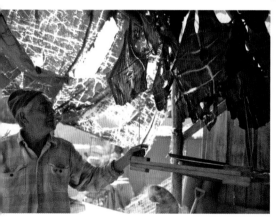

Sockeye salmon drying in the backyard. TK

Every year, the salmon make their way from the Pacific up the Fraser River through Harrison Lake and Lillooet Lake to spawn in the Lillooet and Birkenhead River. The fish are intimately connected with the Lil'wat culture and are still the main source of food for many in Mount Currie. "A lot of people start fishing in March for trout," John says, as we sit in the morning sun next to the drying rack. "Later on it's the spring salmon in April or May. Then we go to Lillooet to fish for sockeye; a lot of people here are intermarried to people at Lillooet." Many of the older band members stay at the head of Lillooet Lake at their traditional fishing site from May until November. "They dig roots across the lake and pick mushrooms," John says. The Williamses also subsist, to whatever degree they can, from gathering traditional foods from the land.

"My daughter Gabrielle does a lot of weaving with cedar—she makes baskets, jewellery and beading. I do a lot of bone carving and my wife does basket weaving," he says. And with their grounding in their own culture, the Williams children are equally at home off the reserve. Louise worked for Whistler Mountain for many years, and Melvin raced for the Whistler Mountain Ski Club when he was younger.

118

"Melvin wanted to make a traditional suit from cedar bark," John says. "He researched it for years, looked at pictures in museums. How to prepare the bark, when to harvest it." Learning to weave from his grandmother and mother and sister, Melvin went on to become a master weaver, selling his work and teaching courses at Whistler's Summer Art Workshops on the lake.

"We're fighting to bring our culture out to the world," John says. "After getting out of the residential schools, the older people didn't want to pass on the traditions. For two generations they grew up with that fear. A lot of the traditional spiritual practices were not handed down." Now some of the traditions are starting to come back. "We read those stories. Before when you caught the first salmon, you put it on a broad leaf and sent the bones back to the water to thank the salmon. We do it. We don't make a ceremony of it, though we should. But we still do it."

A sketch of Arnold Ritchie's house in Mount Currie, by Rudi Dangelmaier.
Harbour Archives

Laha7lus (Loretta Pascal) and her late husband Tsemhu7qw (Harold "Chub" Pascal) the guardian of Lil'wat burial sites, travelled to Ottawa, Geneva and the Hague in their struggle for Lil'wat rights, were arrested at blockades, and appeared in court on various occasions. Laha7lus retired from her job at the band in 2005 and became an elected councillor the following year. "When I retired, at the age of sixty, I took a look at my life and I realized I needed to learn more about my culture. I felt that being a grandmother there were some things that I needed to learn still." At the Ts'zil Learning Centre on the reserve, Laha7lus took courses in St'at'imcets (her native Lil'wat language) as well as basket weaving at the Xit'olacw Cultural Centre. "One of my baskets is going in the cultural centre in Whistler. I went digging cedar roots and canary grass—gathered those and blanched them so they get white." The pattern of the *Lawa7* (sockeye salmon) is woven from red and blackened cherry bark.

The Cultural Centre also offers courses in carving, canoe building and drum making. But it's not only in the area of arts and language that many Lil'wat are embarking on educational

The Birkenhead River sockeye run. Salmon are intimately connected with the Lil'wat culture. TK

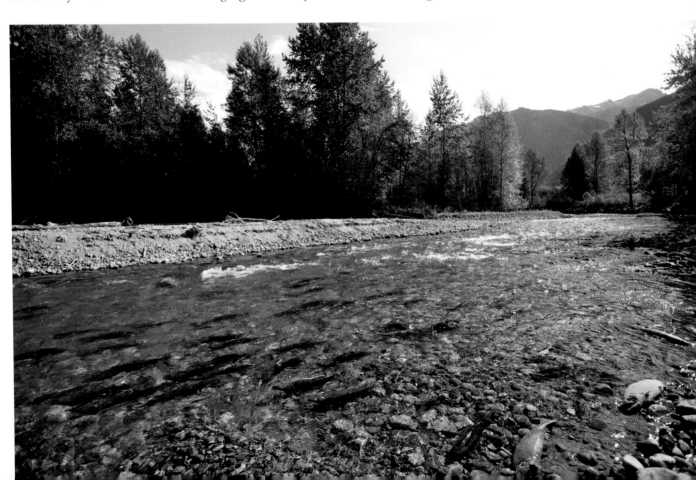

courses. The First Nations construction program was founded to develop skill sets among band members. Laha7lus's son got a job working on the Olympic Sliding Centre in Whistler, and her son-in-law on the Squamish Lil'wat Cultural Centre. Other jobs came up at the Nordic Centre in the Callaghan Valley and at the band-owned Lil'wat Concrete at Rutherford Creek where band members manufactured concrete highway barriers. "We do have knowledgeable people here with expertise," Laha7lus says. "Priscilla Ritchie is making recordings with our language, giving our name for things as well as the English. People are training as hosts, and we had a gathering of artists. I think maybe with all that we're doing now, people will notice Mount Currie—that we can work and meet any challenges, that we're able to administer and look after ourselves."

Laha7lus sits on various boards at the band including those of Creekside Resources Incorporated, Resource Business Ventures and Lillooet Properties Incorporated. They're looking at developing other businesses than logging for their people, she says. The band has 1,300 on-reserve members and a very high unemployment rate. "Because there's no jobs here, people go to Whistler to chambermaid and waitress." The Olympic-related work consisted of mostly short-term construction jobs and none of it in Mount Currie itself. When the Olympics were first proposed to the band in 2000, Laha7lus says the people weren't really for it: "People were concerned about all the traffic, and again it would be in Whistler. They called a forum and the council at the time voted right in front of us for it. But even if our people didn't approve it, now we have to get them involved."

The necessity to get involved in issues throughout the Sea-to-Sky corridor has led to some exciting initiatives from the band. One of these was the publication in 2006 of a small but important booklet titled *The People and the Land Are One* (*Pelpala7wit i ucwalmicwa múta7 ti tmícwa*). The booklet chronicles the history and culture of the Lil'wat, lays older colonial attitudes toward First Nations to rest, reiterates the 1911 Lillooet Declaration of Independence, and explores the band's strong cultural connection to its clearly mapped-out 797,131 hectares of traditional territory.

"Now they're looking at some of the things we used to say—talking about our traditional territory," Laha7lus says of the stance she and Tsemhu7qw and others once took that has now found its way into the more mainstream approach of the band. *The People and the Land Are One* traces the struggles of the Lil'wat people back to the Cariboo Gold Rush, including the loss of their land, rights and resources; confinement to reserves comprising 0.4 percent of their traditional territory; smallpox epidemics; and the abuse-ridden residential schools. All these events took a heavy toll on the Lil'wat people and culture.

Yet despite more than a century of hardships there is currently what the booklet describes as "a renewed sense of Lil'wat energy, a resurgence of hope and confidence." The community is young and growing fast and is aware that re-exerting its rights depends upon rebuilding a strong culture. "My grandchildren get shy to dance or sing," Laha7lus says, "but I tell them that's who you are. If you know who you are, you're able to go out and do what needs to be done."

The Whistler Valley is full of evidence of a Lil'wat culture that has thrived for thousands of years. There are rock paintings overlooking Green Lake, culturally modified trees near the River of Golden Dreams, animal traps at Cheakamus Lake, and a burial cave near Mons that was found to contain the remains of victims of the smallpox epidemics. To say that this valley wasn't inhabited by the Lil'wat is to misunderstand their culture. Before they were confined to the reserve at Mount Currie, the Lil'wat lived throughout their traditional territory with villages in many places, following the important cultural principles of *K'úl'tsam* (take only what food we need) and *K'ul'antsút* (take only what materials we need).

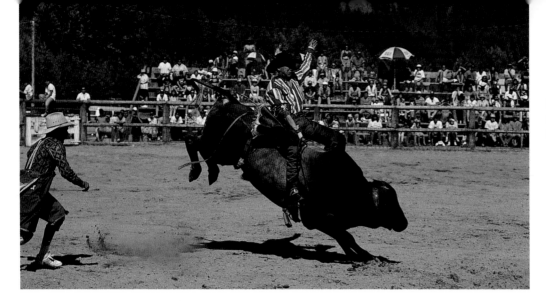

A bull rider looking deceptively relaxed at the Mount Currie Rodeo. BM

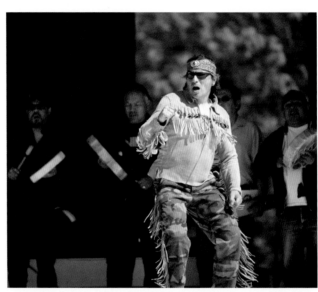

Left: **Troy Bikadi, member of the Lil'wat Nation dances at the gathering.** TK

Far left: **In May 2007 the Unity Riders and Feather Runners travelled on horseback and foot through the St'at'imc tribal territories to Mount Currie for the St'at'imc Gathering.** TK

Bottom: **Mount Currie and Whistler residents gather for a bonfire on the reserve.** TK

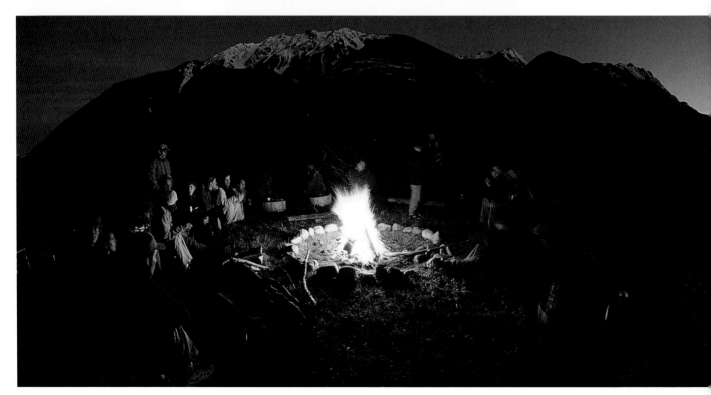

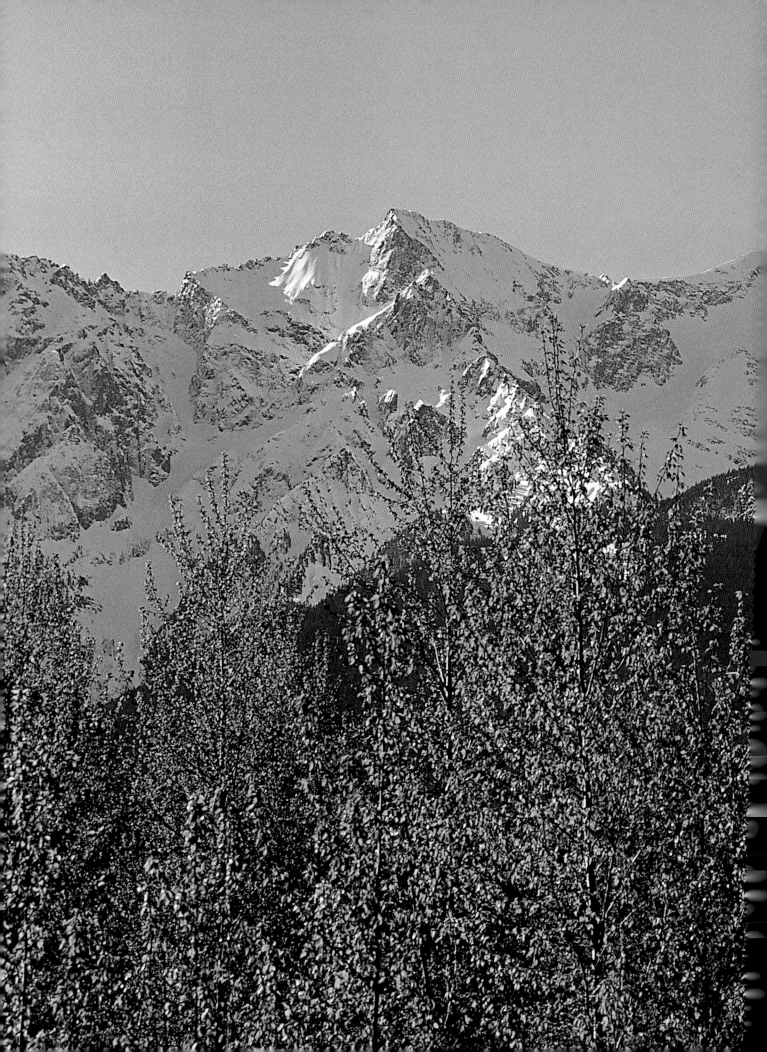

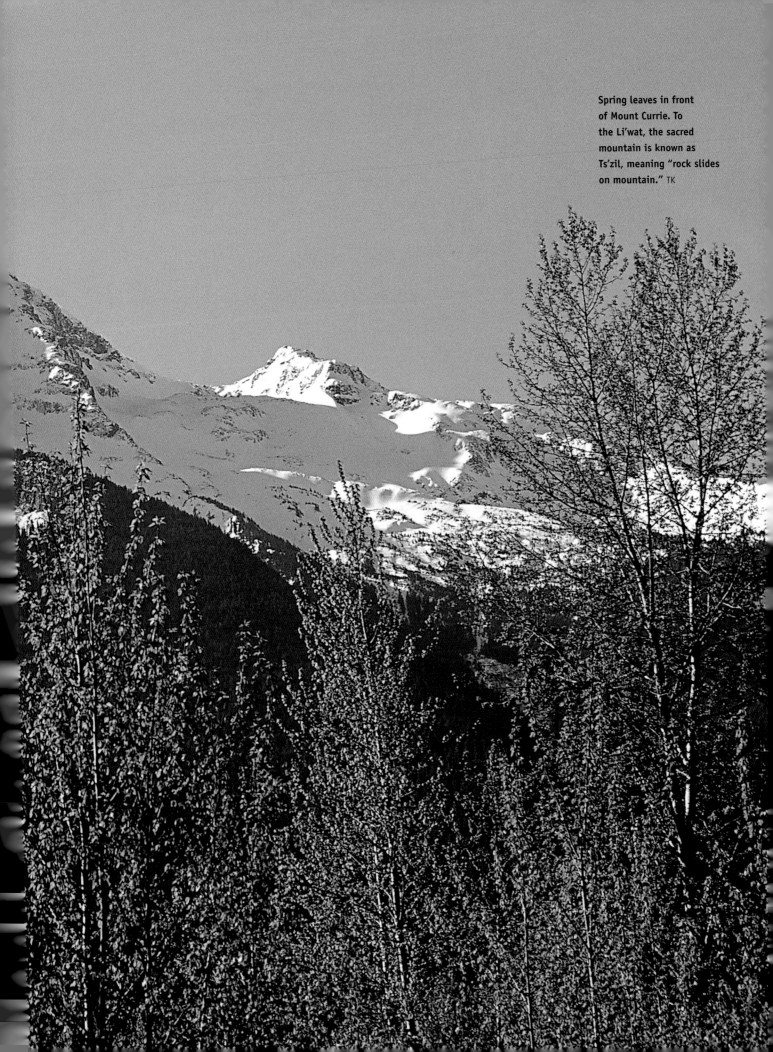

Spring leaves in front of Mount Currie. To the Li'wat, the sacred mountain is known as Ts'zil, meaning "rock slides on mountain." TK

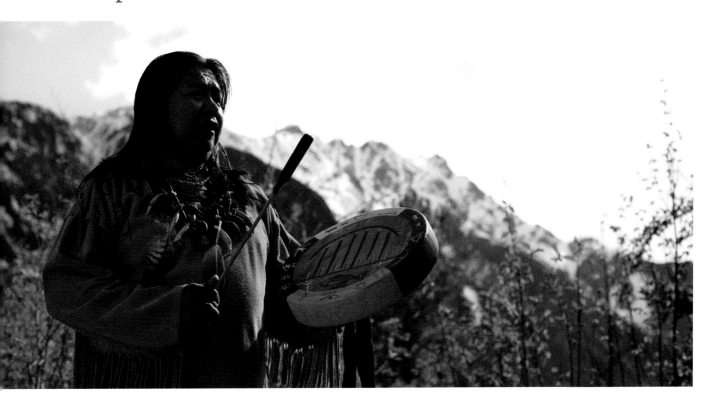

Johnny Jones (Yeq'iakwa7) sings one of the traditional songs passed down from his Lil'wat elders. TK

In the Lil'wat story of the great flood, the people of Green Lake were saved in Ntcínemqen's large canoe until they came to rest on a mountainside. There, they waited for the waters to subside before going out to populate the land again. In some versions of the story, all of the people of the West Coast originated from this Green Lake tribe at the top of the pass. In Whistler, people have been fond of the story that the Lil'wat travelled through this pass, but never settled here. The amount of evidence stemming from the research and traditional knowledge of Lil'wat historian Johnny Jones says there was a tribe living at Green Lake until 1858 and that Lil'wat individuals Alec Peters, Marvin Pascal and Charlie Frank were living at Lost and Alta lakes until recent times. The village at the north end of Green Lake (Kitsectsecten, or "place where deer lie down") was called Metsáltsem. The north end of Alta Lake at the mouth of the River of Golden Dreams is known as S7um'ik; Tapley's Farm is called Stsátsecwam, meaning "wading in the water."

Johnny Jones' traditional name, Yeq'iakwa7, means "weather changer" and once belonged to a medicine man from the Fountain Tribe. Growing up, he and two other young Lil'wat were taught the songs and dances. "Back in the seventies, we were the only ones interested in it, and the elders taught us to

Some of the Lil'wat artifacts Jones has collected are thousands of years old. TK

carry it on and not to lose it." When Johnny was nine or ten, he recalls walking past three Mount Currie elders, Charlie Mack, Slim Jackson and Baptiste Ritchie. "They stopped me and said, 'Hey what are you doing, are you lost?' I said 'No, I just like to walk the land, I enjoy it out here.' After that they were like my mentors and passed on stories. I learned a lot through them."

Jones's maternal grandfather Kupman, or August Hunter, was the last medicine man in Mount Currie, and lived to be 125. "A lot of people on the reserve respected him because he doctored them," Johnny says. "I was there for some of his ceremonies, watching him put on his paint and using a cup of cold water. It seemed like hours we'd sit in a circle and watch him do his ceremonies with paint and songs. And my dad told me a lot of the stories and the training [to become a

medicine man]—how to read the rock paintings and how the paint was made. The stories I was told got to me, and that's who I am today."

In 1990, Johnny Jones was at the forefront of a blockade at Ure Creek, a sacred Lil'wat site where the band's medicine men are buried. "I was the one who found the rock paintings and stopped the road there." The road was stopped for two weeks while the judge waited for evidence of a burial ground. On the advice of an archaeological consultant, the logging road eventually zigzagged through the site, destroying some of the burial grounds and leaving others.

Following the Ure Creek incident, Johnny took courses at the University of Victoria in archaeology. He now works for the band as archaeology field technician. "I'm the *Skele7a'wlh*, the resident headman or watchman of the territory. I caretake the sites to see if they're being destroyed by bikers or hikers or ATVs. With the rock paintings, sometimes climbers put hooks in and it starts to wear down. So I put a sign up saying not to do that." Johnny is also monitoring the work being done in the Callaghan Valley for the 2010 Nordic events. "I have five reports on the Callaghan. The environmental monitors up there are sleeping. There's a bear tree den behind the biathlon shooting range and they say there isn't. I find all this stuff—they have horse goggles on."

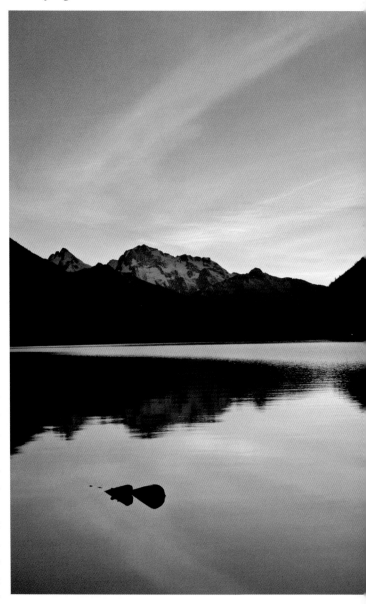

Digging through Whistler's layers of people and history is a fascinating endeavour. Beneath the commercial veneer of the village lies a ski-bum culture with roots in the 1960s and '70s squatting community; beneath that, a logging town and a fishing resort with hand-hewn log cabins perched on the shore of Alta Lake; and beneath that is a whole other rich culture of the Lil'wat that extends back for thousands of years. People in each era have found it a challenging environment that demands resourcefulness—a place imbued with the rare beauty and power of the Coast Mountains.

The top of the pass may not only be a place to move through, but perhaps also a place in which to stay and build a lasting culture. Such a culture will be built by locals and visitors, by those who love to play with gravity and those who love to walk the land, by aboriginals and newcomers with gradually intertwining histories and blurring boundaries. Above all, the culture will be deeply rooted in the place itself. For as the Lil'wat have known for millennia, the people and the land are one.

Sunset on Duffey Lake north of Pemberton. BM

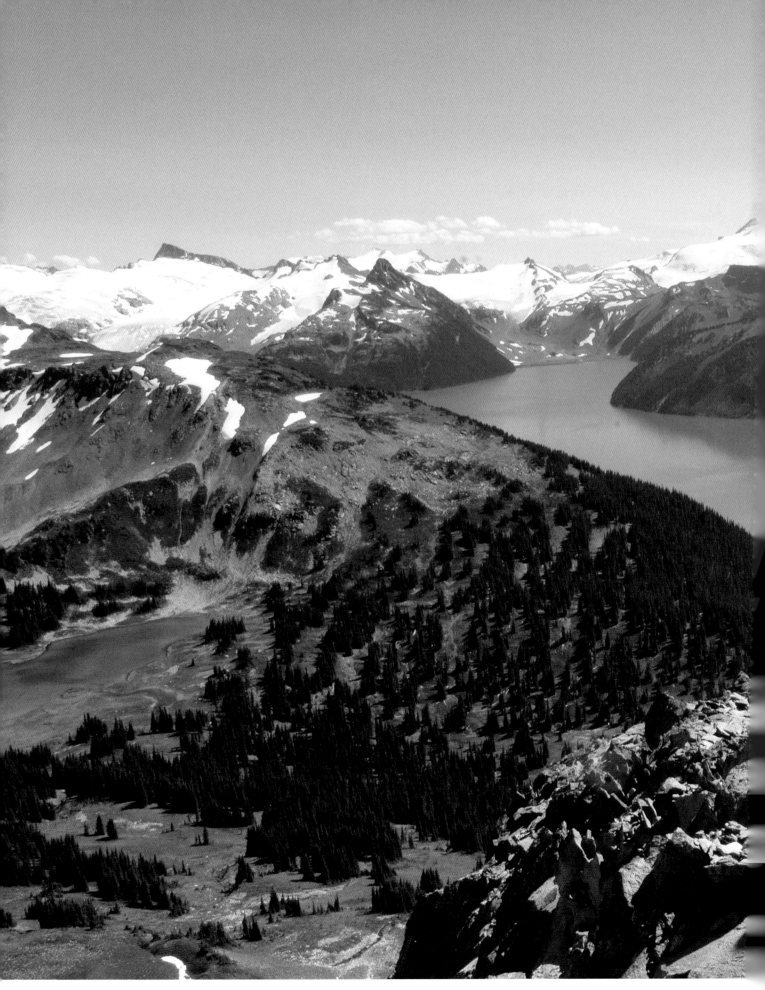

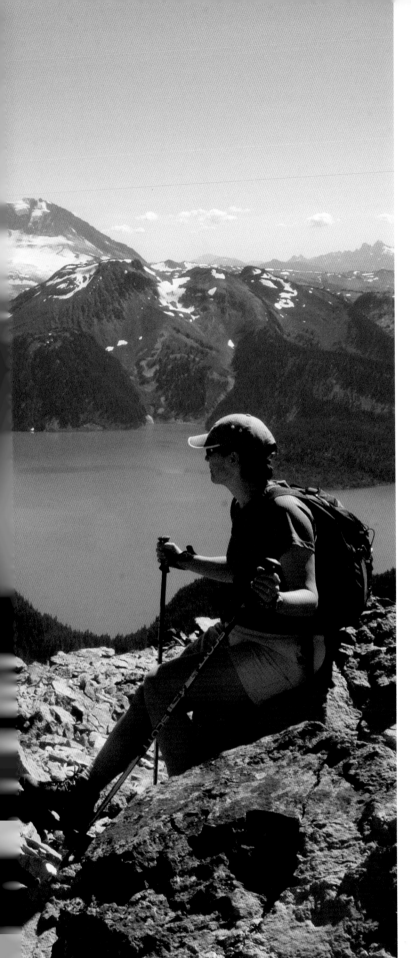

Getting Here

THE 120-KILOMETRE JOURNEY THROUGH THE SEA-TO-SKY COUNTRY FROM VANCOUVER TO WHISTLER IS ONE OF THE MOST SPECTACULAR TRAVEL ROUTES IN THE WORLD. BOTH THE HIGHWAY AND THE RAIL LINE HUG THE STEEP COAST ALONG HOWE SOUND PAST LIONS BAY, BRITANNIA BEACH, FURRY CREEK AND SQUAMISH BEFORE CLIMBING NORTHEAST INTO THE COAST MOUNTAINS WITH VIEWS OF MOUNT GARIBALDI, THE TANTALUS RANGE AND EVENTUALLY THE STRING OF PEAKS IN THE WHISTLER VALLEY.

The continuation of the route to Pemberton, Mount Currie and either Birken, D'Arcy and Anderson Lake, or Duffey Lake and the town of Lillooet, is equally breathtaking as the coastal climate gradually and then suddenly gives way to the dry interior.

Top of the Pass

Previous pages: **Karen
Tamaki enjoys a view
of Garibaldi Lake in the
provincial park.** BM

The Coast Circle Route follows the Fraser River past Lytton and Hope back to Vancouver.

Recent improvements to the Sea-to-Sky Highway have made the 1.5-to-2-hour drive to Whistler much easier, but it still demands keen attention, staying in the right lane when not passing, and pulling over when a large line of cars forms behind. Sightseeing is best done by using the pullouts along the route and stopping to explore the communities along the way. The Sea to Sky Cultural Journey, a series of route markers, road signs and pullouts created by the Squamish and Lil'wat First Nations, allows travellers to experience the landscape through Salish art, myth and culture culminating at the Squamish Lil'wat Cultural Centre in Whistler Village.

Wildlife

Sea-to-Sky Country is surrounded by wilderness areas rich in wildlife. While species such as wolf, moose, grizzly bear and cougar generally avoid populated areas, black bears continue to use the valley bottom lands they have inhabited for millennia. **Never approach, feed or pet black bears or any other wildlife**. Keep food securely stored away, and dispose of garbage in bear-proof garbage containers. If you encounter a black bear on a trail or in the forest, slowly back away while facing it and talking in a calm voice. The bears are generally as scared as you are and will wander away. For more information go to *www.bearsmart.com*.

Right: **Black bears
are a common sight in
Whistler.** BM

Below: **A recently widened
section of the Sea-to-Sky
Highway with a spectacular
view of the Tantalus
glacier.** TK

Whistler Area

If your journey into Sea-to-Sky Country has landed you in Whistler Village, by all means enjoy the morning cappuccinos, the window shopping, extended lunches, fine dinners and festive atmosphere. But when a feeling of

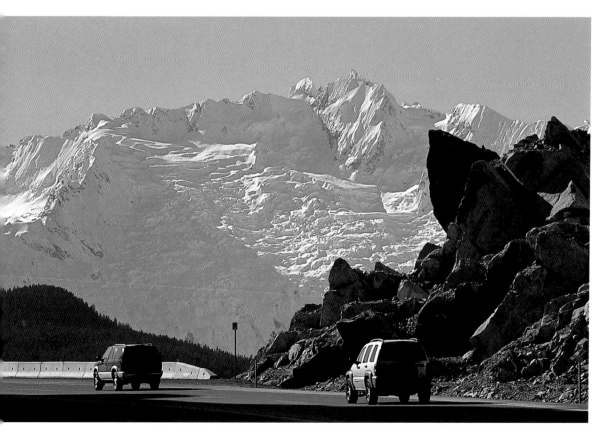

curiosity creeps in about what exists beyond the village paving stones, it may simply be the rest of the valley and the surrounding Coast Mountains beckoning you to come and explore. Not all recreation activities in the area need be of an extreme nature (though there are plenty of those) or a huge endurance test. Even after thirty years in the valley, walking or riding on the Valley Trail or up to Lost Lake are still favourite activities.

To access the **Lost Lake Trails**, walk from the Village toward the base of Blackcomb Mountain and turn left before the covered bridge over **Fitzsimmons Creek**. Follow the trail past the **skateboard and BMX park** until a pedestrian bridge crosses Fitzsimmons Creek. A large map of the area stands at the base of the trails next to the Cross Country Connection hut. **The Nature Trail** along the creek or the nicely grown-in old logging road are best for walking to avoid mountain bikers. It's a twenty-to-thirty-minute walk to the lake and approximately an hour to circle the lake and return to the village. In winter the trails are groomed for **cross-country skiing** and **snowshoeing**. Rentals are available at the Cross Country Connection and at other ski shops in the village, and the fee is payable at the little log cabin.

For an even shorter walk, before crossing the bridge to the Lost Lake Trails, turn left and then right in about fifty metres onto a winding trail through the alluvial forest next to Fitzsimmons Creek. The trail emerges at Nancy Greene Drive where you can turn left and immediately left again on the Valley Trail adjacent to Blackcomb Way to return to the village.

The thirty-five kilometres of paved **Valley Trail** are another great way to explore the valley by foot or by bike. Exit the village on Golfer's Approach with the **Telus Conference Centre** on your right and take the underpass under the highway. Never walk more than two abreast and please stay on the right side of the trail as it is a well-used transportation route shared by pedestrians, bicyclists and in-line skaters. From the **Whistler Golf Club** the trail goes either south

Above: **The ticket booth at the bottom of the Lost Lake Trails.** BM

Below left: **Marika Koenig and Lori Snowden climb Centennial in the Lost Lake cross-country trails.** BM

Below right: **An aerial view of Lost Lake and Green Lake.** BM

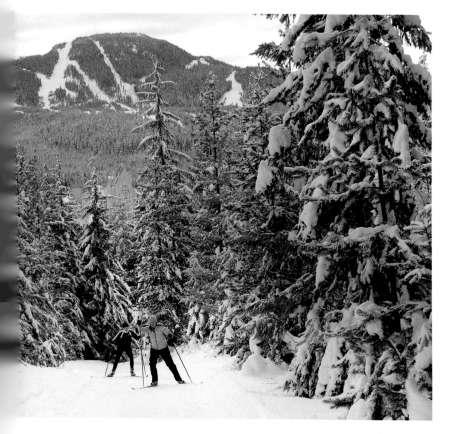

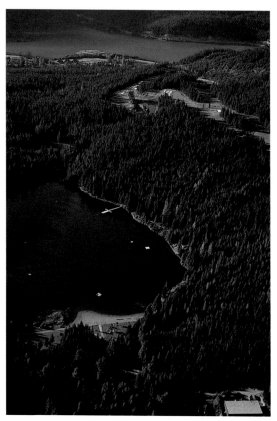

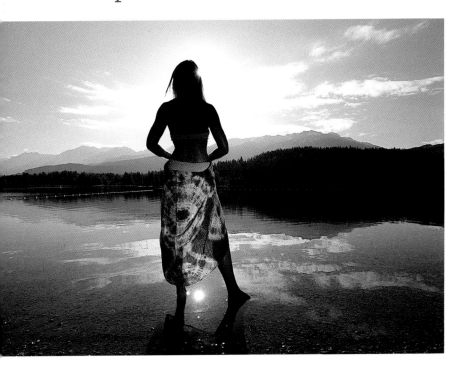

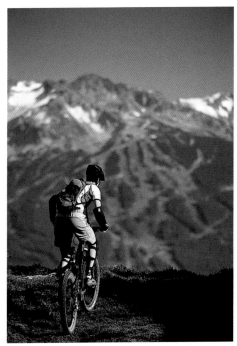

Above: **A swimmer ponders the reflective waters at Rainbow Beach.** BM

Above right: **Kris Ongman mountain bikes in the backcountry opposite Blackcomb Mountain.** BM

Below: **The Valley Trail is suited for every level of biker.** TK

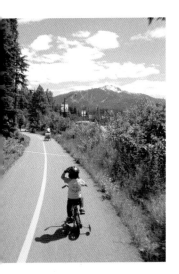

(left) toward Creekside and around the golf course, or north (right) toward Alpine Meadows (four kilometres from the Village). The northern route branches at Tapley's Farm (two kilometres) either left through the wetlands to Rainbow Park (one kilometre), or farther north along the meandering **River of Golden Dreams** to the **Meadow Park Sports Centre**. Take a map along or consult the ones en route. If not wanting to follow the return trail via Green Lake and Lost Lake to the village, transit buses run every fifteen minutes from Alpine Meadows and even more frequently from the Creekside. Some sections of the Valley Trail are groomed for cross-country skiing in the winter and are always free of charge.

The Valley Trail and the Lost Lake Trails are also the place to begin exploring the valley by bike. **Mountain bikes** are available for rent at various shops in the village and throughout the valley. Pick up a valley map at the **Whistler Activity Centre** kiosk or **Whistler Visitor Centre** next to the taxi loop and follow the Valley Trail wherever it leads you. Again, always stay on the right and *share the trail*. If you want to get more adventurous and explore the valley's forests and mountainsides on single-track trails, pick up a mountain-biking trail guide at a shop or *www.whistlerbikeguide.com* and note the ratings of difficulty from beginner to expert. Most single tracks can be accessed from the Valley Trail network. **The Lost Lake Trails** are a great place to work your way up from riding on a gravel road to the municipally built crushed gravel double track such as **Tin Pants**, **Molly Hogan** and **Donkey Puncher** to the true single track that veers off these other trails. All these trails link back together somewhere along the way, so getting lost at Lost Lake isn't usually a problem. The **Whistler Mountain Bike Park** offers lift-serviced downhill mountain biking on over two hundred trails from easy cruisers to gnarly, adrenaline-fuelled descents. *www.whistlerbike.com*

Swimming in Whistler's lakes is another favourite activity on long summer days. **Lost Lake Park** offers the closest beach to the village, while **Rainbow Park** on Alta Lake (best accessed by Valley Trail or bus) has a large beach and grassy area with spectacular mountain views, volleyball nets and a happening beach scene. On the opposite shore, **Lakeside Park** and **Wayside Park** have smaller beaches and **boat rentals**. Lakeside Park and **Alpha Lake Park** in Creekside also have children's play structures. To get farther out on the water, rent a canoe, kayak, sailboat,

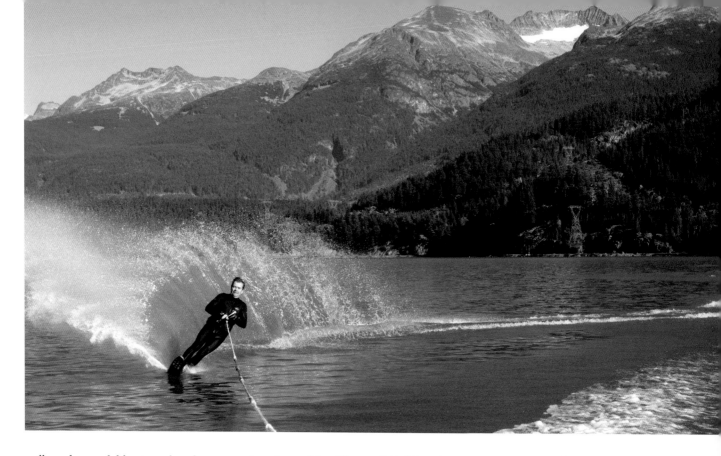

sailboard or pedal boat, and perhaps negotiate the snaking **River of Golden Dreams** to Green Lake.

Keith Reynolds sprays up a rainbow on Green Lake. BM

There are many **day and overnight hikes** into the unspoiled wilderness of **Garibaldi Park** on the east side of the Whistler valley. **Cheakamus Lake** is the easiest of these with a six-kilometre gravel access road east off the highway at Function Junction, followed by a 3.5-kilometre walk through ancient forest to the lake. The **Singing Pass Trail** leaves right from the transit bus loop in Whistler Village with a twelve-kilometre hike into alpine meadows. The **Himmelsbach Hut** and tenting sites are available for camping at **Russet Lake**. Rather than climbing from the village, many people ride the **Whistler Gondola** and hike across the **Musical Bumps** to Singing Pass and down to the village. Other trails accessible from the top of Whistler Mountain include the short **Harmony Lake Trail** and the eight-kilometre **High Note Trail** with spectacular views of Cheakamus Lake and Black Tusk. Whistler also offers cable-secured rock climbing on the **Via Ferrata**, and starting in 2008, rides between Whistler's and Blackcomb's mountaintop restaurants on the **Peak to Peak Gondola**.

Some of the most impressive volcanic formations in Garibaldi Park, including **The Barrier, Garibaldi Lake** and **Black Tusk** are accessed nineteen kilometres south of Whistler just below the Daisy Lake dam. The **Helm Creek Trail** provides a loop from Garibaldi Lake in the high alpine to the Cheakamus Lake Trail. Only ten kilometres south of Whistler, **Brandywine Falls Provincial Park** offers camping and an easy ten-minute walk to the falls, which plunge sixty-six metres into Daisy Lake. **Alexander Falls** and **Callaghan Lake** are accessed five kilometres south of Whistler at the entrance to the **Callaghan Valley**. Here the new **Whistler Nordic Centre** offers an extensive network of cross-country ski trails complementing the hiking and biking trails which abound in the area.

Other hikes in the Whistler area include **Rainbow Lake** beginning where Alta Lake Road crosses 21 Mile Creek. It's only a fifteen-minute hike to the beautiful **Rainbow Falls**, and eight kilometres all the way to Rainbow Lake. From the high alpine, one can continue on a rough trail to **Madley Lakes** and the Callaghan Valley. At the turn-off to **Cougar Mountain** just north of **Green Lake** is the **Ancient Cedar Loop Trail**. Eight kilometres of gravel road leads to the four-

Top of the Pass

**Filling up at a mountain
stream near Black Tusk.** BM

kilometre loop trail through a grove of nine-hundred-year-old giant cedars. Just north of here on the other side of the highway is another access to Garibaldi Park and the trail head for the steep eight-kilometre hike to **Wedgemount Lake** with a small overnight cabin.

Two of Whistler's three world-class eighteen-hole golf courses, the Arnold Palmer-designed **Whistler Golf Club** and Robert Trent Jones Jr.-designed **Chateau Whistler Golf Club** begin just steps away from the village, while the **Nicklaus North Golf and Country Club** is only a five-minute drive north at Nicklaus North Estates. All of the courses feature incredible views of the surrounding mountains and have pro shops and restaurants at the eighteenth hole. Information on tee times and fees can be found at *www.golfwhistler.com.*

The list of other recreational opportunities in the Whistler area is extensive: whitewater rafting and kayaking, rock climbing, fly-fishing, heli-skiing, zip-lining through the forest canopy, bungee jumping, eco tours, horseback riding, dogsledding, horse-drawn sleigh rides, tube-park sliding, snowmobiling, ATV rides and cat skiing.

Finally, of course, there is **downhill skiing** and **snowboarding** on **Whistler and Blackcomb mountains**. *www.whistlerblackcomb.com.* Ski touring into Garibaldi Park and other areas requires advanced backcountry and avalanche knowledge and experience. Guides and information are available through the Whistler Alpine Guides Bureau at *www.whistlerguides.com.*

Information on all of the above-mentioned activities can be found at one of the activity centres in Whistler Village, or online at *www.tourismwhistler.com.*

**A snowboarder threads
his way through snowed-
under trees on Whistler
Mountain.** TK

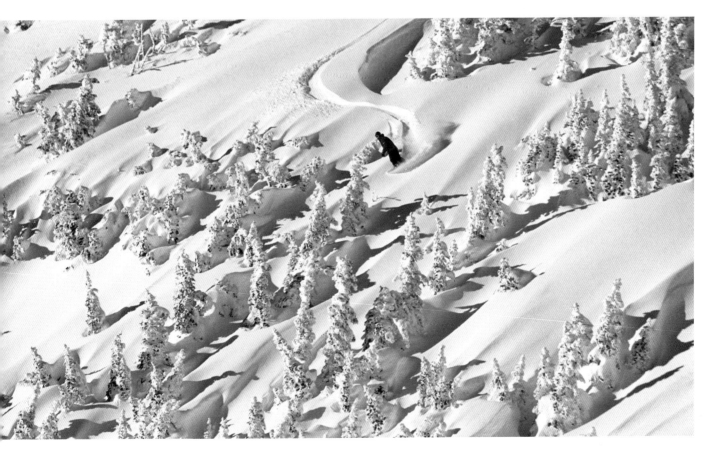

132 Whistler and the Sea-to-Sky Country

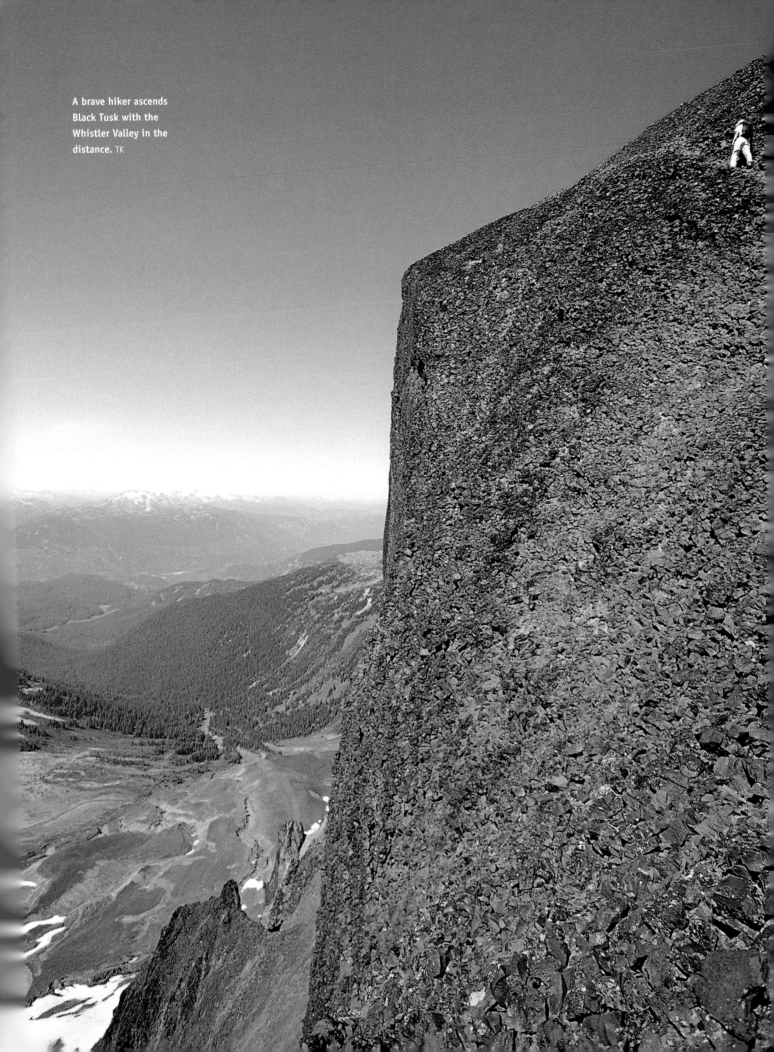

A brave hiker ascends Black Tusk with the Whistler Valley in the distance. TK

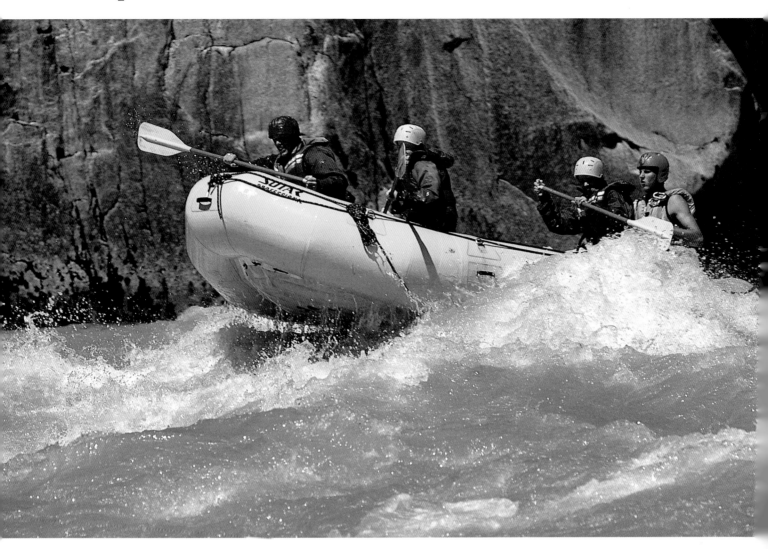

Whitewater rafters shoot the rapids on the Elaho River. TK

Squamish Area

Squamish is billed as the Outdoor Recreation Capital of Canada, and for good reason. The easiest and most accessible walking and birdwatching trails emerge from downtown Squamish into the **Squamish River Estuary**. Explore on your own or take one of the monthly Squamish Environmental Conservation Society bird walks that leave from the Howe Sound Inn.

To gain perspective on the town and the entire Howe Sound area, hike the trails from the foot of the **Stawamus Chief** to one of its three peaks. The forty-five-to-seventy-minute climb up the world's second-largest granite monolith is well worth the eventual view from its 650-metre summit. Just south of the Chief, the beautiful **Shannon Falls** cascade down a 335-metre drop. A fifteen-minute hike takes you from the base of the falls to the trails at the Stawamus Chief.

Since Jim Baldwin and Ed Cooper first climbed the **Grand Wall** of the Stawamus Chief in 1960, **rock climbers** have arrived from around the world to explore Squamish's many granite cliffs. Both the Chief and the nearby **Smokebluffs** offer a variety of routes, slabs and bouldering options that have turned Squamish into Canada's premiere rock-climbing mecca.

Where the Squamish River meets Howe Sound the strong southerly winds blow daily, attracting **windsurfers** and **kite boarders** from far and wide to the **Squamish Spit**. The area is known as one of the ten best windsurfing sites in the world, where expert windsurfers reach speeds of

up to sixty kilometres per hour. **Windsport Park** at the end of the spit offers areas for rigging and for watching. The views toward Mount Garibaldi, the Stawamus Chief and Shannon Falls are also spectacular. Access is from Government Road between Squamish and Brackendale. *www. squamishwindsurfing.org*

For less advanced windsurfing, as well as **canoeing, hiking, biking, fishing** and **camping**, head to **Alice Lake Provincial Park**, thirteen kilometres north of Squamish. The four lakes in the park are connected by an easy trail and are surrounded by grassy meadows, thick forest and towering mountains. With a playground, beach and picnic area it is one of BC's favourite family camping spots.

The southwest corner of **Garibaldi Provincial Park** is also accessed just north of Squamish at Garibaldi Estates. Turning east off the highway, the road follows Ring Creek for sixteen kilometres to the **Diamond Head** and **Elfin Lakes** trail head. Tent sites and a small shelter are available at Elfin Lakes, and the trail continues from there in the high alpine to **Opal Cone** and **Mamquam Lake**.

Adventurous hikers might also follow the Squamish Valley Road north of Brackendale into the **Upper Squamish** and **Elaho Valley**, known as the **Stoltmann Wilderness**. Designated by the **Squamish Nation** as one of seven **Wild Spirit Places** (Kwa Kwayexwelh-Aynexws), the Elaho and Sims valleys are home to an ancient rainforest with 1,300-year-old trees as well as wildlife including black bears, grizzlies, moose, deer, eagles and wolves. Hikes can range from the five-kilometre **Elaho Loop** to the two-day twelve-kilometre **Meager Creek–Elaho Trail**. The **Squamish Nation Youth Ambassadors** offer interpretive tours as a means of sharing their traditional culture and territory with visitors. *www.squamish.net*

Squamish offers over one hundred **mountain biking** trails ranging from easy family-oriented riding to intense single track climbs and descents. Many of the easier trails are in the **Garibaldi Highlands** to **Alice Lake** area. The **Mamquam Forest Service Roads** are active logging roads leading to gnarly freerides and downhills with some spectacular views of Mamquam Glacier. The **Valleycliffe** and **Crumpit Woods** trails challenge riders with steep single track, creek beds, rock faces and thickly forested trails. The **Squamish Mountain Bike Festival** is held every July and includes the demanding sixty-seven-kilometre **Test of Metal** mountain-bike race. For information on trails and events go to *www.sorca.ca*.

Squamish's three unique **golf courses** all provide spectacular views of the natural surroundings. In the Garibaldi Estates area, the tight and challenging Les Furber-designed **Garibaldi Springs** course contrasts the more open and easygoing **Squamish Valley Golf Course**. Sixteen kilometres south of Squamish, the Robert Muir Graves-designed **Furry Creek Golf and Country Club,** considered BC's most scenic golf course, looks directly out over Howe Sound.

Every year between mid-November and mid-February the **Brackendale Eagles Provincial Park** attracts thousands of wintering bald eagles. The birds feed on returning chum salmon in the Squamish, Cheakamus and Mamquam rivers and can be easily viewed from the **Eagle Run Viewpoint** on Government Road across from the Easter Seal Camp. Guided walking, rafting and horseback tours are also available. The **Brackendale Winter Eagle Count Festival** is headquartered out of the **Brackendale Art Gallery**, also on Government Road.

Other recreational opportunities in the Squamish area include **whitewater rafting, canoeing** and **kayaking** on the Squamish and Elaho rivers, **horseback riding, kayaking, hiking** and **biking** in the **Paradise Valley** where one of the first sections of the **Sea-to-Sky Trail** has been completed, **SCUBA diving** at Porteau Cove, **scenic flights, ski touring, snowmobiling, sailing, jet boating, railway and mining museum tours**, and more. Consult the **Squamish Adventure Centre** *www.adventurecentre.ca* or *www.mysquamish.com* for more info.

Below: **Windsurfers skim across Howe Sound beneath Mount Garibaldi and Atwell Peak.** BM

Bottom: **Great blue herons are plentiful throughout Sea-to-Sky Country.** BM

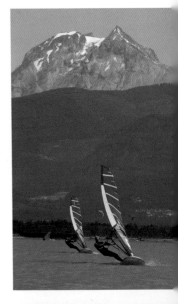

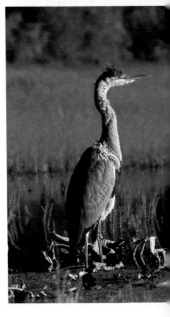

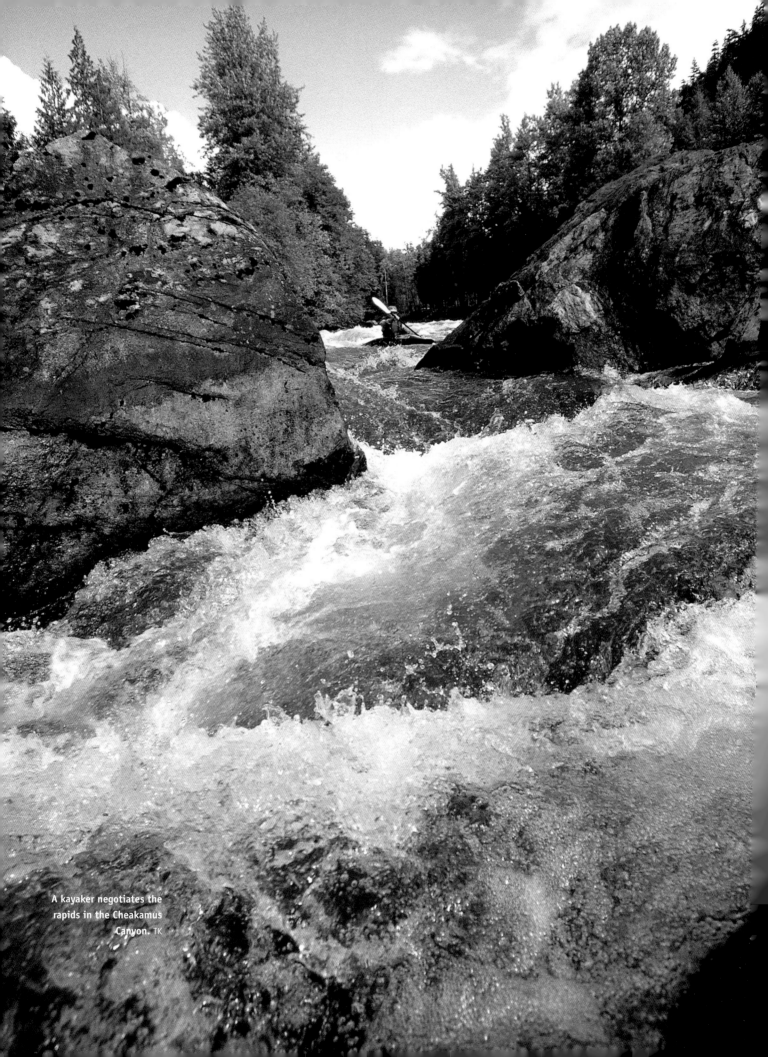

A kayaker negotiates the rapids in the Cheakamus Canyon. TK

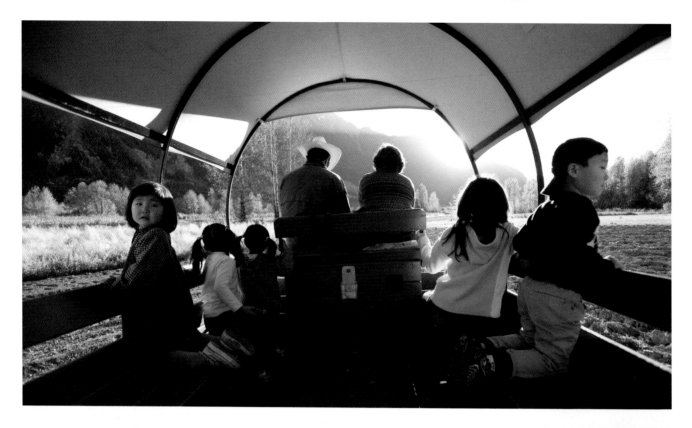

Pemberton and Mount Currie Area

Three kilometres south of Pemberton on the Sea-to-Sky Highway, **Nairn Falls Provincial Park** offers **camping**, **picnicking**, and forested **walking trails**. A 1.8-kilometre trail traverses the steep, thickly forested slope to **Nairn Falls** where the **Green River** tumbles sixty metres through a narrow, boulder-filled gorge. Another three-kilometre trail leads north to **One Mile Lake**, which has a day-use park on the highway side (one kilometre south of Pemberton), a boardwalk and trail circling the shore, and warm waters for swimming.

The beautiful **Pemberton Valley** offers a variety of recreational pursuits and a gateway to other travel routes. A stroll through the **Village of Pemberton** to the **Pemberton Heritage Museum** or the **Saturday Farmers' Market** can lead to longer walks on the **Pemberton Creek Trail** or toward the **Lillooet River** on the eight-kilometre **Valley Loop** (*www.pembertontrails.ca* for map). The **Pemberton Valley Road** offers a picturesque and nearly level bike ride through farmland to the **Pemberton Meadows**. In August, the **Slow Food Cycle Sunday** follows this route with stops at **farms**, **artists' studios**, **a winery**, and other food producers along the way.

Twenty-six kilometres northwest of Pemberton, a bridge crosses the Lillooet River, and the gravel **Lillooet River Road** continues toward the Lillooet headwaters with a turnoff to **Meager Creek Hotsprings** at the forty-kilometre mark (across the bridge and up another eight kilometres, keeping left). At 7.5 kilometres along the Lillooet River Road, the 4x4 **Hurley Pass Road** branches to the right toward the historic mining towns of **Bralorne** and **Goldbridge** as well as **Tyaughton Lake**. Access to the **Tenquille Lake hiking trail** is at Mile 5 (kilometre 8) on the Hurley Road leading to beautiful alpine meadows and a cabin built by long-time Pemberton residents. Tenquille Lake is also connected by trails to **Owl Creek** and **Gramsons** along the D'Arcy, Anderson Lake Road.

Pemberton has a growing network of **mountain-biking trails** that make use of logging roads,

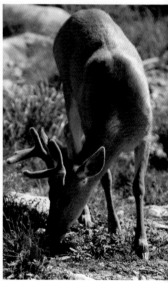

Above: **Black tail deer are native to the region.** BM

Top: **A fall wagon ride at North Arm Farm.** TK

horse trails and challenging single track. With imaginative names such as Blood, Sweat and Fear, Meat Grinder and Smell the Glove the over one hundred trails are divided into six geographic areas known as **Mosquito South Side**, **Mosquito North Side**, **Mackenzie**, **Pemberton Valley**, **One Mile Lake**, and **Rutherford Creek**. Maps and extensive info are available at *www.pembertontrails.ca* and at the Pemberton Bike Co. next to the Pony Espresso.

Just right off the Sea-to-Sky Highway between Pemberton and Mount Currie, the **Pemberton Airport** offers sightseeing flights over the valley and the **Pemberton Icefields**. The **Soaring Centre** offers similar tours in fixed-wing gliders that soar silently over the valley and surrounding peaks on the thermal updrafts. **Paragliders** take flight just north of here from Mount Mackenzie. Pemberton Airport Road also leads to the **Pemberton Valley Golf Club** and **Big Sky Golf Club,** both eighteen-hole courses with Mount Currie's 2,620-metre peaks as a majestic backdrop. At the turnoff to Airport Road, the **Pemberton Adventure Centre** offers everything from horse-back riding, whitewater rafting, jet boating and cultural tours.

From Mount Currie, the road heads north on the old **Gold Rush Route** past the Forest Recreation Campsite at **Owl Creek**, to Birken, D'Arcy and Anderson Lake. At Gramsons, north of Owl Creek, a forty-kilometre section of the **Sea-to-Sky Trail** runs to Birkenhead Lake. **Birkenhead Lake Provincial Park** is accessed just south of Anderson Lake at **Devine** on a seventeen-kilometre gravel road to **camping, canoeing, fishing** and **hiking trails. D'Arcy**, at the south end of Anderson Lake, also has **camping, swimming, boating, waterskiing** and **fishing.** From D'Arcy, the 4x4 **Highline Road** continues on to **Seton Portage** and **Seton Lake**.

To follow Highway 99 to **Lillooet** on the **Coast Mountain Circle Route**, turn right in Mount Currie at **Lillooet Lake Road** and follow it fifteen kilometres to the headwaters of **Lillooet Lake**. Here the paved **Duffey Lake Road** climbs to the left with steep switchbacks. Ten kilometres farther at Cayoosh Pass, **Joffre Lakes Provincial Park** offers hiking, climbing and tent camping next to the glacial green waters of the three Joffre Lakes. En route to Lillooet, the surroundings suddenly and spectacularly change from lush coastal forest to dry sage brush interior. The circle route continues down the **Fraser Canyon** to **Lytton**, **Hope** and back to **Vancouver**.

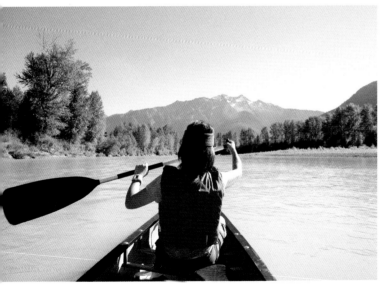

Canoeing down the Lillooet River is a great way to explore the Pemberton Valley. TK

At Lillooet Lake, one can also turn right onto the gravel **Lillooet Lake Road** with Forest Service campsites at **Strawberry Point**, **Twin Creeks** and **Lizzie Bay**. There is also camping at **Lillooet Lake Lodge** and the **St. Agnes Well Hotspring** just north of **Skookumchuck** with its ornate **Church of the Holy Cross** built in 1905. Another circle route may one day continue past Skookumchuck back to Vancouver, but the drive to Harrison from here is still a rough 4x4 road.

On long weekends in May and September, Mount Currie hosts the **Lillooet Lake Rodeo** and **First Nations Pow Wow** side by side at the **Lillooet Lake Rodeo Grounds** just north of Lillooet Lake. Bull riding, barrel horse racing and calf roping occur at the rodeo grounds while fifty metres away, visiting and local First Nations display traditional dancing, drumming and singing. There are also artisans' stalls, food vendors and bingo at the rodeo bleachers.

The Mount Currie Band offers traditional nature walks, cultural interpretive tours and Native art sales. Contact the band office at *www.lilwatnation.ca* or the Squamish Lil'wat Cultural Centre in Whistler.

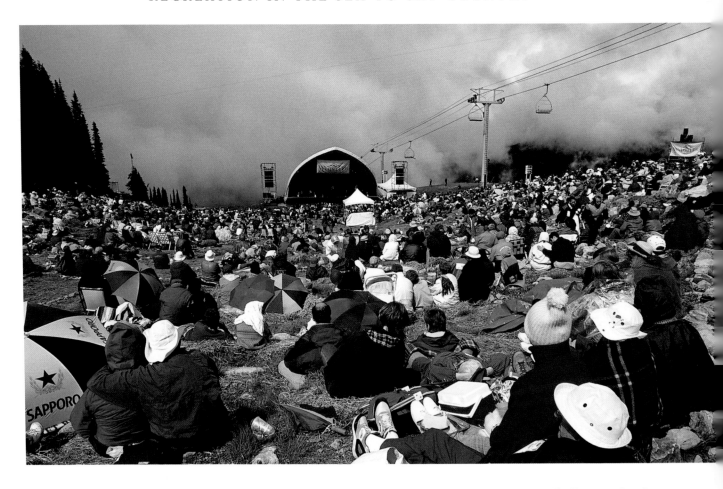

Arts and Cultural Events

The Vancouver Symphony Orchestra performing at the top of Whistler Mountain. BM

Life in Whistler isn't only about exercise and spiked adrenaline. The ongoing **Whistler Art Tour** offers a leisurely stroll through the village's public art exhibits and art galleries. Pick up the map and brochure at the Whistler Visitor Centre or go to *www.whistlerartscouncil.com*. In the months of July and August, non-traditional gallery spaces such as cafés and shops become part of the festive **ARTWalk** featuring the work of Sea-to-Sky artists. The Valley Trail and local parks also feature sculptures and other art installations, and many local artists open their studios to interested visitors.

The **Maurice Young Millennium Place Theatre** offers a rich program of music, theatre, dance, film, naturalist speakers and other performances throughout the year. Opening in 2008 in the Upper Village, the **Squamish Lil'wat Cultural Centre** will feature a longhouse and traditional ítsken (underground pit house), display local First Nations art, house a restaurant, and offer performances and lectures in a small theatre as well as cultural interpretive tours in the area. The new **Whistler Public Library** offers an intellectual safe haven in the centre of the village for locals and visitors alike, and next door the **Whistler Museum and Archives** conducts historic walking tours. **Summer Street Entertainment** in Whistler Village features everything from juggling and comedy to spoken word and jazz. A great way to end a long summer day is to attend a Thursday night **Luna Flicks** movie under the stars at Lost Lake Park. Both the **Saturday Farmers' Market** at Franz's Trail in Creekside and the **Sunday Farmers' Market** in the Upper Village offer local and regionally grown produce as well as prepared foods and arts and crafts.

Festivals and Cultural Events

Whistler

Celebration 2010—February/March
An annual month-long celebration of art and culture leading up to the 2010 Olympic and Paralympic Games. Includes local and Canadian art exhibits, film screenings, literary and performing arts events. *www.whistlerartscouncil.com*

Winter Pride—February
Canada's biggest and best gay ski week has morphed over the years into a community-wide event featuring parties, skiing, fine dining, theatre, music and more.

Telus World Ski & Snowboard Festival—early April
Ten-day season-ending celebration with skiing and snowboarding competitions, live music, mountain culture and lots of partying. 72–Hour Filmmakers' Showdown, Pro Photographers' Showdown, Words and Stories, and more.

Whistler Children's Art Festival—mid-July
A full weekend of live entertainment and hands-on workshops in fine arts, crafts and performing arts for the whole family. *www.whistlerartscouncil.com*

Summer Art Workshops on the Lake—July & August
One-to-three-day artist workshops at Alta Lake Station, a rustic heritage home on the shore of Alta Lake. Introductory-to-advanced instruction in drawing, oil, acrylic and watercolour painting with BC artisits. *www.whistlerartscouncil.com*

Crankworx Freeride Mountain Bike festival—late July
Ten days of freeride mountain-bike competitions, pro riding demos, films, live music and entertainment.

Whistler Music Festival—mid August
A wide variety of live music, street entertainment and interactive activities.

Whistler Writers Festival—mid-September
Four days and nights of readings by visiting authors, writing and publishing workshops, and a writer-in-residence program. *www.theviciouscircle.ca*

Cornucopia —early/mid-November
Whistler's wine and food celebration featuring gourmet food, wine, events, seminars, workshops and festivities. Includes the ARTrageous art exhibit and party.

Whistler Film Festival—late November/early December
Four days of new Canadian and international film screenings, industry workshops, seminars, special events and parties. Philip Borsos award for best new Canadian feature film.

Squamish

Brackendale Winter Eagle Festival—January

Tours to prime eagle-viewing areas, slide shows, art exhibits, Natural World Lecture Series, music and entertainment. *www.brackendaleartgallery.com*

Wild at Art—late February

Annual ten-day Squamish arts festival leading up to the 2010 Olympics. Gallery at the West Coast Railway Heritage Park features art, music, history and culture. Other events at Eagle Eye Theatre, Main Stage and Market Stroll downtown.

Squamish Mountain Bike Festival—mid-June

A weekend of fun and entertainment centred around the legendary sixty-seven-kilometre **Test of Metal** mountain-bike race. Acrobatic trials competitions, costumed chariot racers, a Mini-Metal obstacle course for six- to nine-year-olds, mountain bike poetry competition, and cowbell-ringing crowds cheering on the eight hundred cross-country riders. *www.testofmetal.com*

Squamish Mountain Festival—mid-July

A weeklong celebration of rock climbing, bouldering and mountain culture. Screening of international adventure film finalists, speakers, clinics, competitions, volunteer trail maintenance days and plenty of parties. *www.squamishfilm.com*

Squamish Days Loggers Sports—early August

Showcase of Squamish's heritage and community spirit. Music events, children's activities, parade, wacky bed races, ten-kilometre run and pancake breakfast. Two world-class loggers' sports shows with international competitors.

Pemberton & Mount Currie

Pemberton Winterfest—early February

The village of Pemberton comes alive with its Winterfest Parade, live music, street performers, outdoor concerts, local fine arts exhibits, artisan displays, beer garden, polar bear swim and more.

Lillooet Lake Rodeo and Pow Wow—May and September long weekends

At the Lillooet Lake rodeo grounds between Mount Currie and Lillooet Lake. Bull riding, barrel horse racing, saddle bronc and calf roping as well as First Nations traditional dancing, drumming, singing and competitions.

Slow Food Cycle Sunday—mid-August

Pemberton's signature slow food agri-tourism event. A unique back-to-the-land bike ride through the Pemberton valley to farms, food producers and a winery. Connects farm folk with city folk, and consumers with their food source. Gate sales, artisan displays and entertainment. *www.slowfoodcyclesunday.com*

Acknowledgements

This book was greatly enriched by many people in the Sea-to-Sky corridor who generously shared their knowledge and stories. Due to limited space, many engaging tales couldn't be included, though all of them added in some way to the final manuscript and to my enjoyment of writing it. In Whistler I'd like to thank Victor Beresford, Rob Boyd, Ian Bunbury, Eric Crowe, Kevin Damaskie, Charlie Doyle, Leigh Finck, Ace Mackay-Smith, Florence and Andy Petersen, Derek Rhodes, Pat Rowntree, Jack Souther, Jan Tindle, Garry Watson, and Nancy Wilhelm-Morden.

I'm grateful to Kathy Macalister, Tim Smith, Laurie Vance and Dan Wilson for their help with the Whistler Index, and to the many friends who contributed their unique "words for snow." For sharing their photos, my thanks goes out to J'Anne Greenwood, Charlie Doyle, Tim Smith, Greg Griffith, Terry "Toulouse" Spence, Greg Eymundson and especially Colin Pitt-Taylor for his photo gallery at the Riverside Café. Thanks also to Karen Overgaard and Jehanne Burns for their great help at the Whistler Museum and Archives, and to the helpful staff at the Whistler Public Library.

In writing about Squamish, I'm indebted to Kevin McLane, Peter Legere, and especially Perry Beckham for his knowledge and insight of the Squamish area. Thanks also to Harold and Bob Baker at the Stawamus reserve, and to Carl "Curly" Crosson and Dorte and Thor Froslev in Brackendale. Jean and Derry McEwan graciously shared their stories of an earlier era in Pemberton, while Jordan Sturdy, Lisa Richardson, Karen Love, and especially Jan and Hugh Naylor, provided perspective on the present.

Thank you to Laha7lus (Loretta Pascal), Yeq'iakwa7 (Johnny Jones), and John Williams and his family, for their insight into Mount Currie and the Lil'wat culture. Thanks also to the Mount Currie Band Council and to Lois Joseph and Martina Pierre of the Lil'wat Language and Heritage Authority for permission and assistance in quoting words from the St'at'imcets language.

Many written works were consulted during the writing of this book. These included *Around the Sound*, Doreen Armitage; *Whistler: History in the Making*, ed. Bob Barnett (especially pieces by Bob Barnett, Jack Christie and G.D. Maxwell); *Whistler: Against All Odds*, Michel Beaudry; *Lillooet Stories*, Randy Bouchard & Dorothy Kennedy; *The Whistler Outdoors Guide*, Jack Christie; *The Whistler Handbook*, ed. Bob Colebrook; *Pemberton: The History of a Settlement*, Frances Decker; *The Same As Yesterday*, Joanne Drake-Terry; *Short Portage to Lillooet*, Irene Edwards; *Squamish: The Shining Valley*, Kevin McLane; *The Whistler Story*, Anne McMahon; *Whistler Reflections*, Florence Petersen, Sally Mitchell & Janet Love Morrison; *History of Alta Lake Road*, Florence Petersen; *Beyond Garibaldi*, Irene Ronayne; and *The Lillooet Indians*, James Teit.

Thank you to all of the staff at Harbour Publishing and especially to Howard White and Silas White for seeing the book through to publication. Finally, I'd like to thank my family for their patience and support, and Bonny Makarewicz, Toshi Kawano and Roger Handling for making this book a feast for the eyes.

Stephen Vogler
Whistler, 2007

To my parents, Betty and Heinz Vogler,
whose sense of adventure and love of the mountains brought me here.

Harbour Publishing Co. Ltd.

P.O. Box 219

Madeira Park, BC

V0N 2H0

www.harbourpublishing.com

Printed and bound in China.
Text design by Roger Handling/Terra Firma.
Front cover image by Toshi Kawano, back cover and flap by Bonny Makarewicz.
Index by Hugh Morrison.

Harbour Publishing acknowledges financial support from the Government of Canada through the Book Publishing Industry Development Program and the Canada Council for the Arts, and from the Province of British Columbia through the British Columbia Arts Council and the Book Publisher's Tax Credit through the Ministry of Provincial Revenue.

Library and Archives Canada Cataloguing in Publication

Vogler, Stephen, 1964-
 Top of the pass : Whistler and the Sea-to-Sky country / Stephen Vogler ; photography by Toshi Kawano and Bonny Makarewicz.

Includes index.
ISBN 978-1-55017-430-4

 1. Whistler (B.C.)--History. 2. Whistler (B.C.)--Description and travel.
3. Whistler (B.C.)--Pictorial works. 4. Whistler Region (B.C.)--History.
5. Whistler Region (B.C.)--Description and travel. 6. Whistler Region
(B.C.)--Pictorial works. I. Kawano, Toshi, 1969- II. Makarewicz, Bonny,
1962- III. Title.
FC3845.W49V635 2007 971.1'31 C2007-904199-X

WHISTLER and SEA-TO-SKY COUNTRY

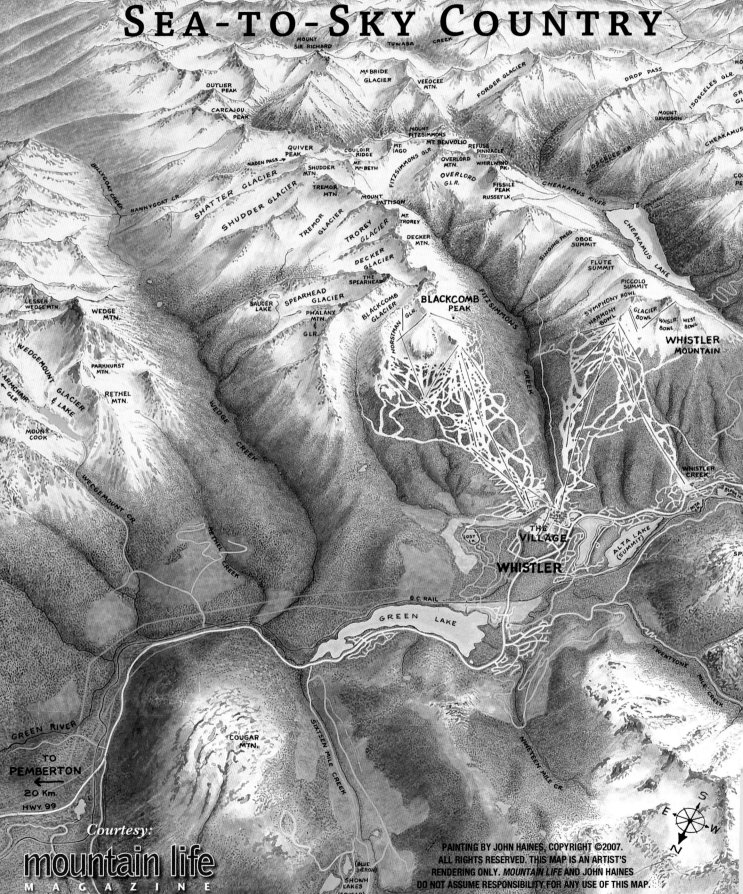

Courtesy:

mountain life
MAGAZINE